The Waking Dream

The Waking Dream

Fantasy and the Surreal in Graphic Art
1450–1900

Introduction and commentaries by
EDWARD LUCIE-SMITH

Notes on the plates by
ALINE JACQUIOT

with 216 black-and-white plates

Alfred A. Knopf New York 1975

THIS IS A BORZOI BOOK
PUBLISHED BY ALFRED A. KNOPF, INC.

Text Copyright © 1975 by Thames and Hudson Ltd., London
All rights reserved under International and Pan-American
Copyright Conventions. Published in the United States by
Alfred A. Knopf, Inc., New York. Distributed by Random
House, Inc., New York. Originally published in France as
Quatre Siècles de Surréalisme: l'art fantastique dans la gravure by
Editions Pierre Belfond, Paris. Copyright © 1973 by Belfond,
Paris

This edition first published in Great Britain in 1975 by
Thames and Hudson Ltd., London

Notes on the Plates Translated from the French by
Nicholas Fry

ISBN: 0-394-49758-9
Library of Congress Catalog Card Number: 74-21775

Filmset and printed in Great Britain by BAS Printers Ltd.,
Wallop, Hampshire
Bound in Great Britain by Cox & Wyman Ltd., Fakenham,
Norfolk

FIRST AMERICAN EDITION

CONTENTS

INTRODUCTION

Looking at an image in two dimensions is a more complicated process than we suppose. It is also, largely, a matter of habit: both how we look at the image in question, and how we interpret what we see. All representations of three-dimensional objects or scenes on a flat surface are a matter of convention; and these conventions have varied widely in different cultures. In some societies, men never acquire or invent such techniques at all, or acquire them only in rudimentary form. I am told, for example, that if you show a desert Touareg a photograph you have just taken of him, he may not even recognize it as a human being, much less as intended to portray himself. Even if we are able to construe what is before us, we may easily mistake its import. Turning the pages of this book, the temptation is to interpret the incongruities, the strange juxtapositions, the deformations and transformations and shifts in scale in terms which are misleading because too strictly contemporary with ourselves. Freudian psychology and the Surrealist movement have something to answer for: one kind of insight can blind us to another.

In this case, let us consider not only the images themselves, as we now see them, but the context – the milieu within which they were made. Since their making spans a period of more than four centuries, this cannot be regarded as something fixed. It evolved as European society evolved. Indeed, that society is the milieu. In the circumstances, how much can one generalize?

One generalization, at any rate, is worth making. During the period covered by this book, the print was the chief means of conveying visual information, a function now taken over by the mechanical reproduction of photographs. Many of the prints shown here had an informational purpose. Some – the anatomical prints, for example, or the perspective demonstrations – have the transmission of information as their prime *raison d'être*. More subtly, we can see how the print, often associated with an explanatory text, became assimilated to the print medium in general. We are invited to look at these compositions; but we are also invited to *read* them. The apparently incongruous things which appear in many prints can be brought together to form coherent intellectual structures, even though visual logic has been sacrificed.

But there is also a sense in which the print medium seems to have set the artist free, to have made fewer demands on him than other kinds of visual expression – at least in terms of the concessions he was expected to make to the audience. Here, too, I think we can draw an analogy with print in general. The act of looking at a print is on the whole private and solitary, just like the act of reading a book. Part of our negative response to fantasy and irrationality is out fear of other people. The irrational world of the fantastic novel, and the equally irrational world we find in some prints, are things we can savour without committing ourselves too publicly.

This much said, it is time to make a more detailed examination of the fantastic world which these prints make available to us. In that world, the most contradictory impulses flourish side

7

by side. Appeals to superstition compete with things which are emblematic of the growing commitment to objective investigation and to reason. The hermetic rubs shoulders with the popular.

One theme which recurs again and again is that of death and of the fear of death. We are constantly reminded how precarious was the life of our ancestors, and how obsessed they were with their own mortality. The 'Waking Dream' of our title was, in part at least, a nightmare.

Among the earliest images to fascinate printmakers was that of the Dance of Death. A particularly lively example occurs in the *Nuremberg Chronicle* of 1493 (*pl. 19*). But death also makes his appearance in more tremendous and less sardonic guise: he drives a chariot drawn by bulls in *The Triumph of Death* by Georg Pencz (*pl. 26*). But, in the imagery of the sixteenth century, death is everywhere, and he appears in many guises. Titian's *Death in Armour* (*pl. 29*) is ironic – what need of protective steel has the invulnerable monarch of all things? An anonymous Flemish engraving from the end of the century (*pl. 83*) shows death between a pair of courtly lovers; a great ruff frames the grinning skull, turning it into a kind of baleful sunflower. The idea is repeated, in more elegant guise, in the last plate of Robert Boissard's *Masquerades* (*pl. 90*), where death, richly clothed and with an hour-glass in his hand, accosts a fashionable woman. Even more deliberately cruel than these two, in the way it plays upon the spectator's sensibility, is the print by Beham (*pl. 32*). This shows an infant, either sleeping or dead, with the symbolic hour-glass beside him, and, in the foreground, a pile of skulls.

The fanciful and even freakish nature of these images seems to spring from the need to distance fear, while at the same time acknowledging it. One reason why Christians were so very much afraid of mortality was, of course, the paradoxical one that the end, though ghastly to contemplate, was not final. The dead man would eventually be raised up again at the Resurrection (*pl. 31*), and made to answer for his misdeeds (*pl. 78*).

Faced with this tremendous and terrifying body of doctrine, there were two ways in which a man's mind might go. On the one hand, he might give himself up to transcendental visions, following, in this, the example of St John the Divine, and of many a theologian after him. Representations of scenes from the Apocalypse form a quite special category in European graphic art. Dürer's *Four Horsemen* (*pl. 6*) have a menacing sweep and grandeur which is also to be found in the series of plates devoted to the subject by the French sixteenth-century artist Jean Duvet (*pls. 55, 56*). One thing we notice when we examine the latter closely is their immense and painstaking literalism, the fidelity Duvet shows to the sacred text. The strangeness we find in these illustrations springs in large part from the fact that they are scrupulously unimaginative translations. The symbolism of words is turned into visual imagery without any adjustments to suit the change of medium. Visionary though they are, Duvet's Apocalypse illustrations are also diagrams, not far removed from the diagrams we find in Robert Fludd's *Utriusque cosmi maioris scilicet et minoris metaphysica, phisica atque technica historia* (*pls. 98, 99*). There is also a relationship to the more personal, but still to some extent diagrammatic symbolism to be found nearly a century and a half later in Blake's *Illustrations of the Book of Job* (*pls. 149–51*).

The fear of death, however, might also draw a man's mind another way. He might seek for a better understanding of the workings of his own body, not only out of curiosity, but in the hope of finding the means of curing the various ills which destroyed it before its due time. In many respects the anatomical illustrations included here form a series within a series, a kind of commentary upon the rest. A number of classic works are represented, ranging in date from Vesalius (*pls. 45, 46*) to a plate from Charles Bell's *A Series of Engravings explaining the Course of the Nerves*, published in 1803 (*pl. 170*).

One of the most striking impressions one gains from looking at these anatomical plates is a

sense of the hesitation which those who drew them feel in confronting the subject matter they were called upon to depict. One may think that these feelings are to some extent reflected in Hogarth's *Anatomy Lesson* (*pl. 136*) from the *Stages of Cruelty*. In any case, these are far from being the coolly schematic illustrations we are used to finding in our own textbooks. Asked to draw an anatomical figure, the artist feels compelled to stress its corporeal reality by supplying it with a setting; often, too, he hints at a narrative. Nearly always there is a feeling of compassion for these abused bodies which are being forced to yield their secrets, first to the knife and then to the engraver's burin. Almost equally often there is a hint of sadism.

A good example of these conflicting impulses at work is the male figure lolling in a chair, its cranium split open, which comes from Charles Étienne's *De dissectione partium corporis humani libri tres* (*pl. 52*). This suggests some scholar murdered in his study. Yet more savage is the flayed man, or, rather, the skin of such a man, which appears as the frontispiece of Bartholin's *Anatomia reformata* of 1651 (*pl. 123*). The skeleton with a rhinoceros, from Albinus's *Tabulae sceleti et musculorum corporis humani* of 1747 (*pl. 133*), chiefly reflects the light-hearted, if sardonic, spirit of the age that produced it. But the way in which certain forms echo one another – note the correspondence between the pattern of the skeleton's rib-cage and the folds of skin on the rhinoceros's neck and back – suggests that the juxtaposition is not entirely accidental, and that some kind of comparison is intended. We may guess that a moral is meant to be drawn: the traditional one of death's invulnerability.

For a long time anatomical studies had a far from respectable reputation. Indeed, science in general had to be careful to distinguish itself from occult activities forbidden by the Church. The astrologer or astronomer in Giulio Campagnola's mysterious print (*pl. 28*) is accompanied by a monster which suggests an association between his activities and the powers of evil. It is only a step from here to the representation of St Anthony actively tormented by devils (*pl. 2*). The witch cult – at once the inversion of science and the inversion of religion – is represented by a number of images in this collection, not all of them early in date. Baldung Grien's *Bewitched Groom* is the most famous of them, notable for its extreme economy of means, and the way in which it uses the newly perfected science of perspective to reinforce the message (*pl. 24*). Very different, because in the taste of Renaissance allegory, is Agostino Veneziano's print, where a naked witch rides towards the sabbath mounted on a skeleton which might almost be that of a dinosaur (*pl. 37*).

The witch theme continued to fascinate artists even when the panic fear of witchcraft had receded from the public mind. Two examples of this fascination are Tiepolo and Goya (*pls. 134, 156*) Interestingly enough, Tiepolo's obsession is with the necromancer rather than the witch, and in his compositions it is men rather than women who conduct secret rites and pursue forbidden knowledge. I may, I think, be in the minority in finding more of the true spirit of the occult – its melancholy, its nullity, its dangerous frustration – in some of Tiepolo's *Scherzi* and *Capricci* than in Goya's more traditional allusions to witchcraft, which seem to be inspired mainly by his mistrust of the sexual charm of women.

Tiepolo's prints, as much as Goya's *Caprichos*, are the product of a festering, stagnating society. When we speak of the eighteenth century as the 'Age of Reason', we forget how many pockets of superstition remained. Decaying Venice, in particular, was the nurse of superstition. In the purely art-historical sense, we can trace the ancestry of Tiepolo's compositions back to some of the work produced by Giorgione and Giorgione's followers. There is a direct comparison to be made with Campagnola's astrologer – the composition there is certainly based on an original by Giorgione (*pl. 28*).

In discussing prints of this sort, I have begun to touch on a theme which has not, so far, been

more than mentioned: the theme of transformation. One might even describe it as the thread which binds together all the images in the collection.

Transformations, of course, occur throughout the history of the European visual arts. There have been times when the artist's ingenuity in transforming his material was chiefly admired; just as, at other times, he won admiration for the startling fidelity with which he reproduced the forms he observed in front of him. While prints provide perhaps more instances of violent transformation than any other means of expression in the visual arts, the process is certainly not confined to the graphic medium. A number of images reproduced here are reproductive. Thus *pl. 68* is a copy or paraphrase of a painting by Arcimboldo or a follower of Arcimboldo's. *Pl. 77* is a reproduction of a painting by Hieronymus Bosch, made a considerable time after the artist's death. *Pls.* 78 and 79 are probably later exercises in the manner of Bosch, but contain much that is certainly borrowed from him.

This does not prevent me from saying that the process of transforming and deforming images can be more conveniently examined through prints than it can be elsewhere.

Sometimes, it is simply a case of the artist turned conjurer, as in the group of anamorphic and 'two-way' prints illustrated (*pls. 164–9*). The essential thing about these prints is that they call into question the processes of seeing, and of comprehending what one sees. The 'two-way' prints are visual paradoxes: look at the image held in one direction, and you see the head of a bearded man; turn it upside down, and you have an elaborately coiffured woman. Anamorphic prints rely on perspective deformations, which the spectator can correct by looking at the sheet from an angle – the most famous example of this kind of trickery in art is the skull which appears at the foot of the composition in Holbein's *Ambassadors*. Prints of this sort are essentially unambitious in their artistic aims. A few use the trick to point a moral: J. H. Glaser's depiction of *The Fall* (*pl. 167*), viewed from one side, shows the head of Christ, crowned with thorns.

The reason for paying some attention to these prints is not their artistic quality, but what they have to tell us about the print as an object – a piece of paper, covered with lines and patches of tone. They remind us of the essential 'dryness' of the print medium, its tendency to concentrate attention on the symbolic rather than the physical reality of the image.

We do well to keep this characteristic in mind when we turn to the extraordinary compositions which Pieter Breughel the Elder designed for professional engravers such as Van der Heyden to engrave (*pls. 69–74*). These are heavily influenced by Bosch, and we find in them many images which were favourites with the earlier artist: the egg-like forms, twisted trees, strange birds, hollowed figures with other figures swarming within them.

The simplest of these compositions, and therefore the easiest to interpret, is probably a copy or paraphrase of Bosch, and illustrates a proverb: 'Big fish devour little ones' (*pl. 74*). This saying is used as an excuse for the most extraordinary visual excess. There are fish everywhere, always in the process of eating or being eaten. The pressure of the imagery makes the print into far more than an illustration to the commonplace theme which provided the initial impulse. What seems to spill out on paper, as everything spills out of the huge, sad fish whose belly is being ripped open by a little man in armour equipped with a serrated knife much bigger than himself, is a flood of the associations which the artist finds in his own mind.

The prints showing the consequences of the Seven Deadly Sins illustrate this accumulative and associative process with much greater variety. *Anger* (*pl. 71*) is an anthology of the horrible punishments in use in Breughel's day – we see two people being boiled in a cauldron, another being roasted over a slow fire. Yet a cautionary word is necessary. Many of the elements we find in the print are traditional rather than personal symbols – the bear in the foreground, for example, is a conventional emblem of anger. If the print seems mysterious, this is due not only

to the strangeness of some of the imagery, but to the fact that it relies on our comprehension of a symbolic language many of whose terms are unknown to us.

This remark applies with even greater force to the elaborate Renaissance allegories which also appear in this collection. The so-called *Melancholy of Michelangelo*, engraved by Giorgio Ghisi, supposedly after a design by Luca Penni (*pl. 33*), is an outstanding example of this, and has been the cause of much controversy. Modern scholarship now recognizes in it an allusion to the *Aeneid*, with the Sybil of Cumae, Aeneas's guide to the nether world, approaching Theseus, who is chained to a rock, Avernus behind him, and a boat symbolic of those who succumb to temptation sinking at his feet.

The problem, here, appears to have been solved because the allegorist relied mainly upon a single literary source, and we can use the source to unlock the puzzle presented to us by the imagery. An allegory which draws upon a more varied collection of source-material, such as Dürer's *Melancholia* (*pl. 8*) is unlikely to yield all its secrets; and here, I think, it is legitimate to wonder if Dürer intended any spectator, even one contemporary with himself and rooted in the same culture, to be able to probe it completely.

The elaboration of the great allegories, however, represents the culmination of the print-maker's symbolic art; and it is easier to understand the way in which this art operates by looking at simpler and less ambitious images. In discussing the anamorphic and 'two-way' prints included in this collection, we made a first approach to the question of transformation. Transformations of various kinds recur throughout the collection. Makers of prints transpose natural appearances with great freedom. We can see an early example of this process in the *Songes drolatiques de Pantagruel* by François Desprez (*pls. 59–67*). When we examine these grotesque little personages, we note that the grotesquerie relies on distortion, but also to some extent on a kind of collage technique, whereby the figures are constructed in part of other, and perfectly familiar, objects.

The same characteristics appear, but far more clearly, in an elegant series of images dating from the end of the seventeenth century – the *Costumes grotesques* of Nicolas de Larmessin (*pls. 125–8*). In these we find a series of personages, each symbolic of a particular trade or metier. The mason's costume is made up of the tools of his trade; the turner and the cooper are clad in the same fashion. So far so good – the prints are related to those which represent the fantastic costumes worn at court ballets and masquerades, produced both in de Larmessin's own time and earlier (*pl. 57*).

The disturbing thing, however, about the *Costumes grotesques* is that the figures seem not merely to be clad in the accoutrements of their trades, but to be made of these accoutrements, with human faces, hands and feet added. This is particularly the case with the potter (*pl. 128*), who is only a step away from the Roman trophy made entirely of shells from the *Museum Kircheriarum* (*pl. 129*).

This collage technique survived into the nineteenth century, where it was used for purposes of caricature. Grandville's satire on landscape painters (*pl. 183*) should be compared to the little seventeenth-century etching entitled *The Knight of the Culverin dancing with Monsieur Rigaudon* (*pl. 115*), which reveals a very similar kind of vision.

But there is another category of transformed figuration even more interesting than this one. It occurs when the figures are reduced to abstract forms. We see this at its simplest in the 'cubist' figures of Erhard Schoen (*pl. 58*). Schoen's purpose is practical – the design is intended to demon-strate, in simple terms, the way of achieving correct proportions when drawing the human body in action. The designs from Bracelli's *Bizarrerie* (*pls. 100–5*) may, at first glance, appear similar, but in fact are abstractions from the figure undertaken for their own sake. Bracelli is like a man who invents a language, with its own grammar and its own relationships, and

then sedulously translates a famous literary passage in a 'known' language into this new tongue.

One very striking thing about his little figures is their graphic quality. The longer we look at them the more aware we become of their existence as lines on paper rather than as forms in imagined space – this in spite of the appearance of a horizontal line in each print, which represents the far edge of the horizontal plane.

Even more closely linked to the idea of the living and moving line are the four groups of arabesque figures by the German goldsmith Christoph Jamnitzer (*pls. 85–8*). In many people's minds these will provoke a comparison with the work of Saul Steinberg, and despite the difference of date, and a probable difference in basic intention, I think this is a comparison which can easily be sustained. One striking feature of the figures in many of Steinberg's drawings is their relationship to the idea of line and of the page. Steinberg is good at inventing ambiguities. For example, he will show us a hand that holds a pen that draws a line that creates the hand which is holding the pen. Jamnitzer's arabesque designs abound in rather similar effects. The bird in the top left corner of *pl. 86* is almost purely calligraphic. The rams the jousters ride are solidly three-dimensional, apart from the scrolls which form their feet. With draughtsmanship of this sort the page forms a matrix; the line rests not on but within the white surface, as a black vein rests within a piece of marble.

The large class of perspective prints might seem at the very opposite end of the spectrum from these calligraphic works, committed as they are to the idea of a third dimension, but, as Schoen's design suggests, there is in fact a kind of link. Perspective explorations are richly represented here. The earliest, designs by Lorenz Stoër (*pls. 17, 18*), tend to keep the eye close to the front plane suggested by the design. This may have been due to timidity, but may also have been dictated by the fact that they were at least partly intended to serve as models for makers of marquetry. One significant feature is the artist's exploitation of the contradictions to be extracted from drawn perspective. Thus, it would be impossible to create some of the structures shown in *pl. 17* in three dimensions, though perspective itself is supposed to be a system designed to reduce three dimensions in logical fashion to two.

Later work in the same field operates upon a rather different set of principles. Vredeman de Vries, in a famous set of perspective demonstrations (*pls. 93–6*), draws out space, makes it dynamic, tries to suggest the way in which it flows into, and then out of, the confines of the design. This is particularly noticeable in the plunging perspective of *pl. 93*.

In a sense, the culmination of all these perspective experiments are the *Carceri* of Piranesi (*pls. 140–2*). Here the art of the perspective print becomes suffused with a mysterious poetry. Piranesi's *Carceri* (Prisons) are a series of 'caprices', and the caprice is a concept closely linked to the development of Venetian art. Giorgione's *Tempestà* may, perhaps, be claimed as the earliest example. But essentially the caprice is an eighteenth-century phenomenon. We meet it in the work of Canaletto and Guardi, who transpose the architecture and scenery of Venice and the lagoon. We also meet it in the œuvre of G. B. and G. D. Tiepolo. The prints of the elder Tiepolo give us a very clear demonstration of what the caprice was supposed to be about. They are sets of variations upon a theme. The artist invites us to compare him with a musician, who improvises upon a phrase, drawing from it a set of variations. The caprice contains within itself a declaration of the artist's faith in himself – not only of faith in skill, but of faith in invention, which gives him the right to tyrannize over the world of appearances.

The architectural spaces which Piranesi represents in the *Carceri* are influenced by Late Baroque stage design, and, in particular, by Daniel Marot's designs for opera scenery, etched in 1702. But they carry the manipulation of space much further than even the most ambitious

stage-designer would dare to do – the colossal arches, instruments of torture, staircases apparently leading nowhere that Piranesi created have impressed the Romantic imagination ever since. The tiny figures which populate some of these scenes serve to emphasize the sheer vastness of the constructions which Piranesi creates upon the page; and, as Callot (*pl. 97*) knew before Piranesi was born, this disproportion stresses the dream-like atmosphere. When Piranesi reworked the plates after the first edition, he deliberately increased the tenebrous quality the designs already possessed. It is not merely abstract space, but a palpable, rather miasmic atmosphere, that now fills these immense chambers.

The Romantics rightly regarded Piranesi's art as being one of the turning points between a previous epoch and their own. When we look at the plates included in the last section of this book, we are, I think, aware that they are an expression of a new attitude towards both the graphic medium and the symbolic use of images.

Goya's *Colossus* (*pl. 153*) is a symbol of a different kind from any we have so far encountered. It is different not only because it is personal – an emblem of the artist's feelings, put forward without false modesty – but because its symbolism is open-ended. The implications stretch out in any direction that we may care to take them. The precise, complex, limited and limiting mechanism of the Renaissance allegory has been entirely discarded.

Nineteenth-century artists were to cling for a while to certain props, most notably to the support offered by a literary text. We find Delacroix using Goethe as a springboard (*pls. 184–6*), and Doré doing the same with Dante (*pls. 191–3*). The distinction of Romantic book illustration is the way in which the artists, even lesser ones, such as Louis Boulanger (*pls. 172, 173*) and Horace Vernet (*pl. 190*), illuminate the spirit of the text. But gradually the bonds between text and illustration loosened. Redon's illustration to *Les Fleurs du Mal* – '*Sans cesse à mes côtés s'agite le démon*' – is peripheral, a gloss on the words, rather than a direct transposition (*pl. 209*). And of course Redon himself, and Ensor, as well as lesser artists such as Félicien Rops, produced work which is, like the *Colossus* (*pl. 153*), an illustration not of any text but of the artist's state of mind. It is fitting to conclude with Redon's famous *Spider* (*pl. 216*), which Huysmans, in *A Rebours*, made into a totem of the Symbolist movement.

As a footnote to this, however, it ought to be noted that it was Redon's drawing of the *Spider* (done in 1881) which impressed Huysmans. *A Rebours* was published in 1884 while the print dates from as late as 1887, and was perhaps undertaken in response to the interest aroused by the book.

Be this as it may, Redon's work, and in particular this haunting image, provides a suitable vantage point from which to look back at the 'Waking Dream' as it expresses itself in the history of European prints. Looking down the long tunnel of time, we do of course see things, and receive intimations, of which the artists themselves were unaware. At the same time, many of the things they intended to be of the most importance have become of little interest to us, and have camouflaged themselves in consequence.

Basically, what has happened is that the rational intention has been overwhelmed by the irrationality of the result. In that sense, many of these images must be thought of as 'found objects'. Their original context has disappeared with their original use – nowhere do we see this more clearly than with the series of anatomical illustrations – and what remains has a suggestiveness the more powerful because rooted deep in the unconscious – our own unconscious, our own fears and desires, as well as those of the artist responsible for the print.

EDWARD LUCIE-SMITH

I THE FIFTEENTH AND SIXTEENTH CENTURIES

Prints produced in the fifteenth and sixteenth centuries are often rich in fantasy. The sources they drew upon are very various, and often opposed. Some engravings are almost purely medieval in style. An example is the ornamental letter T (*pl. 1*) designed by the Master E.S. The grotesque animals to be found here are direct translations of the kind of decoration to be found in illuminated manuscripts. In complete contrast to this, other images, only slightly later in date, are an expression of the new concerns of Renaissance humanism. Antonio Pollaiuolo's famous *Battle of Naked Men* (*pl. 10*) seems designed to demonstrate the artist's skill in depicting the male nude; and other prints, such as the architectural fantasies of Lorenz Stoër (*pls. 17, 18*) are tributes to the new science of perspective. But even these apparently 'academic' exercises became vehicles for the expression of personal emotion. Pollaiuolo's print is filled with a ferocity which goes beyond the apparent primary purpose; and, when a School of Fontainebleau engraver – sometimes supposed to be Jean Viset – attempts a similar exercise a generation later (*pl. 39*), the didactic intention succumbs to the wilful and personal vision of the artist.

At this period, allegory occupies an especially important place; and it is the characteristic disjunctions imposed by allegory that give the images their strangeness. The symbolism employed can be simple and popular, as, for instance in the various versions of the *danse macabre* (*pls. 19, 21*), but it can also be ambiguous, hermetic and complex, as in Dürer's two celebrated prints – *Melancholia* and *The Great Fortune* (*pls. 8, 9*). Here the meaning continues to arouse scholarly controversy. Related to these complex allegories, but more easily accessible, are elaborate compositions showing scenes from the Apocalypse (*pls. 6, 45, 56*), or depicting *The Temptation of St Anthony* (*pl. 2*), *The Last Judgment* (*pl. 78*) or *The Resurrection* (*pl. 31*).

Far more than paintings, prints are concerned to communicate ideas. They continually refer us to matters outside the realm of art. Some echo the superstitions of the time – Baldung's *Bewitched Groom* (*pl. 24*), for example, reflects the panic fear of witchcraft prevalent in the sixteenth century. By contrast, other images are a response to the growing interest in science. The objective, enquiring approach to natural phenomena is represented here by a series of anatomical illustrations (*pls. 45–6, 52–3*). But the artists who created these illustrations are unable to present their material as drily and coldly as it would be presented today. The settings, attributes and even the gestures of these *écorché* figures encourage us to think of them as emotional and aesthetic statements, as well as scientific ones.

The richness and complexity of imagery in many of these prints impose a similar complexity of response. We are frequently reminded that fifteenth- and sixteenth-century printmakers worked for an audience which was still accustomed to receiving information through the interplay of images as well as through the word.

15

Notes on Plates 1–83

1 THE MASTER E.S. (*c.* 1440–67). Letter T from a grotesque alphabet.

A Swiss goldsmith and engraver about whom practically nothing is known, the artist is sometimes also called the 'Master of the Year 1466', since a number of his engravings bear this date. A precursor of Schongauer, he was also to influence Dürer.

The letter T is part of an alphabet engraved in drypoint which Max Lehrs (in *Die Spielkarter des Meister E.S.*, Berlin 1891) dates between 1464 and 1467, i.e. towards the end of the artist's career; the only complete copy is in Munich. The letters are all composed of human figures, animals, landscapes and little narrative scenes.

The beautifully composed letter shown here is doubly interesting as an example of the 'fantastic bestiary' which was perhaps derived from the zoomorphic scrolls on Irish and Carolingian manuscripts. This was to have a considerable vogue in the sixteenth century and looks forward to the hybrid creatures of Schongauer and Bosch.

2 MARTIN SCHONGAUER (1445–91). *The Temptation of St Anthony*, 1471–3.

Schongauer was the most important painter and engraver of the end of the German Gothic, both for the quality of his work and the influence it had on Dürer. He was the first systematically to sign and date his engravings, thus exemplifying the awakening consciousness of the artist as an individual after the anonymity of the Middle Ages.

The Temptation of St Anthony, a drypoint engraving, follows the story given in Jacopo da Varazzo's *Golden Legend*. Baltrušaitis (in *Réveils et prodiges*, Paris 1960), following Goldschmidt, considers it to be derived from the scroll of St Guthlac, of 1230, where the saint is seized by a swarm of devils and carried down to hell. Here St Anthony is attacked during his ascent to heaven. Later, he was more usually portrayed in a grotto or lost in a vast landscape. Following the German tradition, he is not subjected to the temptations of the flesh, which were used by Italian and Flemish artists as a pretext for portraying female nudes. He is undergoing genuine physical torment, not to say torture, by a horde of monstrous creatures such as will be found again in the work of Matthis Grünewald. Hieronymus Bosch and Lucas Cranach. It is interesting to note that Michelangelo was greatly struck by this engraving and, according to Vasari, made a copy of it.

3–5 NOEL GARNIER. Letters X, C and I from an alphabet.

We have practically no information about this engraver. The style of his signature (in addition to the name itself) suggests that he was French, and the costumes of his figures indicate that he must have lived at the end of the fifteenth century. His only known works are two alphabets and some copies of works by Dürer. The three letters are part of his large Gothic alphabet, engraved on copper.

The X is formed by two chimerical animals, each a kind of serpent-cum-dragon, entwined round a man wearing a turban. The C represents Bathsheba at her toilet while King David, at the top of a tower, is saluted by another person. In the centre is a flowering thistle. The I is purely ornamental – a pine cone surrounded by scroll-like foliage, with cupids and birds.

6–9 ALBRECHT DÜRER (1471–1528)

Both a painter and engraver, like many engravers of his time Dürer was first apprenticed as a goldsmith, to his father in Nuremberg.

His travels in Italy served to enrich his technique and his inspiration. He was a 'universal' man, symbolizing the Renaissance in the North just as Leonardo did in Italy. A writer, philosopher and scientist, he took a passionate interest in the religious struggles of his time and in the nature of the phenomenal world.

The Four Horsemen of the Apocalypse (*pl. 6*) of *c.* 1498 is one of a series that has a notable place in Dürer's work, since it was one of the first subjects which he tackled and does not seem to have been produced to order, but merely for the artist's own satisfaction; he certainly intended it for a popular audience. It appeared in a time of upheaval, in the year in which Savonarola perished at the stake, a time haunted by fears of the end of the world. While Dürer no doubt took his inspiration from already existing illustrated Bibles, the series achieved widespread success.

The illustration to Revelation 6,1 conveys an extraordinary sensation of movement. The sweeping gestures, the flying draperies, the horses' tails streaming in the wind and the clouds scudding across the sky all combine to give a sense of violence and destruction. It is a vision of an apocalyptic tornado which destroys everything in its path.

The Knight, Death and the Devil of 1513 (*pl. 7*) is also one of Dürer's key works, together with *Melancholia*. It has been given widely differing interpretations, and knowing Dürer's profound interest in the problems of the Reformation, it should perhaps be interpreted on several different levels, relating to its historical and religious context. According to Karl-Adolf Knappe (*Dürer, The Complete Engravings, Etchings and Woodcuts*, 1965), *The Knight* (the only title which Dürer gave the picture) represents not only the Christian knight journeying towards the light of the celestial city, but also the prophet Savonarola, who is suggested by a whole range of symbols very much in vogue in the Humanist circles frequented by Dürer; thus the dog symbolizes the prophet himself (the Dominicans called themselves the dogs of the Lord), and the salamander suggests the fire beneath the stake.

Despite the complication of symbolism, the engraving has a resonance which is accessible to everyone. Nietzsche speaks of it as an emblem of the human condition.

Melancholia of 1514 (*pl. 8*), even more hermetic than the previous picture, has never ceased to fascinate those who have studied it, from Gérard de Nerval to William Blake.

Numerous interpretations have been put forward, drawing on magic, alchemy, astrology and humanism, but none of them has really produced a coherent explanation. As with *The Knight, Death and the Devil*, one must assume several possible levels of interpretation or several intermingled myths. It was first thought that the engraving represents one of the four medieval temperaments – the melancholic being the most inclined towards artistic creation. The interpretation offered by Karl-Adolf Knappe (op. cit.) is the clearest and most full, resuming the interpretations of Karl Giehlow, Panofsky and Saxl, together with that of Robert W. Horst:

The print 'gives us . . . at least an idea of the diversified, syncretistic universe of pre-Reformation humanism, com-

pounded of Christian, Neoplatonic, and magic elements. Accordingly, the print reflects the five levels of world order. Highest of these is the celestial world, at night ruled by Saturn, the cause of all melancholy, with his demon, the dragon. Next comes the elemental world – air, water, earth, and fire (under the alchemist's crucible in the middle distance). The material world is present in the crystalline polyhedron; beneath lies the living world, represented by the dog, asleep under Saturn's influence. Finally, there is the intelligible or intellectual world, represented by the giant woman. But she is not hopelessly at the mercy of the planet: she wears a protective wreath of the bitter-sweet herb teucrium, and above her, on the wall, is a cryptogram containing the numerical square of Jupiter, the planet opposed to Saturn. The bell over the numbers is interpreted as a magic instrument for evoking good spirits, effective only on Thursday (Jupiter's day). To counteract the dragon, Saturn's negative emanation, there is Jupiter's beneficent emanation, the *putto*, who, according to authorities on magic, 'writes what one wishes'. In this view, Dürer's Melancholy is not an image of despair at the limitations of human knowledge or a symbol of bottomless sadness, but rather an image of inspired listening, of sensitivity to the mysterious language of the imagination, compared with which instruments and scientific equipment are useless and of no import. The scales hang on the wall in perfect balance; the millstone, symbol of restless physical activity, is no longer usable. The ladder symbolizes ascent to the upper sphere of the world, to which the melancholy spirit, in particular, has access, borne by its two wings of knowledge: contemplation and magic.'

Great Fortune of 1501–3 (*pl. 9*) is an illustration to a poem by Angelo Poliziano. Holding her attributes – the bridle which restrains the unrepentant and the cup which rewards the elect – the goddess flies over a landscape which has been identified as Klausen in the southern Tyrol. Dürer had travelled through this country on his first visit to Italy. The panorama seems crushed by the power of the goddess. The two realms are clearly separated by the curtain-like fringes of the clouds and the whirling drapery: beneath lies the insignificant terrestrial world; above, the world of mythology, embodied in a very real sense by the powerful female form, which is obviously a study from life. The artist's technical virtuosity can be seen in the modelling of the naked figure, in the wing feathers and the details of the harness.

10 ANTONIO POLLAIUOLO (1432–98). *Battle of Naked Men*, *c.* 1461.
An Italian goldsmith, painter, sculptor and architect, Pollaiuolo represents the second stage of the Italian Renaissance in which the problems of anatomy took precedence over those of perspective. (According to Vasari, his passion for anatomy led him to 'flay many, many corpses'.)

Better known as a painter, he worked on a number of pictures representing the labours of Hercules, a subject which must have satisfied his taste for showing nude bodies in action. Only two of his engravings survive, but they are among his masterpieces of fifteenth-century engraving.

The Battle of Naked Men is one of these. The subject of the scene is in some doubt.

Against a background of thick vegetation interlaced with vines, a number of nude figures fight with a variety of weapons (axes, scimitars, bows, chains); some have a band tied around their heads. The muscles of the figures are strongly emphasized and the poses are somewhat exaggerated, but the composition shows a carefully studied

symmetry. The figures are arranged symmetrically around the central group and the sweeping blades of the swords give a powerful rhythm to the whole. The effect is suggestive of a bas-relief. The predilection for male studies shows the return to Antiquity which was to be confirmed by Mantegna (again according to Vasari, it was Pollaiuolo who introduced him to engraving) and by Michelangelo.

11 GIOVANNI BATTISTA DEL PORTO, or the Master I.B. with the Bird, *c.* 1500–6.
This artist signed his works only with the monogram I.B. followed by a water-bird. The bird might possibly be the 'Ripanda', which would suggest alternatively Jacopo Ripanda of Bologna.

His known works show the influence of Dürer and indicate a penchant for non-religious subjects. This is certainly the case here, where the engraving, according to its accompanying Latin text, relates to the extraordinary birth on the same day of Siamese twins, a three-headed cat, and a curiously shaped chicken's egg (shown between the two). One wonders if the idea was taken from one of the 'fly-sheets' which were distributed in the countryside, relating strange incidents of this type and always ready to draw horrific conclusions from such 'omens', or whether it merely demonstrates the curiosity of a Renaissance artist, observing nature's eccentricities with an encyclopedic interest. Dürer had already done an engraving of the monstrous pig of Landser in 1496.

12 ALBRECHT DÜRER (1471–1528). *Coat of Arms with a Skull*, 1503.
Dürer frequently treated the subject of death, as we have seen in *The Knight, Death and the Devil*; love and death or death and beauty are also present in the engravings entitled *The Ravisher* and *The Promenade*.

The subject shown here was executed at the same time as the famous *Coat of Arms with a Cock*, and forms a kind of pendant to it.

Again we find the helmet, in profile this time, and the magnificent foliated scrolls which display all the perfection of the artist's skill. The cock is replaced by two eagle's wings and a young woman who seems to be lending a sympathetic ear to a lover, who is none other than Time, or Death or the Devil (we may assume from his hairy torso and forked staff).

The shield with the death's head suggests the familiar allegory of Time carrying away Beauty, Love – all. The theme is one which we shall encounter again and again in these prints, where it forms one of the main elements of fantasy.

13 Title-page initial for *Le Grand Testament Villon*, Paris.
A very rare edition, published between January 1505 and May 1506 by the famous Parisian printer, Michel Le Noir (1498–1520). The only known examples are that in the collection of J. de Rothschild, and that in the Condé Museum, Chantilly.

Although the printer is known, the name of the author of this woodcut remains a matter for conjecture. The illuminated ornamental letter contains animal, vegetable and human elements, with a dragon devouring or vomiting out a fool with his cap and bells.

14 Title-page initial for *Le Grand Testament Villon*, Paris.
Another, equally rare edition, of which there is also a copy in the Rothschild collection. It is considered the older of the two. Here again the author of the woodcut is unknown.

18

The design is stronger and the artist has not followed the sinuous line of the L so closely as in the previous plate. He has filled all the gaps, which makes it less legible, but the magnificent head inserted in the body of the letter, and the woman and fool (whom we see here again), raises the quality of the design above the ordinary.

15,16 GEORG SIMLER (1507–10). Illustrations from *Rationarum Evangelistarum Omnia in se evangelia prosa, versu imaginibus que quam munifice complecteus*, couplets by Petrus of Rosenheim. According to Baltrušaitis (*Le Moyen Age fantastique*, Paris 1952), Simler was an engraver of the school of Schongauer. These wood engravings are mnemonic devices, known as *ars memorandi*, and refer to episodes in the Bible: the numbers relate to the relevant chapters. Both plates illustrate the Gospel according to St John, and his symbol, the eagle, forms the basis of the composition in each.

Our *pl. 15* is the second plate. The episodes denoted by the chapter numbers are as follows: 7 the feast of tabernacles; 8 the woman taken in adultery; 9 the healing of the man who was blind from birth; 10 the parable of the Good Shepherd; 11 the raising of Lazarus; 12 Mary Magdalene anointing the feet of Christ.

The third plate (*pl. 16*) has: 13 the washing of the disciples' feet; 14 Jesus' 'Let not your heart be troubled'; 15 'I am the true vine, and my Father is the husbandman'; 16 Christ's prophecy; 17 Christ's prayer to his Father; 18 the Garden of Olives; 19 the scourging; 20 Mary Magdalene at the sepulchre; 21 Doubting Thomas.

17, 18 LORENZ STOËR (born *c.* 1510?). Fantastic architecture from *Geometria et perspectiva*, 1555. The sixth and eleventh (last) plates.
Lorenz Stoër lived in Nuremberg. Apart from two drawings of horses in the Louvre, these perspective studies are his only known works.

A curious effect is created by the clash between the ruins with their vegetation and the purely geometrical shapes; however, an effort to create a kind of fantastic order lies behind the apparent confusion. The illustrations are composed around a central motif consisting of a purely geometrical shape such as a sphere or, in *pl. 17*, a polyhedron inscribed in a cube.

The illustrations are thought to be designs for marquetry work, and this seems obvious if one compares them with the panels executed by Wrangel-Schrank *c.* 1566.

19 *Dance of Death*. Final plate from the *Nuremberg Chronicle*, 1493.
The *Nuremberg Chronicle* was one of the finest and most important books of the period. The text was by Anton Koberger, a printer, and Hartmann Schedel, a doctor; the woodcut illustrations were drawn and engraved by Michael Wolgemut and Wilhelm Pleydenwurff. Michael Wolgemut was considered one of the most eminent painters of his time. Today he is known chiefly as Dürer's first teacher.

The three skeletons dancing to the sound of an oboe played by a fourth give a startling impression of movement, even of gaiety. The deathly figures include two 'clean' skeletons, which is a new development, while the other three, one of whom is a woman, still have their flesh hanging in shreds, indicating various stages of decomposition. The dancing skeletons still have a few tufts of hair on their skulls, introducing a comic element which must surely be intentional.

20 Plate from the *Danse macabrée, dite des trois morts et des trois vifs*.
The first dated copy is a reprint of this one, published by Guyot-Marchand in 1486.

This *Danse macabrée* was so successful that it continued to appear, with additions and modifications made by its various publishers in Paris and Troyes, up to the nineteenth century. The last old edition is the one from Troyes often known as *La grande danse de Troyes*. On this occasion it was augmented by *The dialogue of the body and the soul* and *The lament of the soul in torment*.

The original edition consisted of only seventeen woodcuts, representing the dialogue between Death and mankind, beginning with the pope, the emperor and the great of this world, and continuing through all the social classes and down to the infant. Beneath them were written Death's exhortation and the often resigned reply of his victim.

The plate shown here is a more general one, a sort of résumé which shows Death carrying a javelin in his hand and a coffin under his arm, followed by Hell devouring a victim.

The verse under the engraving reads: *Allez, maudits, au feu là-bas,/ Avec Satan votre semblable./Vous avez marché sur ses pas./Soyez comme lui misérable.* ('Go, ye damned, to the fire below,/With Satan, your colleague and friend./In his footsteps you have chosen to go,/So share his wretched end.')

The woodcuts are possibly the work of Pierre Lerouge, the royal printer in 1488, who is reputed to have illustrated books for Guyot-Marchand.

21 *Dance of Death*, Heidelberg, 1465.
The dance of death is a distinct genre with its own rules and conventions, which was widely popular in the Middle Ages.

The origins and ramifications of the subject have been thoroughly studied, most notably by Maurice L.-A. Louis (in 'Danses macabres en France et en Italie', *Revue de médecine*).

Originally it was no doubt acted out in costume, in Mysteries or as an illustration to a sermon. The skeleton is still to be found today as a feature of some country carnivals.

The principle is usually that of a dialogue – a duel between Death and persons of different ages and circumstances. This is the schema followed in the *Danse macabrée* (see note to *pl. 20*).

The plate illustrated forms part of a series of engravings published in Heidelberg, the author of which is unknown. The duel is between a knight in armour and a curious figure which is not the bare skeleton to be encountered later, but a sort of mummy with protruding ribs on which the skeletal effect is confined to the skull and the line of vertebrae down its back. Wearing a sardonic grin, Death challenges the knight in his own speciality. The contest is a sort of 'Chinese wrestling' in which the knight's hand is bare and his sword and armour are of no use to him. One wonders if the gauntlet on the ground indicates the challenge he has taken up, or his surrender. In any case, as with all Death's opponents, his defeat is a foregone conclusion.

22, 23 HANS HOLBEIN THE YOUNGER (1497–1543). Illustrations from *Les Simulacres de la Mort* ('Images of Death'), Lyons 1538.
Holbein was born in Augsburg and came to Basle in 1515, where he worked on book illustrations in collaboration with the printers. Basle was a centre of the printing trade and the works produced there were well known for their quality. From 1526 he was in England, and in 1536 he became Court painter to Henry VIII.

Holbein drew *Les simulacres de la mort* around 1523–5, but several trials were needed before an engraver capable of transcribing his designs on to wood was found in Hans Lützelburger. The first edition in France did not appear until 1538.

The work is a series of fifty-one plates, to which Holbein made later additions. He undoubtedly knew the Guyot-Marchand *Danse macabrée* (*pl. 20*), and was possibly influenced by it, and also by the *Totentanz* frescoes which decorated the cemetery walls of the former Dominican Abbey at Basle, now the Barfüsser Kirche, or those of the convent of Kligenthal.

He, too, illustrates Death appearing to the intended victim who in each case is shown in his daily life, almost as a portrait. Thus the king is not an anonymous one, but Francis I, the emperor is Maximilian I and the pope, Clement VII. There is also a nun surprised during as assignation with her lover. The two engravings illustrated are something of an exception.

The Arms of Death (*pl. 22*), which may be compared with Dürer's treatment of the same subject (*pl. 12*), ends the work with the following quotation from Ecclesiastes, 7: *Memore novissima et in aeternum non peccabis*; and in French: *Si tu veux vivre sans péché voy cette image à tout propos, Et point ne seras empêché, Quant tu t'en iras à repos.* ('If you would live without sin, look at this image at every opportunity, and when you go to your rest, nothing will hinder you.')

As in Dürer, we find the helmet and the death's head, with the horrific detail of a worm emerging from between its teeth. There is also an hour-glass, traditional symbol of Time, threatened by two skeletal arms brandishing a piece of rock.

The Day of Judgment (*pl. 23*) has the following words: *Malheureux qui vivez au monde toujours remplis d'adversités pour quelque bien qui vous abonde, serez tous de mort visités.* ('Unhappy ones who live in the world, forever faced with adversity, whatever goods you may be blessed with, Death will visit you all.')

Here the seven angels of the Apocalypse are skeletons sounding their trumpets to announce the arrival of death and destruction. Again, the trumpeters are notable for their ferocious glee, while one of the skeletons bangs his kettle-drums with demonic energy.

This illustration follows the one for Genesis, and announces the dance of death which will follow.

24 HANS BALDUNG, called GRIEN (1484–1545). *The Bewitched Groom*, 1544.
Baldung was the most original and gifted of Dürer's pupils. He is chiefly known for his paintings of voluptuous female nudes entwined with grimacing skeletons. He also produced cameos, and was one of the first artists to bring this genre to perfection.

His engravings often contain the theme of sorcery – the preparations and departure for the sabbath, in which the economy of the means employed only serves to heighten the sense of unease which is produced.

Thus in *The Bewitched Groom* everything is done by suggestion. There is a feeling of oppression, conveyed by the horse turning round towards the spectator, its flaring nostrils scenting invisible danger; and of course the groom, curiously foreshortened as he lies on the floor. The characteristic figure of the witch leaning in through the window with her torch only serves to confirm our anxiety.

The engraving is so inexplicit that several interpretations are possible. Has the witch sent the groom to sleep so as to slip into the body of the horse, or is it the groom who is travelling to the sabbath in spirit, as is suggested by the

forked staff lying beneath him – a satanic symbol which is the usual means of locomotion for Baldung's witches?

This engraving also introduces the theme of the horse as a messenger from the beyond, as the mount of Death. There is perhaps also a link with the horse of nightmares (see *pl. 146*).

25 Plate from Petrarch's *De Remediis utrius que Fortunae Libri II*, Augsburg 1532.
One of the philosophical and religious treatises written by the Humanist who is best known for his *Canzone* in honour of Laura. The wood engraving illustrates Chapter VII of Part 4 in which the author enumerates all the qualities which attract good fortune or serve to remedy its opposite.

In talking of the necessity for a penetrating and virtuous mind, he quotes the legend of the competition between Pallas Athena and Arachne; the young woman had boasted that she could spin as well as the goddess, and the latter, unable to find fault with her work in the ensuing contest, transformed Arachne into a spider (the legend, in spirit if not in detail, recalls that of Apollo and Marsyas). It is not wise to be more gifted than the gods – such is the theme which the artist has chosen to represent, although the Latin caption, which extols the prudence of the snake as against the excessive cunning of the fox, is not very enlightening.

26 GEORG PENCZ (1500–50). *The Triumph of Death*.
A painter and engraver, and a pupil of Dürer, Pencz belongs to the second generation of Dürer's school, which perhaps shows a weakening of inspiration, although the technique is perfectly assimilated. Together with the Beham brothers, he was one of the creators of small format engraving, which won them the title of the 'Little Masters'. The traditional visit to Italy marked a turning point in his career. There he studied the work of Raphael and entered the studio of Marcantonio Raimondi, under whose direction he engraved a number of studio works.

The Triumph of Death is part of a series illustrating the six triumphs of Petrarch, which had a resounding success. An edition illustrated with woodcuts had been published by Barthélémy Verard in 1514.

The illustration shows the sinister procession of Death. Riding in a chariot drawn by two buffaloes, the latter draws the great ones of this world towards the jaws of hell with a sweep of his scythe.

The plate is reminiscent of a Last Judgment, with the elect no more than etherial silhouettes as they rise towards the celestial light, while on the left the damned are handed over to their torment.

A classical influence can be felt in the draperies and in details such as the chariot of death – an influence which may have reached the artist via the Triumphs of Mantegna.

27 MARCANTONIO RAIMONDI (1480–1543). *The Dream of Raphael*.
Raimondi began his career as a copyist of Dürer, even going so far as to imitate his monogram. He then felt the impact of Michelangelo, and finally joined the school of Raphael. This may explain the rather mysterious title of this engraving, which in fact owes nothing to Raphael and is more probably inspired by Giorgione, at least in the treatment of the two nude women; it is also known as *The Nightmare*. The meaning of the picture is as obscure as its title, and several explanations have been offered, none of them wholly convincing. For some, the burning castle suggests the destruction of Sodom or Gomorrha, in which case the two sleeping women

represent the sinners of the former, or Lot's daughters fleeing from Sodom; but this explains neither the fact that they are asleep, nor the monsters crawling at their feet (symbolizing the different vices?), nor the river, which H. Delaborde (*Marc Antoine Raimondi*, Paris 1887) sees as the Styx, across which men are ferried in Charon's boat. Whatever the explanation may be, the engraving still has a remarkable and mysterious fascination. It suggests a dream world, or a dream within a dream if one imagines, referring to the title, that the two sleepers are themselves a dream, and that they are dreaming of the strange castle inhabited by Chirico-like silhouettes.

28 GIULIO CAMPAGNOLA (1482–1518). *The Astrologer*, 1509.
A many-sided artist of the kind frequently produced by the Renaissance, Campagnola was a painter, engraver, sculptor, poet and musician. He began in Mantegna's studio at Mantua, then worked in Ferrara and Venice, where he did engravings after Bellini, whose style he spread throughout the rest of Europe.

He produced only a few engravings, all of them bathed in an aura of mystery whose origins are difficult to define, such as *The Old Shepherd*, *The Samaritan*, and this astronomer or astrologer computing the movable feasts of the calendar. He represents, perhaps, a degree of rationalism, while the strange monster and the skull at his feet suggest the opposing forces of magic and the unconscious. Despite the *palazzo* with its arcades, the scene shows the influence of northern landscapes derived from Dürer, while by contrast the figure of the astronomer is very Italian, even Venetian, reminding one of a number of old men by Giorgione. The composition was indeed based on one by Giorgione.

Campagnola was one of the only users in his time of stipple – an attempt to render the *sfumato* effect of the painters which was to become widespread in the eighteenth century – and this no doubt contributes to the strange atmosphere of the scene.

29 TITIAN (1477–1576). *Death in Armour*.
Adam Bartsch (*Le Peintre graveur*, Vienna 1803–21), on the authority of Ridolfi, states that Titian never engraved anything himself, but confined himself to making drawings and then supervising their execution on wood. His best-known plates are *The Triumph of Faith* and *The Crossing of the Red Sea*. Many of his landscapes were also widely distributed through the medium of engravings.

The engraver of *Death in Armour* is unknown; it is clearly based on a simple drawing in which the artist has amused himself by representing the paradox of Death protecting his fleshless limbs with a suit of armour.

30 DOMENICO BECCAFUMI (1484–1551). *Procession of Sea Gods*.
A painter and engraver, Beccafumi worked chiefly in Siena, where he spread the Mannerist style derived from Michelangelo and Raphael which he encountered during his visit to Rome in 1510, and of which he was one of the chief exponents. He is chiefly known for his paintings, in which acid colour tones are combined with strange luminous effects.

The theme of the sea gods comes straight from ancient mythology, and illustrates the profound belief of Mediterranean coastal dwellers in a primal sea as the source of all living things.

The engraving may be compared with Raimondi's *Lo Stregozzo* (*pl. 37*), with which it has a number of points in common, although it is less strongly redolent of evil, and with the *Battle of the Sea Gods* engraved by Mantegna.

31 GIORGIO GHISI (1520–82). *The Resurrection of the Dead* 1554. After a drawing by J. B. Bertano.
Ghisi was an Italian engraver who lived in Mantua, where like all his compatriots he was influenced by Giulio Romano, and engraved a number of prints based on the latter's works. He also engraved works by Francesco Primaticcio and Luca Penni.

The Resurrection of the Dead represents a cemetery in which skeletons and naked men emerge from classical tombs. The banner carried by the cupids proclaims: 'I will give you muscles and make your flesh grow again' – thus it is a genuine resurrection of the flesh, and as we can see, one of the men still has only a skull, being in the middle of his transformation.

The treatment of the engraving and the shading are slightly suggestive of the manner of Marcantonio Raimondi, but the countryside, the mountains and the skeletons give a foretaste of Baroque.

32 HANS J. SEBALD BEHAM (1500–50). *Allegory of Death*, 1529.
The nephew and pupil of Barthel Beham, Hans Beham was also influenced by Dürer. One of the most gifted of the 'Little Masters', he lived in Nuremberg and Frankfurt, according to legend leading a dissolute existence. His work is very close to that of Barthel.

Adam Bartsch (*Le Peintre graveur*, Vienna 1803–21) disputes the authorship of this engraving and attributes it to Barthel, claiming that the monogram has been superimposed. It is a *Vanitas* which shows a foreshortened image of a very young child beside a number of skulls, the artist making a play of the contrast between the child's chubby flesh and the skulls, with the implied comment that even the young are not spared by death.

33 GIORGIO GHISI (1520–82). *The Melancholy of Michelangelo* 1561. After a drawing by Luca Penni.
This engraving has been so titled because of the likeness to Michelangelo of the central figure, who seems absorbed in a philosophical reverie, but it is also known under the title of *The Dream of Raphael*, which has enabled Roger Caillois to compare it to the engraving by Raimondi (*pl. 27*). It has long been regarded as a representation of the perils which the sage must encounter during his lifetime.

The Latin inscriptions have been identified as quotations from the *Aeneid*, and R. Klein has produced a complete interpretation of the engraving (*Ghisi et la gravure maniériste à Mantoue* in *L'Œil*, no. 88, April 1962).

In fact it closely illustrates a number of lines from Book VI of the *Aeneid* (95, 617, 618). On the right is the Cumaean Sibyl who leads Aeneas on his journey down to Hell, where he is shown the damned, including Theseus (the so-called Michelangelo) anchored to his rock. The sunken boat is a symbol of he who yields to temptation; above Theseus can be seen Avernus with its hundred entrances; the luminous spiral is the path of a soul rising to the highest heaven.

The style of the engraving is characteristic of Mannerism. The elegant outline of the Sibyl, with her carefully arranged hair and draperies, recalls the figures of the Fontainebleau school. One can also see a taste for the unstable in the lively pose of Theseus' foot.

34 CORNELIS DE VRIENDT, called FLORIS (1514–72). Decorative motif.

A sculptor, draughtsman, engraver and architect of the Flemish school, Cornelis Floris was born in Antwerp and returned there permanently after working in Italy. He married the sister of the painter Frans Pourbus and attracted a number of pupils. He was a friend of the Prince of Orange, and is better known as an architect.

The plate shown here is a page of pure ornamentation based on grotesque motifs. These were very much in vogue at the time, following the rediscovery of Nero's Golden House. This building is decorated with foliated scroll-work containing all kinds of fantastic or mythological creatures, subsequently known as 'grotesques' because they had been discovered in grottoes. Benvenuto Cellini objects to the term in a well-known passage from his memoirs, and suggests calling them monsters. Many engravers of the time produced similar prints, including Zoan Andrea, Giovanni Antonio da Brescia, Agostino Veneziano and Cornelys Metsys and Daniel Hopfer in the north.

35 MARTINO ROTA (1520–83). *The Battle of Truth.*

Rota was a Dalmatian engraver who lived in Rome and Venice. Very little is known of his life and work apart from his engravings. He produced the best-known engravings of Michelangelo's *Last Judgment* and reproduced other works by great masters, including Raphael and Titian. He also executed a number of excellent portraits of sovereigns, a representation of the battle of Lepanto and several allegories from the Bible.

The engraving shown here is one of the latter, and is full of biblical quotations. The battle shown is that of truth and light, or religion, against the darkness of heresy. The adversaries are Western knights and infidel Turks and the method of combat is somewhat bizarre. Each side is trying to pull down, by means of ropes, two trees which have animal bodies in place of roots. On the right, as ever, is Truth, symbolized by a double tree (the symbol of the two testaments), and linked by a leafy branch on which the dove of the Holy Ghost stands in a halo of light. The tree is young and vigorous, covered with new shoots and rooted on the backs of an eagle and a lion (possibly the symbols of the Evangelists John and Mark), while the tree of heresy, carried on the back of a dragon, is thorny and stunted and seems about to succumb to the onslaught of the Christians. The outcome of the battle is obvious, and the quotation from the book of Proverbs reminds us that: 'The fear of the Lord prolongeth days: but the years of the wicked shall be shortened.'

36, 37 AGOSTINO DEI MUSI, called VENEZIANO (1490–1536?)

A Venetian engraver who chiefly made copies of Dürer and Campagnola, Agostino Veneziano later entered the studio of Marcantonio Raimondi and worked in collaboration with him to the end of his life. He was his chief collaborator and his legatee.

Two Men in a Cemetery (*pl. 36*) raises more questions than it answers. Why the two men, one of them naked and the other dressed? What is the purpose of the instrument at their feet? Is it in fact a clock, as stated by Bartsch? Why are the bones so gigantic, and what is the town in the background?

The Skeleton (or *Lo Stregozzo*), *c.* 1515 (*pl. 37*), may have been done by Raimondi and finished by his pupil. It is probably inspired by a drawing by Raphael.

The engraving apparently represents a procession on its way to some witches' sabbath, as is suggested by the figure of the sorceress riding on the giant skeleton like a chariot, with a supply of sacrificial children at her feet. At the head of the procession, a child rides on a goat announcing its approach with a blast of his horn – especially in this figure, suggestive of the young Pan, the scene is reminiscent of a bacchic procession. The figures are passing through a marsh, as indicated by the reeds and the wild duck taking flight in front of them. Some writers have seen it as a personification of malaria.

38, 39 JEAN VISET (?). *Acrobats,* 1540.

The attribution of these engravings is uncertain, and currently critics such as Henri Zerner (in *The School of Fontainebleau: Etchings and Engraving,* 1969) are tending to revert to the old belief that they are by Juste de Juste, a sculptor known only by name. The monogram of the signature, which reads IVSTE, is certainly ambiguous, since it can be read either as Juste, or as an anagram of Viset; but the engraving seems both too personal and too casual in its technique to be attributed to Viset, who was a skilled but conservative engraver. The series cannot be linked with any known work, and the anatomical detail, together with the theatrical attitudes of the figures, could well be explained if it were an engraving by a sculptor.

The two plates illustrated are from a series of five etchings depicting pyramids of naked men with highly pronounced muscles – not as has sometimes been suggested flayed bodies (which we shall see later). The exaggerated poses stretch the laws of equilibrium to the limit, and show both a personal taste for the bizarre and a certain Mannerist eccentricity.

40, 41 JEAN DE GOURMONT (1483–1526)

Jean de Gourmont was born in Normandy and settled in Paris as a printer with his brothers, around 1508. His activity as an engraver seems to date from 1522–6, when he moved to Lyons.

His engravings are famous for their carefully contrived architectural settings, in which the actual scene or subject becomes of secondary importance to the composition. Such is the case in his *John the Baptist* (*pl. 40*), in which the Baptist adores the lamb as it lies in front of him, amid a group of architectural ruins. The contemporary vogue for such ruins can be partly attributed to de Gourmont. None of these engravings can be dated precisely.

In the *Fight between Two Goldsmiths* (*pl. 41*) the light which bathes the bodies of the two men in this empty architectural setting helps to give a feeling of strangeness and unreality, which is obtained with a great economy of means. Long before Chirico, Jean de Gourmont creates a feeling of disquiet with his 'uneasy spaces', as Marcel Brion calls them, composed of a succession of deserted porticos and arcades in the Italian style. This feeling is also to be found in one of his few known paintings, *The Descent into the Cellar* or *The Trap-door.* Here, in addition to the atmosphere, one admires the technical perfection of the engraving, its luminosity, the delicate cross-hatching of the shadows and the subtle grey tones.

42 MARTINO ROTA (1520–83). *The Wheel of Time,* 1572.

As in *The Battle of Truth* by the same artist (*pl. 35*), this allegorical picture is sprinkled with quotations, both from the Bible and from classical authors – Euripides, Cato, Demosthenes, Cicero. Their theme is that of Time as the destroyer of all things, and it is linked with that of Fortune, symbolized by the wheel, which is turned by Time with the

help of Death and the Devil. The little genie at the top holds out a *éail* to catch the wind of good fortune. In classical times, too, a boy with a single lock of hair was used to symbolize good fortune, which one must grasp when the opportunity arises. The engraving tells us that only the Christian faith can triumph over death and time. Thus the angel with the cross in the right-hand corner forms a counterpoint to Death and the Devil on the left, while on the wheel itself the Christian princes rise upwards, represented by the figures of the doge and the emperor, accompanied by a guardian angel holding aloft a crucifix. A quotation from St Paul's Epistle to the Ephesians tells us: 'Put on the whole armour of God, that ye may be able to stand against the wiles of the devil.' On the other side, a Turk similar to those we have already seen in *The Battle of Truth* is on the downward turn, although he is trying to save himself by grasping fortune by the leg. Other symbols and quotations also refer to the Bible, including the bloody moon of the Apocalypse and the 'land where thy king is a child' cursed by Ecclesiastes at the top of the wheel; on the ground infidels and pagan kings lie unburied at the feet of Death. The inscription on the sarcophagus indicates that it contains the relics of Constantine, the 'first emperor' of the Christian world.

43 *To follow Christ*, engraving published by HIERONYMUS COCK. Flemish school, 1510–70.
Hieronymus Cock (1507–70) plays an important role in the history of Flemish engraving. After spending some time in Rome, he opened a bookshop and printer's in Antwerp 'At the sign of the four winds', which soon became famous throughout Europe. He published the first prints by Breughel and other Flemish and Italian artists. He was also an engraver himself, but his work is well known and it does not seem possible to attribute this engraving to him.

The meaning of the work is clear. Men pass through the narrow gate, leaving behind the cup of pleasures, games, worldly power, and follow Christ carrying the Cross. The diagonal composition conveys a feeling of tension and effort on the part of the men as they become sharers in the sufferings of Christ.

44 LÉON DAVENT (*c.* 1540–65), *Christ in Limbo*, *c.* 1547.
Davent was an engraver of the school of Fontainebleau, about whom very little is known. Even his name is in some doubt, and he is often referred to, after his monogram, as the Master L.D. His engravings are taken from drawings by Primaticcio, Francesco Parmigianino, Luca Penni and Giulio Romano, but his renderings are of the highest quality and reveal an individual temperament.

Christ in Limbo is an etching which according to Louis Dimier is taken from a drawing by Primaticcio, and according to Henri Zerner (*The School of Fontainebleau: Etchings and Engravings*, 1969) from one by Luca Penni. Jesus descends into Limbo, the abode of the just who died before his coming, whom he alone can save. The subject has been treated extensively in painting (Fra Angelico, Bronzino), in frescoes, stained glass and engravings (Dürer, Lucas van Leyden, Mantegna), almost always in the same fashion: Christ carrying his banner bends down to effect the rescue in spite of the threatening gestures of the demons. Those who have already been saved are gathered behind the Cross.

Davent's composition is strongly reminiscent of a wood engraving by Dürer of 1511, *The Great Passion*; it has the same arches, the crow above the doorway, demons at the window, etc. However, the style and spirit of the two works are diametrically opposed, Davent's version presenting an almost nonchalant elegance beside the religious intensity of Dürer's. The demons have become less bestial and savage. We have emerged from the medieval night.

45, 46 Plates from *De Humani corporis fabrica* by Andrea Vesalius, Basle 1543.
The quality of the illustrations in this famous medical work marks the beginning of a new era, achieving for the first time 'the conjunction of science and beauty' (see André Hahn and Paul Dumaître, *Histoire de la médicine et du livre médical*, Paris 1962). The book plates are a series of astonishing wood engravings in which skeletons or flayed bodies are seen in landscapes and engaging in various activities, while amiably displaying the various details of their anatomy to the reader's curious gaze.

The engravings shown here, the sixth and eighth, demonstrate the different muscles, some of which have been detached to reveal those underneath and hang down like 'monstrous petals'. The precise observation even extends to the landscapes forming the setting.

The hanged man (*pl. 46*), with the contents of his rib cage pinned to the wall beside him like a fish, reminds us that doctors often used the bodies of executed criminals for their dissections. The authorship of these engravings is uncertain. Vasari suggests one J. de Calcar. General opinion inclines more and more towards the old tradition that they were produced under the direction of Titian.

47, 48 Plates from the *Prodigiorum et ostentorum chroniconquae, praeter naturae ordinem et in superioribus et his inferioribus mundi regionibus, ab exordio mundi usque ad haec nostra tempora acciderunt*, by Conrad Lycosthenes (Theobald Wolffard), Basle 1557.
Before writing one himself, Conrad Lycosthenes had already published a book by Polydorus Vergil on the oracles, omens and presages which had appeared since Antiquity up to the time of publication. His own 'Treatise of Marvels' gives a résumé of all the marvels recorded up to that time, together with their interpretations. The illustrations for this enormous work were taken from various sources, such as Sebastian Munster's *Cosmographia*, Conrad Gesner's *Thierbuch*, Boiaistuau's *Histoires prodigieuses* and many others, all of which are listed by Jurgis Baltrušaitis (in *Réveils et prodiges*, Paris 1960). Extraordinary creatures and monsters alternate with cosmic upheavals, triple suns, such as are shown here, or moons, showers of stars, etc. The work had a resounding success.

49, 50 Plates from *Horus Apollo de Aegypte*, Paris 1543.
A sub-title indicates that the volume deals with the hieroglyphs and holy figures by means of which the Egyptians recorded divine matters, revealed in French for the first time, for as the author states, 'things which are too well known and manifest lose their reverence and authority and fall into contempt and low esteem'.

This famous work is a classic of hermeticism. The text is accompanied by woodcuts which illustrate it literally, and form the most impressive part of the book. Taken out of their context and drawn in a non-stylized, European fashion, the hieroglyphic signs are shown against miniature landscapes, so that we find surprising images of ears, fingers, beaks, feet and headless bodies hanging in the sky above the countryside. The text which accompanies the lion head (*pl. 49*) explains that the lion symbolizes the watchful man, for 'this beast closes its eyes when awake and keeps them open when sleeping, a thing which is the sign of a good guardian

and watchdog. It is not without significance that they put lions at the doors of temples to be their guardians.'

The human head and eyes (*pl. 50*) is the last plate from the second book. The text informs us that in order to represent 'the infernal gods which they called *Manes*, they painted a face without eyes, and above it, eyes, for by the eyes they signified the gods (which we have seen in the previous illustration, for God sees and considers all things) and by the face without eyes those who are in a lowly place and obfuscated by darkness.'

A manuscript note on a copy of a later edition (published in 1553) tells us, after listing the antecedents of this kind of work, that the woodcuts are by the French painter and engraver Jean Cousin (1490–1560).

51 *Beauty Tempted.* Sixteenth century.
The theme of temptation is applied here to a woman, who is surrounded by monsters in the manner of Desprez (and therefore derived from Breughel and Bosch); a strange bespectacled friar leans out of a hollow tree inhabited by worms and offers her a kind of sausage – an obvious phallic symbol. A monk with a barrel for a body sits astride a cock, another symbol of lechery; the lion with a man's head is a representation of Satan; an acrobatic *gryllus* (a figure composed of a head and two legs) confirms the reference to Hieronymus Bosch. Only one print of this woodcut is known to exist.

52 Plate from *De dissectione partium corporis humani libri tres* by Charles Etienne, Paris 1545.
Charles Etienne was the son of the Humanist printer Henri Etienne and the brother of Robert Etienne. He wrote this work in collaboration with the barber-surgeon Estienne de la Rivière, who helped him with his dissections. The work was in fact begun before that of Vesalius, for it was in the press in 1539 and was stopped because of a lawsuit with the co-author.

It is now thought that the figures in the wood engravings – naked bodies posed amid settings of Italian architecture or in well-furnished interiors – are inspired by the figures of Giovanni Battista Rosso (one of the first artists to show flayed bodies), and that the purely clinical part, showing an anatomical section, is the work of the surgeon Estienne de la Rivière. (See André Hahn and Paul Dumaître, *Histoire de la médecine et du livre médical*, Paris 1962.)

53 Plate from *Anatomia del corpe humano* by Juan Valverde, Rome 1560.
Valverde is an imitator of Vesalius and introduced him to Spain. The plates were drawn by a Spanish artist, Gaspar Becerra, and engraved on copper by Nicolas Béatrizet, a native of Lorraine.

This is the first appearance of copper-plate engraving in medical books, and it was to replace wood engraving from now on.

The plate shown is the frontispiece, and it is a synthesis of the first and third plates on the muscles. It is remarkable for the two details of the knife which the flayed figure holds in one hand, which is presumably that used to remove his skin, and the skin itself which he holds in the other hand, hanging like a cast-off garment with the apertures for eyes and mouth forming a tragic mask; for this reason the plate has sometimes been titled *The Man with the Mask*.

54–6 JEAN DUVET (born 1485)
The son of a well-known Burgundian goldsmith, Duvet left Dijon in 1521 for Langres where, as a favourite of Francis I, he was the organizer of royal pleasures, audiences and entertainments.

He became a secret adherent of protestantism while working in Geneva. His most important works, *The Apocalypse* and *The Unicorn*, date from his maturity. He is traditionally looked upon as the first drypoint engraver.

The unicorn from his famous series (he was for a long time called the Master of the Unicorn) appears again in the *Allegory with Monsters* (*pl. 54*). This mythical beast played an important role in the symbology of the time. It is a symbol of purity which can only be captured by a virgin, and also signifies Christ saving humanity.

It is its role as a supposed antidote to poison which figures in this picture, which is often also called *Poison and counterpoison*. The unicorn transfixes a dragon, which is biting a lion and is already being attacked by a lioness and a bear. The man is possibly protecting himself from the dragon's poisonous breath with a shield. This explanation, it must be admitted, is not entirely satisfactory. The man seems to be not so much protecting himself as trying to reflect the rays of the sun with a glass or mirror, and neither possibility explains the presence of the boar in the background.

This engraving is largely derived from a drawing by Leonardo da Vinci which is in the British Museum, the only differences being that there the seated man is dressed and one can see the sun. A similar sketch by Leonardo is in the Louvre. The resemblance can hardly be coincidental and it seems obvious that Duvet must have known of these drawings; perhaps Leonardo had even presented him with one.

Duvet was much given to copying artists whom he admired; he has often been labelled a plagiarist and he certainly borrowed extensively from Dürer and Raimondi, but he nevertheless produced a strong and original body of work.

The Great Whore of Babylon (*pl. 55*) is taken from the *Apocalypse* on which Duvet worked between 1546 and 1556, and which was published in 1561. It was possibly conceived to commemorate the consecration of the Order of Saint-Michel under the protection of Henri II. Duvet himself described the *Apocalypse* as a 'mystery', or the 'vision of a divine event expressed through the dramatic medium of engraving'. (See 'Jean Duvet' by Colin Eisler in *L'Œil*, no. 70, October 1960.)

The illustrations follow the text closely and the plate shown here refers to Chapters 17 and 18 where we see the great whore of Babylon – beautiful and regally dressed – seated on the beast with seven heads and ten horns. She is holding the golden cup 'full of abominations and filthiness of her fornication'. Beside her are the adoring figures of the kings and merchants who will abandon her when she falls. In the background the burning city prefigures its destruction, announced by the angel who is about to cast the millstone into the sea. One is reminded of Dürer, but Duvet's work survives the comparison, even though it is technically less perfect. Although filled with detail, Duvet's engraving avoids confusion. It is more mysterious, heralding the arrival of the new spirit.

St John eating the Book (*pl. 56*) is another plate from the *Apocalypse*, illustrating Chapter 10. The angel with a rainbow upon his head, 'his face as it were the sun, and his feet as pillars of fire' set one upon the earth and one on the sea, gives the little book to John, who eats it: 'And it was in my mouth as sweet as honey: and as soon as I had eaten it,

my belly was bitter.' Here the fantastic elements arise from the original text; the artist had only to illustrate them literally to produce an extraordinary figure worthy of Dali.

57 ROBERT BOISSARD (born 1570?). Plate from the *Recueil de mascarades*, 1597.
The date of Boissard's death is unknown. He engraved many portraits from drawings by his relation Jean-Jacques Boissard, but his most personal works are the *Recueil de mascarades* and the plates from *Parnassus cum imaginibus Musarum,* published in Frankfurt in 1601.

The engraving shown here is the fourth in the second series of six plates. It represents a couple, the woman of which is wearing a marvellous feathered costume, a kind of cross between classical dress and the garb of a Papuan native. The arrow and the bracelets round her ankles emphasize the 'primitive' aspect of her appearance. The man is wearing a costume made of ivy leaves and an owl's mask. He carries a broom with four lighted candles stuck in the head.

The title of the collection indicates the purpose and fanciful nature of these illustrations. They are costumes for ballets or masquerades, perhaps taken from actual ballets of the time.

58 ERHARD SCHOEN (died 1542?). Plate from *Traité sur les proportions des figures humaines et sur la manière de bien dessiner les écussons d'armes, les heaumes et les chevaux,* Nuremberg 1542.
A pupil of Dürer, Schoen lived in Nuremberg and produced wood engravings for books published in Nuremberg and Lyons, chiefly Bibles.

This is one of the seven plates which bear his monogram, out of the thirty-six wood engravings with which the book is illustrated. As the title indicates, the aim is to teach the drawing of 'human figures, coats of arms, helmets and horses' by enclosing them in a geometric framework and reducing them to a number of simple basic shapes, as is still done today by means of wooden lay-figures. At the same time, one cannot help being surprised by the modernity of these 'cubist' drawings, which seem to prefigure Cézanne, and his contention that 'the whole of nature is contained in the circle and the cube'. They are similar to the works produced by Cambiaso around 1550, and by Bracelli, as we shall see later on (*pls. 100–5*).

59–67 FRANÇOIS DESPREZ. *Songes drolatiques de Pantagruel où sont contenues plusieurs figures de l'invention de Maistre François Rabelais et dernière œuvre d'iceluy pour la récréation des bons esprits,* Paris 1565.
Desprez was a Parisian engraver and publisher of the second half of the sixteenth century. He engraved *De la diversité des habits* in the same style; the *Songes drolatiques* were enormously popular in France, Germany and the Netherlands.

In fact Rabelais is only mentioned in the title to attract the reader, for there is no text to the collection except for a preface in which the author indicates that it should 'serve as a pastime for youth, besides which ingenious minds will find in it the inspiration for disguises and masquerades'.

The plates seem to illustrate both carnival costumes and proverbs (e.g. *pl. 61,* the big fish eating the little fish) in their caricatures based on bizarre deformities and combinations of human features with household utensils.

These figures are influenced by the engravings of Breughel, and are also related to the borders decorated with grotesque subjects which were used by Jean de Tournes at Lyons in 1557. They may also be compared to other collections of monstrosities such as Boiaistuau's *Histoires prodigieuses* (1561)

and Lycosthenes' 'Treatise of Marvels' illustrated earlier (*pls. 47, 48*).

68 *Winter.* Engraving in the style of Arcimboldo, Rome, 1580.
We know that it was Giuseppe Arcimboldo, a Milanese painter working for Ferdinand I and for Rudolf II at the court of Prague, who both created and launched the fashion for these composite portraits.

Much has been written about the origins of the genre, and it is now thought that Arcimboldo remembered the grotesque heads produced by Leonardo and also took his inspiration from the carnivals of northern Italy in which the peasants wore masks made from natural materials.

The eye is drawn into a process of alternate synthesis and analysis as it breaks up the image into its components or reassembles them into a portrait.

One of his paintings carries the revealing phrase: 'man is the sum of the created world'. These compositions are also linked to the popularity in Renaissance times of new editions of Ovid's *Metamorphoses,* in which instability triumphs and man is no longer permanent but like Proteus takes on a multitude of different forms. In this, Arcimboldo is typically Mannerist, and one understands why the Surrealists claimed him as one of their own, for in their work also, the object loses its original function and becomes the stuff of dreams.

This engraving is one of a series illustrating the four seasons, and the fact that the original images were multiplied by engravings and circulated is indicative of their popularity.

69–74 PIETER BREUGHEL THE ELDER (1525–69)
Born in Brabant and brought up in peasant surroundings, Breughel worked in Antwerp, then made a trip to Italy, from which he brought back mostly landscapes. He married the daughter of the scholar Pieter Coecke and settled in Brussels. His engravings were produced in collaboration with Hieronymus Cock (*pl. 43*); he did not engrave himself but produced extremely detailed preliminary drawings.

The series of *The Seven Deadly Sins* (*Avarice, pl. 69; Gluttony, pl. 70; Anger, pl. 71*), which dates from 1558, shows the influence of Bosch, with flying fish, knives and scissors, toads, the alchemist's crucible. The entire series was engraved by P. van der Heyden.

In *Gluttony* (*pl. 70*) many of the details are humorous: the man carrying his stomach in a wheelbarrow, another drowning himself in a barrel. The windmill man whose eye is a window is taken from the *Temptation of St Anthony* of 1556, in which men also emerge from the ear.

Anger (*pl. 71*) is a catalogue of all the methods of torture in use at the time – boiling pitch, the carcan, etc.: again the theme of the giant knife is taken from Bosch. The bear is a symbol of anger, which is personified by a woman in spurs, her arm in a sling and a knife between her teeth, and a flask of alcohol in her hand.

The Rich Kitchen (*pl. 72*) and *The Poor Kitchen* (*pl. 73*), both of 1563, were evidently conceived as a pair. The rich kitchen represents on the one hand the world of opulence and ample proportions: hams, sausages, chickens, sucking pigs being basted on a spit, babies gorging themselves on milk, the enormous cat in front of the fire, and even the corpulent dog helping to drive out the unfortunate bagpipe player from the poor kitchen. Everything is indicative of abundance and satiety.

The composition may be satirical in intention, Breughel chastising the well-to-do for their excesses in the face of other men's poverty.

The Poor Kitchen tells us what it was like to be poor at the time; a dilapidated interior where only vegetables are to be seen, and a minuscule pot over the fire. Even the nurse's breasts are dried up, while lean-flanked dogs gnaw on the shells of the oysters which seem to be the main dish of this poverty-stricken household.

A fat burgher whom they are trying to drag into the room – to use him as meat, or to force him to share in their misery? – forms a link with the previous engraving.

Big Fish Devour Little Ones (*pl. 74*) is a direct copy of Hieronymus Bosch. The proverb provides the pretext for a multitude of variations on the theme of the fish: flying fish, fish hanging from trees, fish with legs. The father is drawing the moral of the scene for the edification of his child. This, too, was engraved by P. van der Heyden. The composition is more spacious and less crowded than usual.

75, 76 Plates from *Pronosticatio* by Theophrastus Bombast von Hohenheim, called Paracelsus, 1536.
This esoteric work consists of thirty-two allegorical engravings, which are reminiscent of the alchemical symbols, accompanied by a text which is open to various interpretations.

Fig. XVI (*pl. 75*) is not entirely explained by the text which talks of childhood activities to which many men remain attached, of time which hides and reveals all, of the upheavals which carry men with them like leaves before the wind.

In Fig. VIII (*pl. 76*) the sword in the hand of God under a shining sun is a direct illustration of a fairly simple text on God's omnipotence, his perfect knowledge of our destiny and the impenetrability of his intentions.

77–9 After HIERONYMUS BOSCH (*c.* 1450–1516)
The Besieged Elephant of 1601 (*pl. 77*) is sometimes also called *The Armed Elephant*. Bosch is presumed to have done a painting on the subject which we know from this engraving and from another by Alart du Hameel which shows a number of differences. The elephant is to be found in drawings as far back as the thirteenth century; Richard of Cornwall saw one in Cremona in 1240, and Martin Schongauer had engraved an elephant with a tower on its back – a theme which is developed here, and which Hannema links with the episode related in the Apocrypha (I Maccabees 6, 28–47) where Eleazar kills an elephant of the pagan army but is crushed as it falls on top of him.

The Last Judgment (*pl. 78*) can be compared with the engraving by Alart du Hameel which shows exactly the same composition in reverse, and contains all the same characters down to the smallest detail.

According to Jacques Combe (*Jheronimus Bosch*, London 1946), Bosch's original drawing dates from the period of the Vienna *Last Judgment*, some features of which are to be found here. There is some doubt, however, about the attribution of this engraving. But, as in the following plate, one finds the Boschian world in all its bizarre detail. Above the figure of Christ seated in glory, between the palm tree and the sword (which Breughel was to include in his engraving of the Last Judgment), the demons try to drag as many of the risen as possible into the fortress of Hell, while the elect mount the steep path to Paradise.

The theme is the pretext for a whole procession of monsters and strange hybrid creatures. One finds here the *grylli*, the acrobatic, somersaulting demons and the combinations of men or animals with utensils or fruits, which were to be taken up by Desprez and many others after him. We might note here the symbolism attached to the somersaulting figure: in contrast to the acrobat, who is freed from the common laws of gravity and society, the somersaulting man has lost his celestial pole, he is turned towards the darkness of the underworld.

In the *Last Judgment*, also of unknown date, published by Hieronymus Cock (*pl. 79*) the theme already found in certain details of the previous engraving is repeated and amplified. The angels and demons struggle for possession of the souls. It is a fight between heaven and earth, between two armies and two principles, good and bad.

80, 81 HANS VREDEMAN DE VRIES (1527–1604)
A Dutch painter, draughtsman and architect, renowned for his architectural compositions (*see pl. 93*), de Vries often worked in collaboration with Philippe Galle (1535–1612), the Antwerp engraver who was the master of Hendrick Goltzius.

In *Ruin 6* of 1600 (*pl. 79*), the theme is a classic one of fantastic art: Time destroys everything. A landscape of ruined Roman architecture is scattered with the emblems of temporal power – sceptres, crowns, mitres and croziers – lying amid the stumps of columns. In the centre we see the fatal trinity of Time, Death and Saturn-Cronos; the latter is often seen as a personification of Time, which devours everything, even its own creations.

Wells and Perspectives was a collection of twenty-four plates, also engraved by Philippe Galle which, like the example shown here (*pl. 80*), depict superb pilastered wells of classical design (which only makes the little wooden bucket hanging from its cord all the more incongruous) in northern European architectural surroundings which are typical of the Netherlandish Renaissance: gardens, squares, palaces, and here a street running alongside a canal, probably inspired by Antwerp.

82 PIETER BREUGHEL THE ELDER (1525–69). *The Man with the Moneybag and his Flatterers*, 1548.
Engraved by Jean Wierix, this forms part of a series of circular pictures illustrating popular Flemish proverbs, all after drawing by Breughel.

The first seven proverbs carry a French text (the Flemish text was written round the edge of the medallion). The French reads: *On ne sait comme entrer on veut,/Au trou de cil qui donner peut.* (Why crawl up his arse,/When he opens his purse?).

The picture is a satire on flattery of the crudest possible kind.

83 Flemish engraving. Late sixteenth century.
The theme is the vanity of love: a declaration is being made, but two sneering demons with claws hold up between the lovers a ruff similar to those worn by the couple, with a death's head fixed in the centre.

Plates 1–83

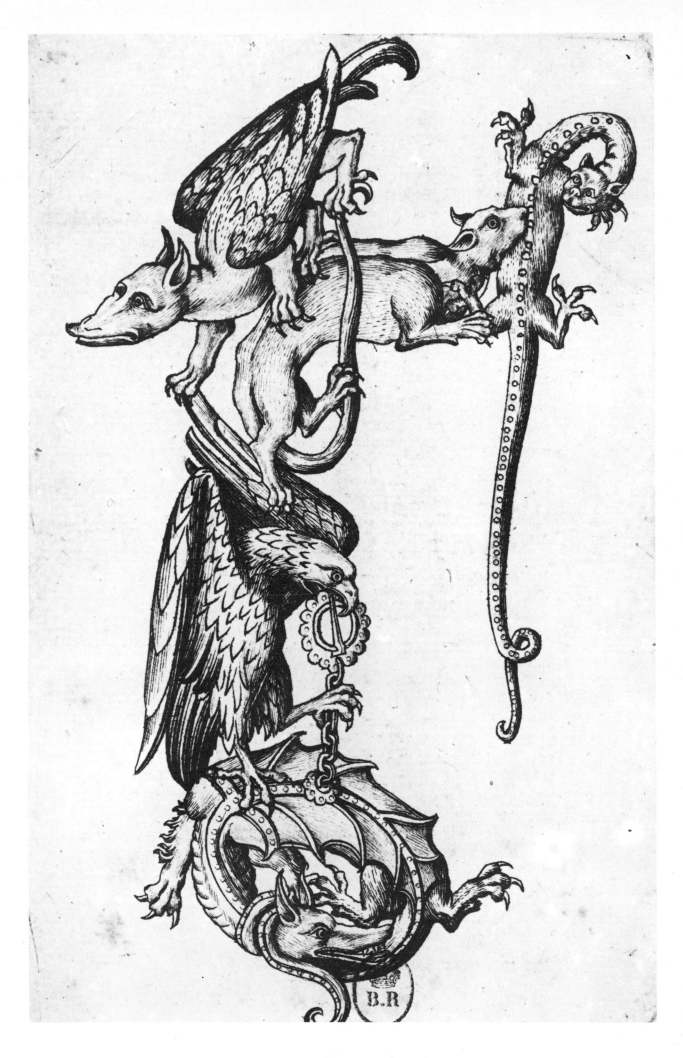

1 THE MASTER E.S. Letter
T from a grotesque alphabet,
c. 1464–7

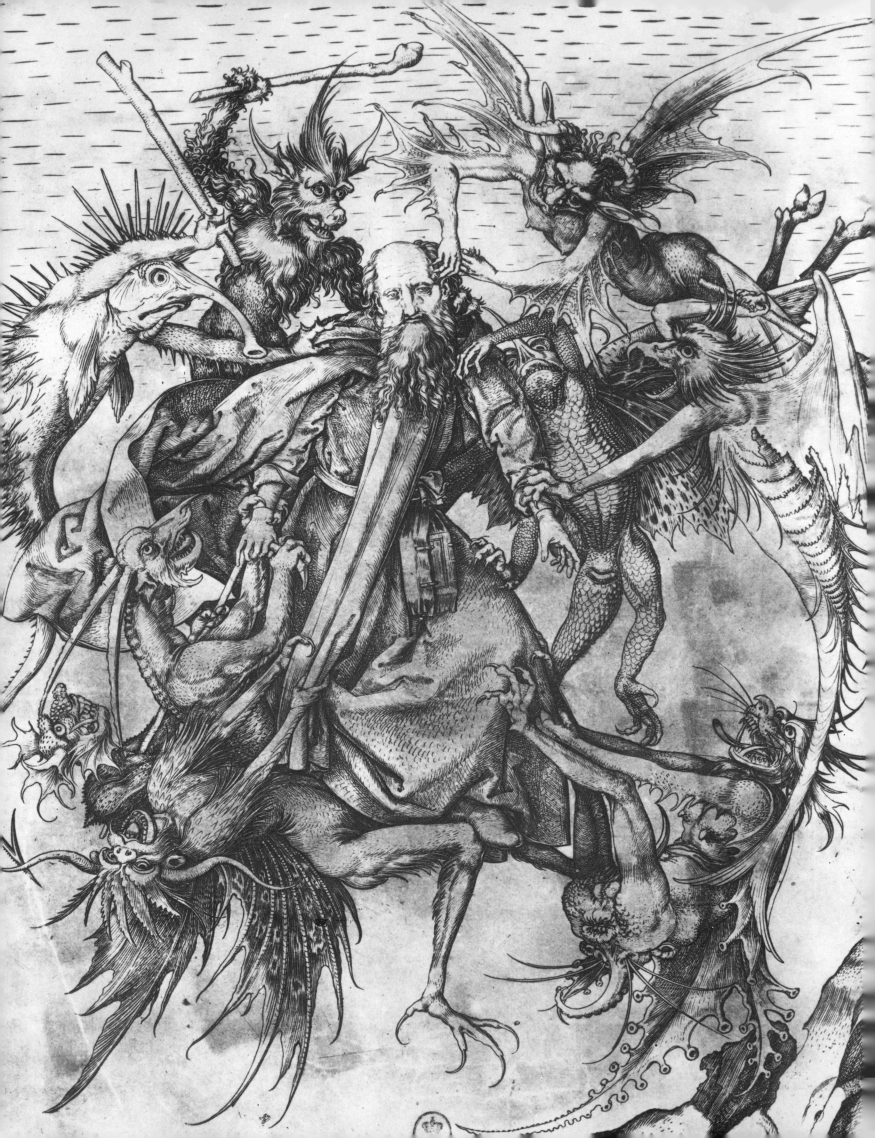

2 MARTIN SCHONGAUER
The Temptation of St Anthony
1471–3

3–5 NOEL GARNIER Letters
X, C and I from an alphabet.
Late 15th century

3

4 5

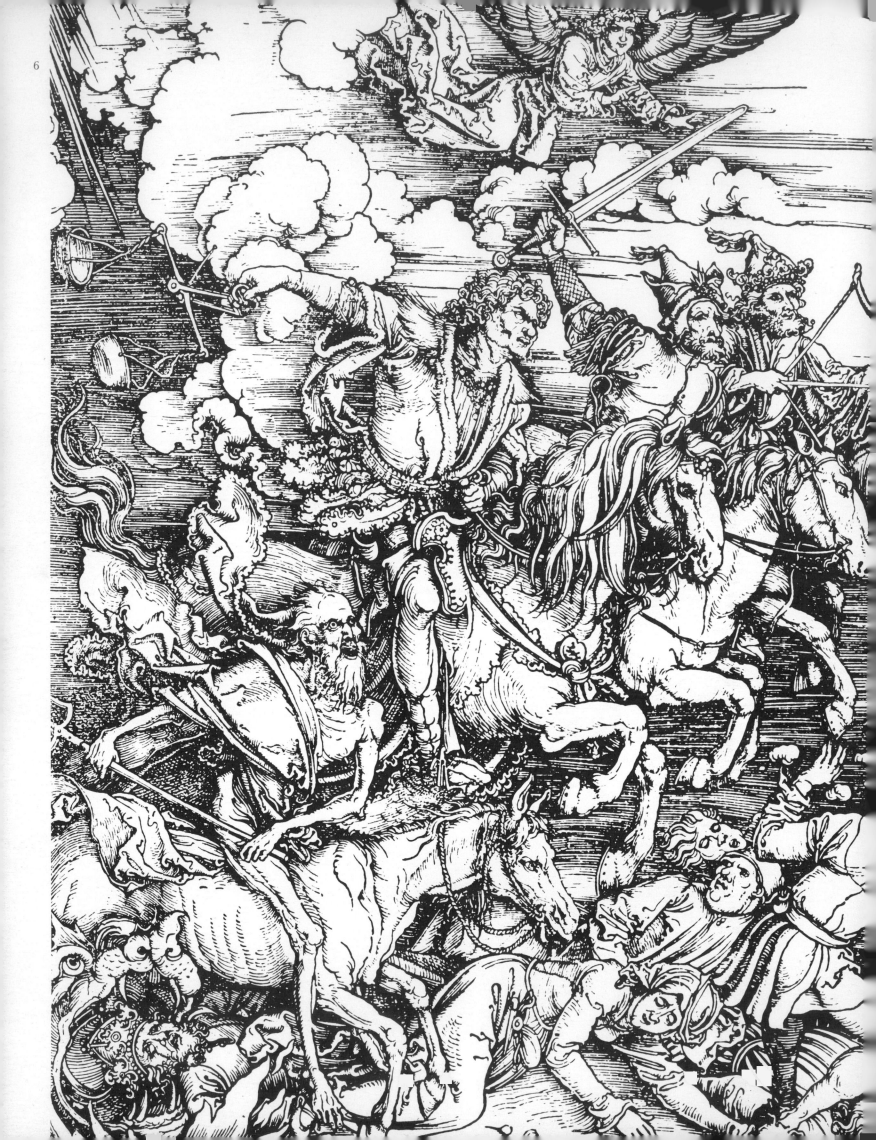

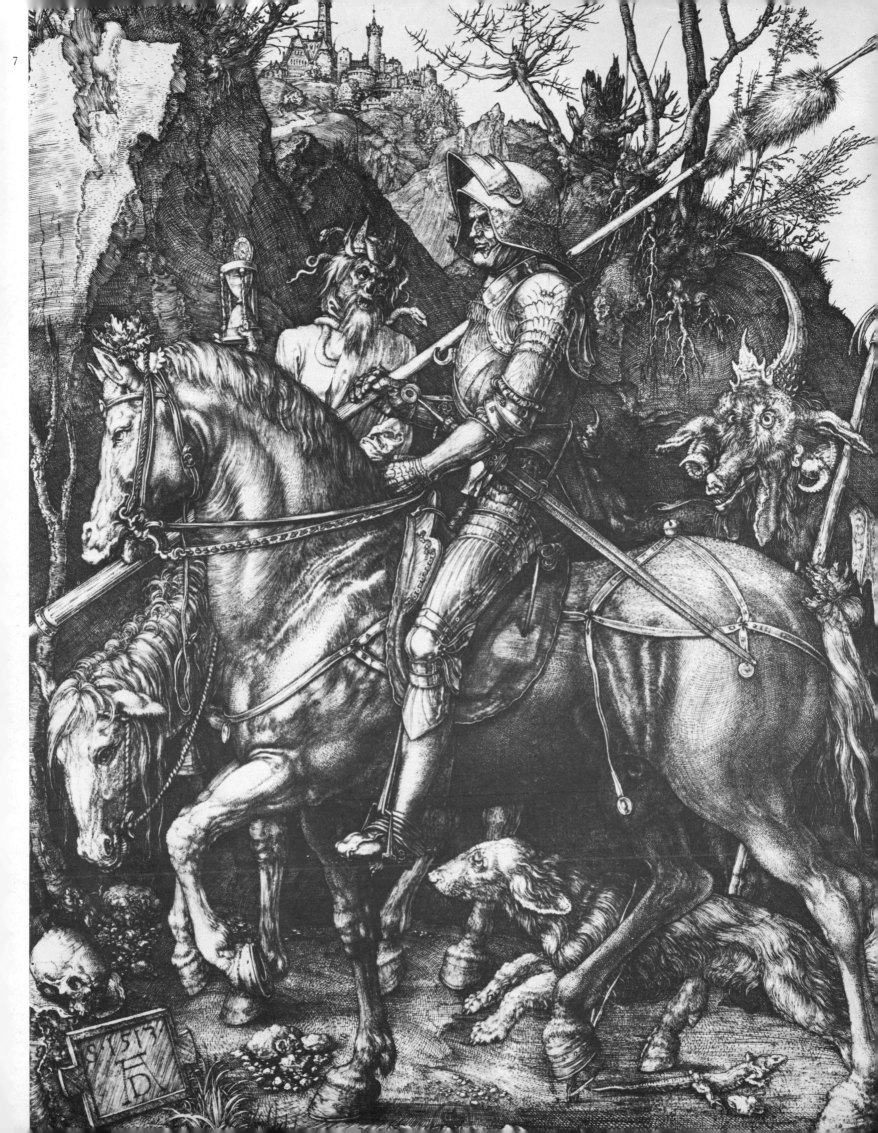

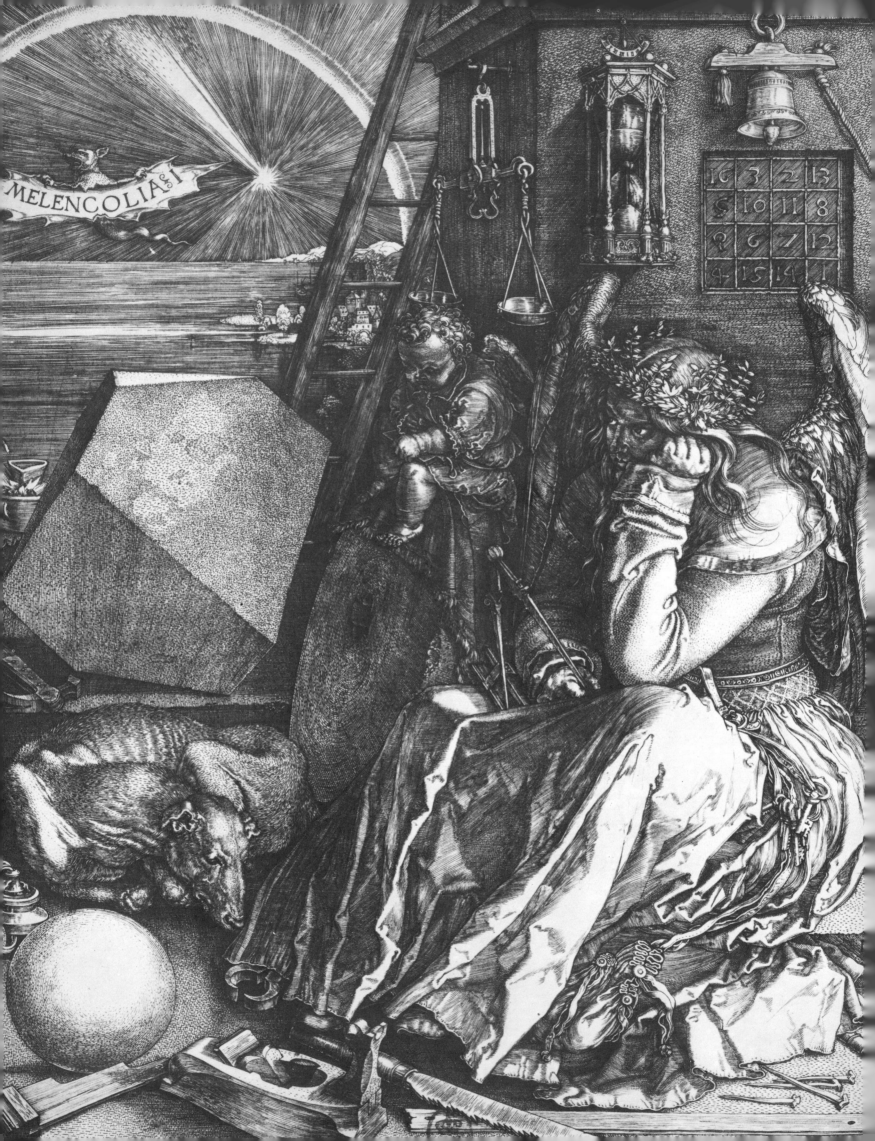

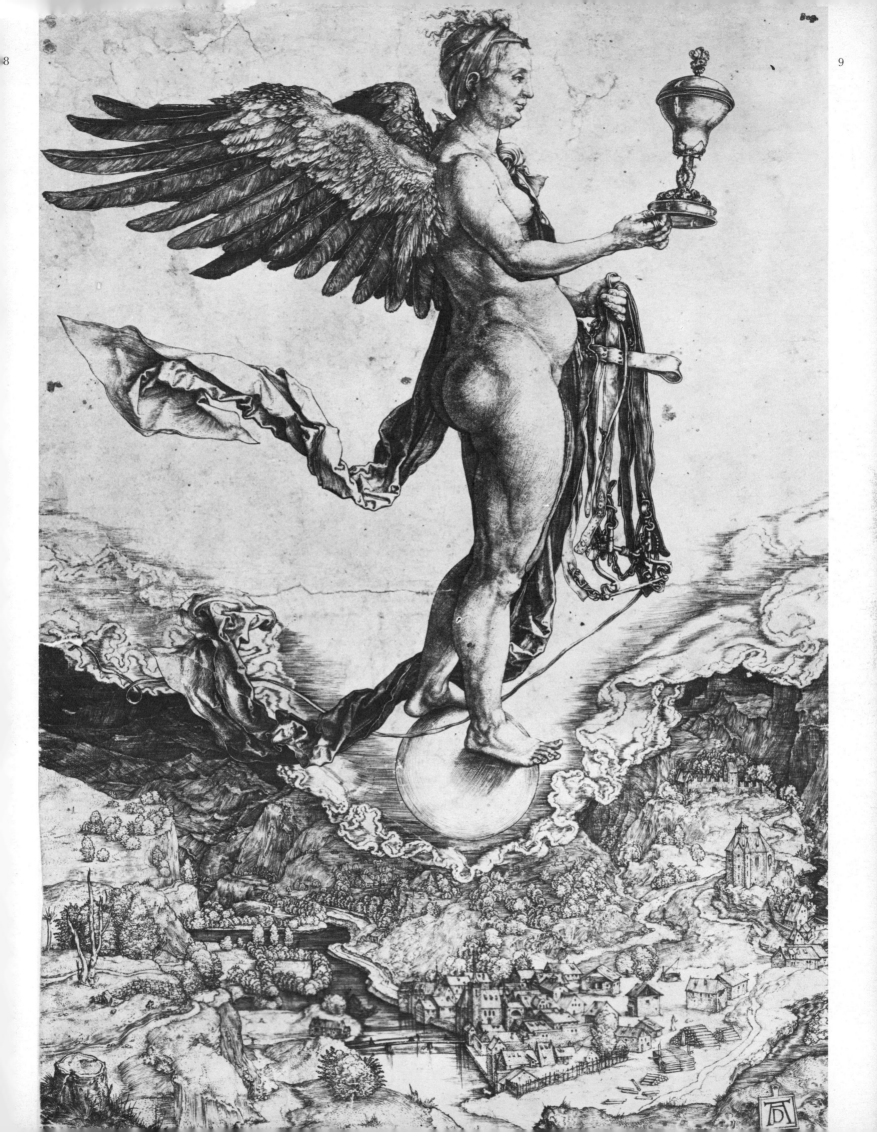

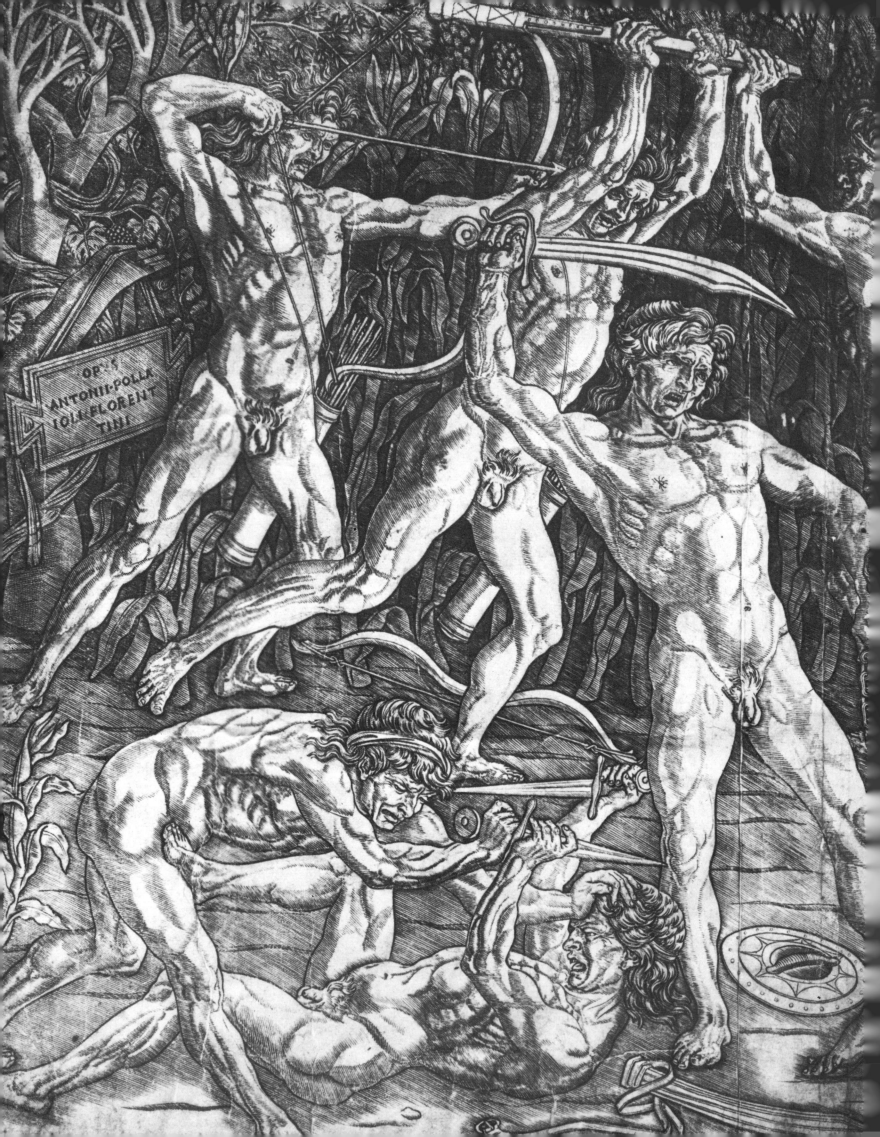

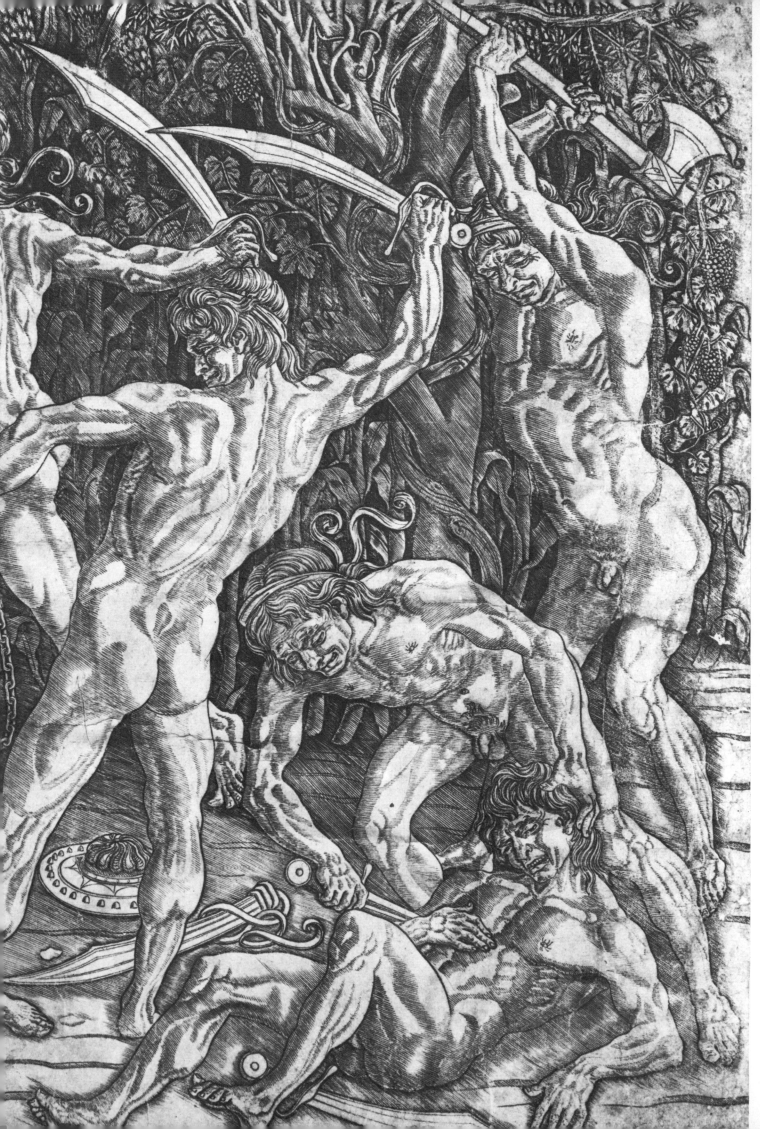

Overleaf
10 ANTONIO POLLAIUOLO
Battle of Naked Men, c. 1461

11 GIOVANNI-BATTISTA
DEL PORTO, or, the Master
I.B. with the Bird, *c.* 1500–06

Opposite
13 Title-page initial for *Le
Grand Testament Villon*, Paris
1505–6

14 Title-page initial for a
different edition of *Le Grand
Testament Villon*, also printed
in Paris (possibly earlier)

15, 16 GEORG SIMLER
Illustrations from *Rationarum
Evangelistarum Omnia in se
evangelia prosa, versu imaginibus
que quam munifice complecteus*,
couplets by Petrus of
Rosenheim, 1507–10

12 ALBRECHT DÜRER *Coat
of Arms with a Skull* 1503

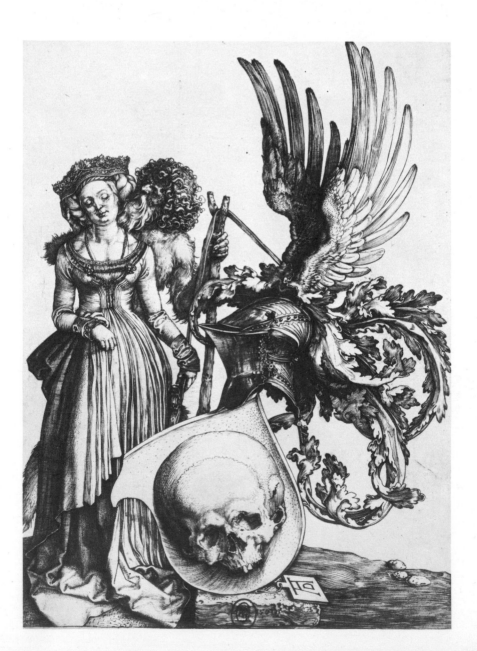

e

grant teſtament vil
lon/ꝛle petit. Son codicille. Le iargon
Et ſes balados:

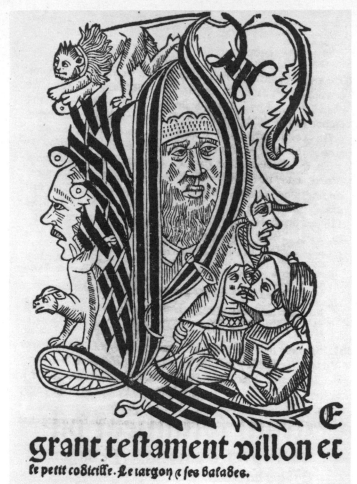

E

grant teſtament villon et
le petit codicille. Le iargon ꝛ ſes balades.

17 LORENZ STOËR Fantastic architecture from *Geometria et perspectiva*, 1555. The sixth plate

18 LORENZ STOËR Fantastic architecture from *Geometria et perspectiva*, 1555. The eleventh and last plate

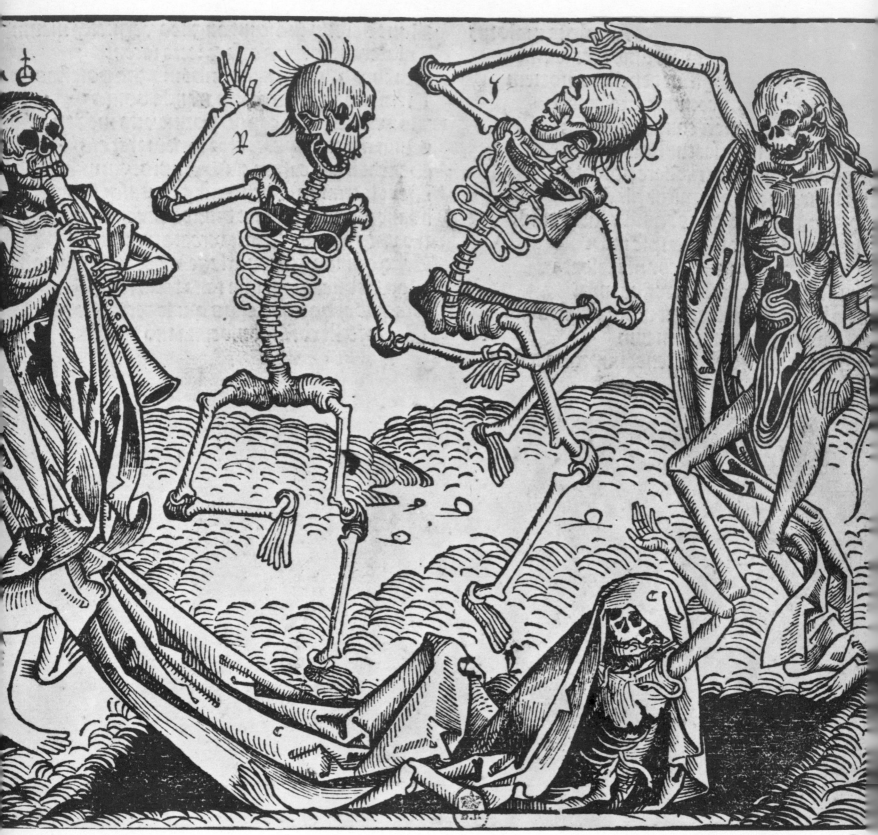

19 *The Dance of Death.* Plate from the *Nuremberg Chronicle,* 1493

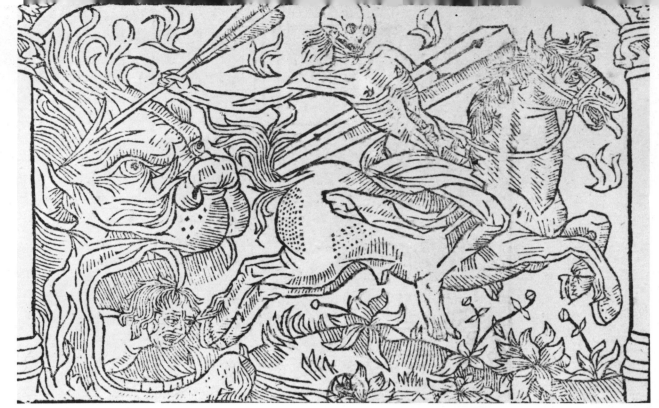

20　Plate from the *Danse macabrée, dite des trois morts et des trois vifs*. Possibly by Pierre Lerouge, *c.* 1488

21　*Dance of Death*. Heidelberg, 1465

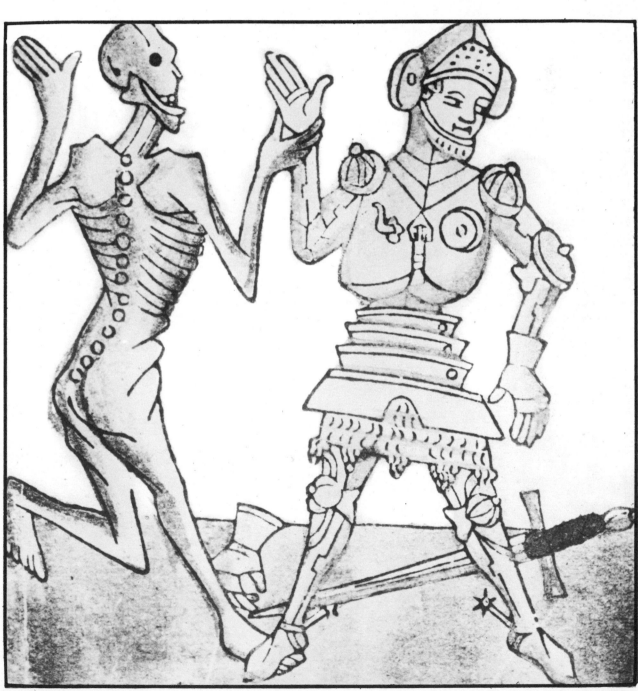

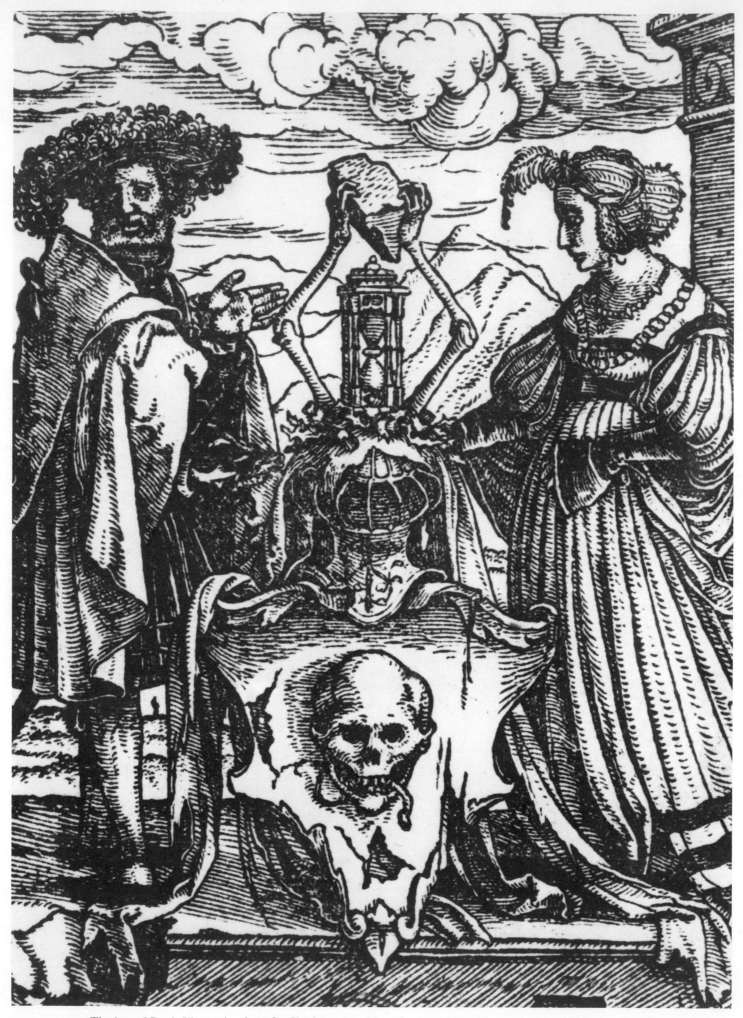

22 HOLBEIN *The Arms of Death*. Illustration from *Les Simulacres de la Mort* ('Images of Death') by Melchior and Gaspar Trechsel, 1538

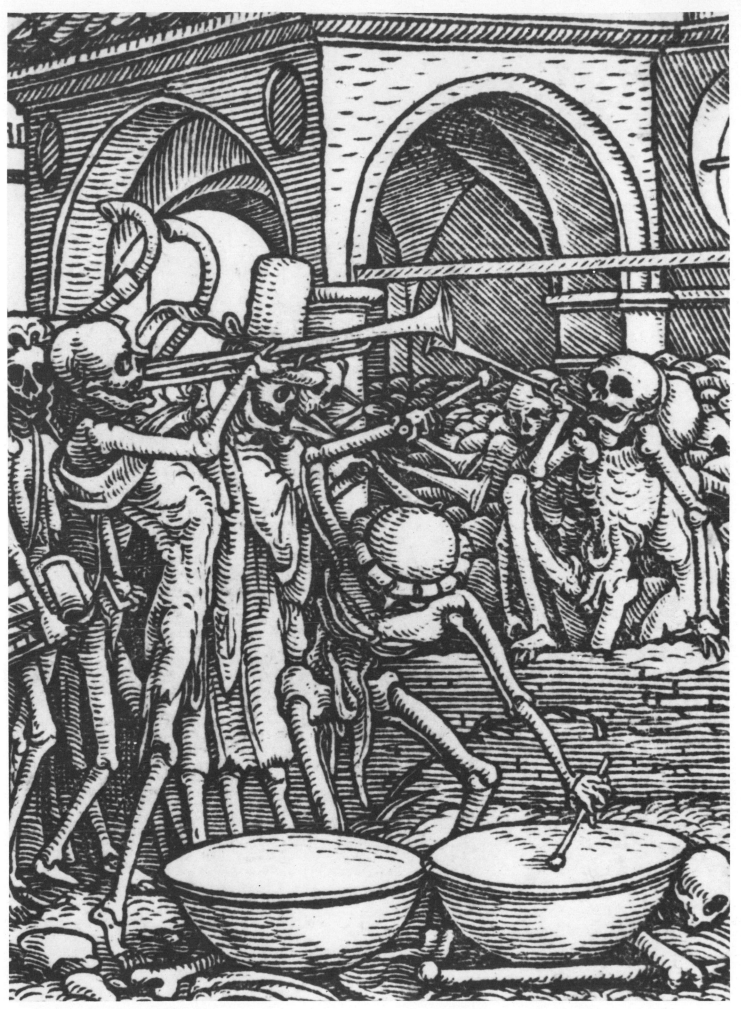

23 HOLBEIN *The Day of Judgment.* Illustration from *Les Simulacres de la Mort* ('Images of Death') by Melchior and Gaspar Trechsel, 1538

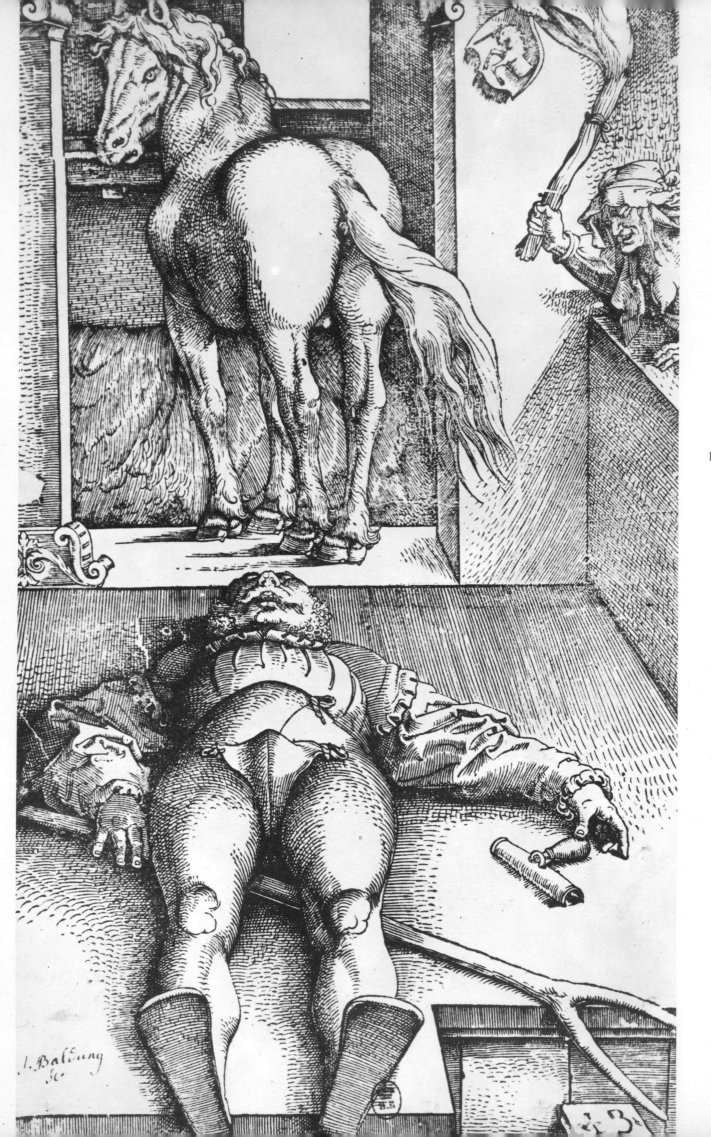

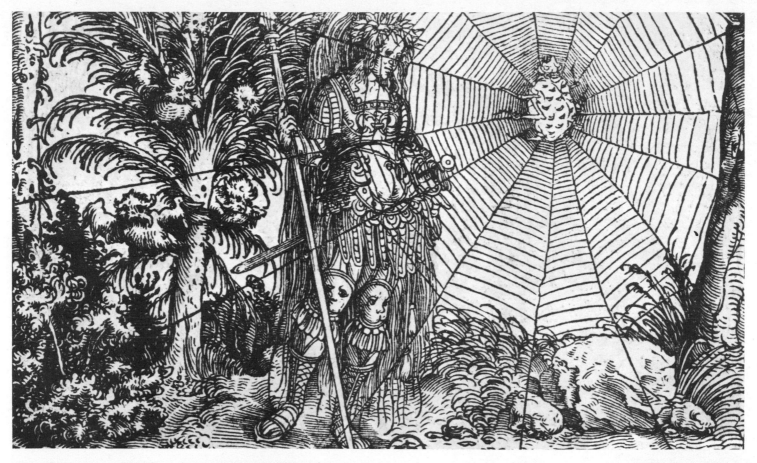

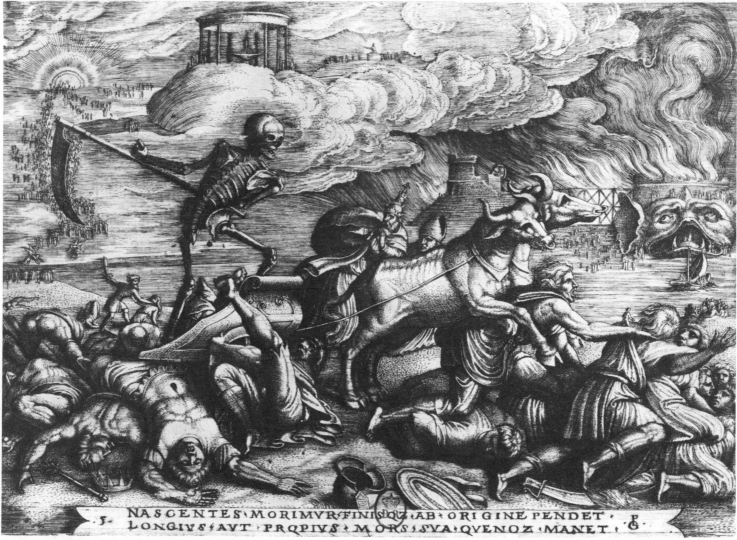

NASCENTES·MORIMVR·FINISQZ·AB·ORIGINE·PENDET
LONGIVS·AVT·PROPIVS·MORS·SVA·QVENQZ·MANET

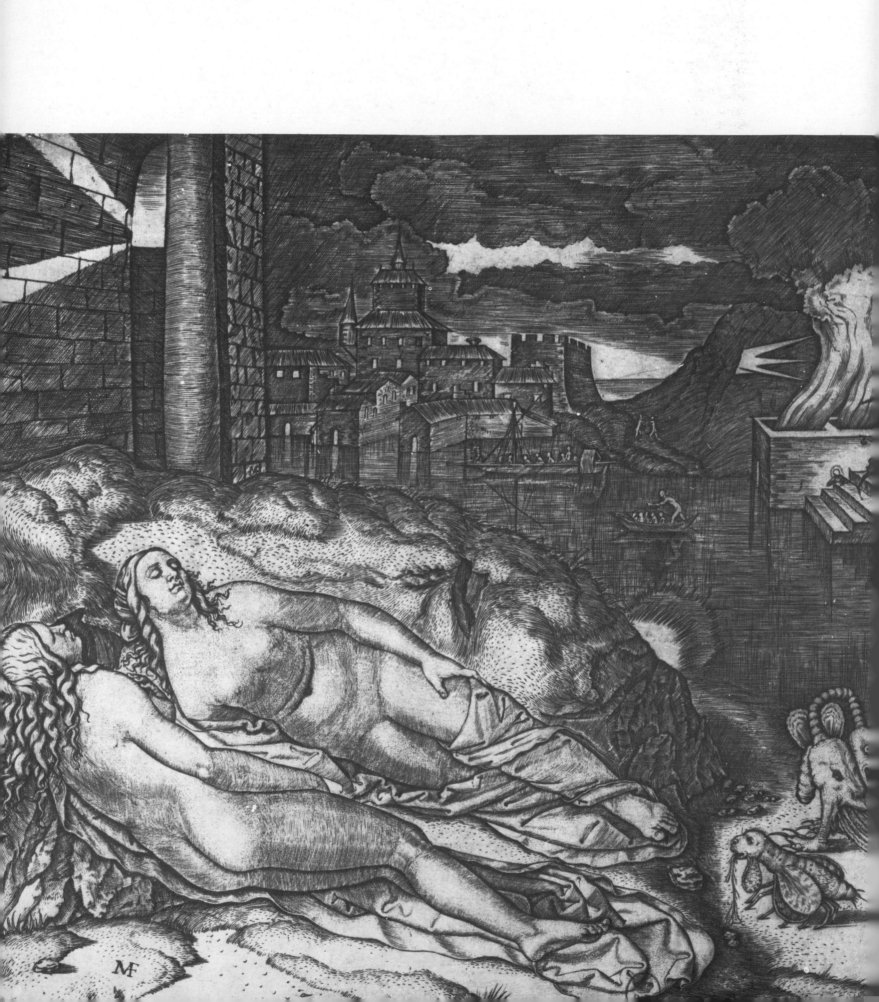

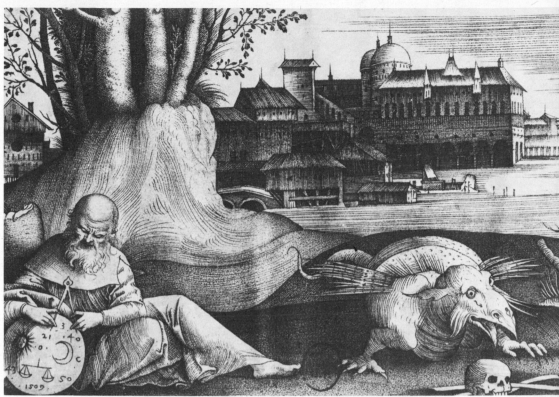

Etiam ferocissimos domari
Per feroce che sia convien esser domato

29 TITIAN *Death in Armour*

30 DOMENICO BECCAFUMI *Procession of Sea Gods*

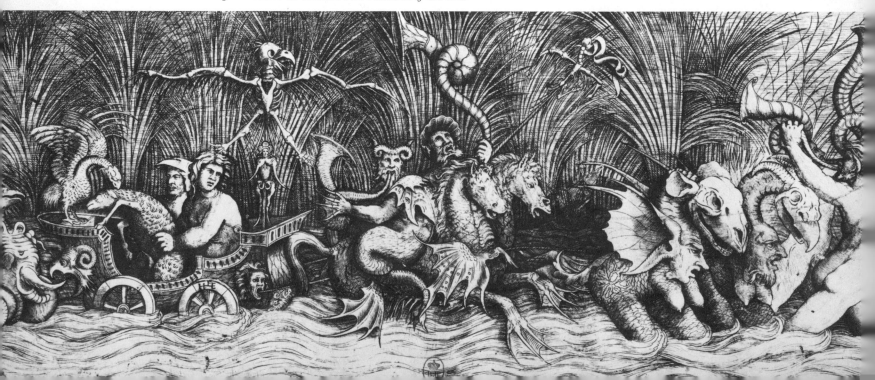

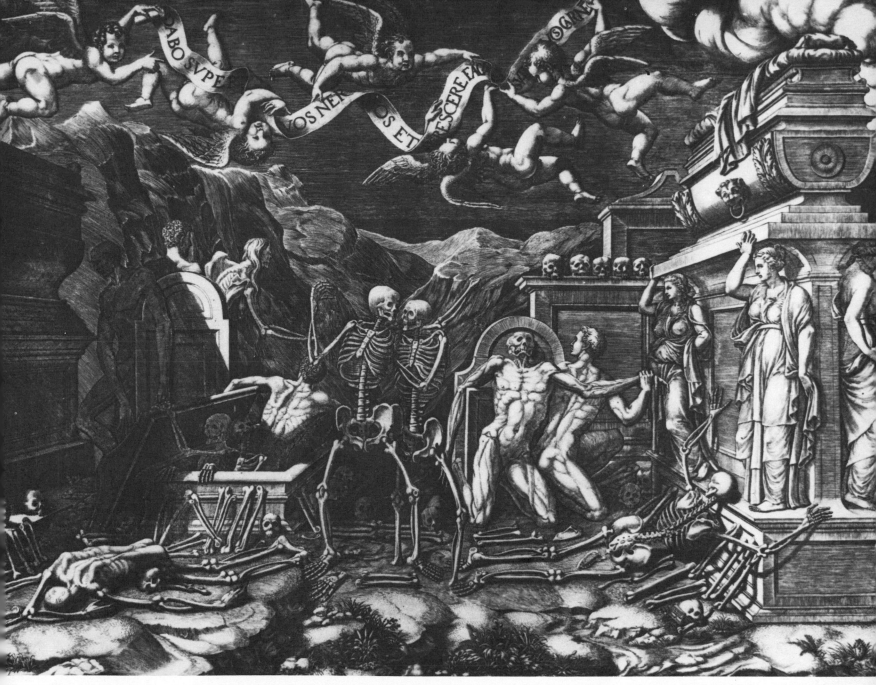

31 GIORGIO GHISI *The Resurrection of the Dead* 1554

32 HANS J. SEBALD BEHAM *Allegory of Death* 1529

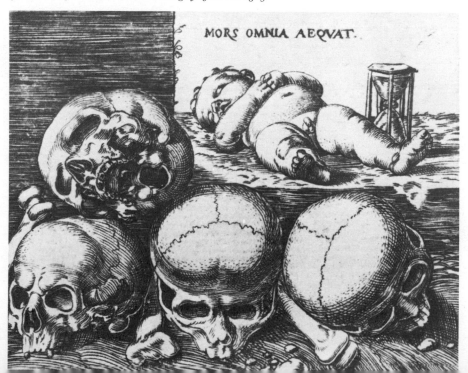

Overleaf
33 GIORGIO GHISI *The
Melancholy of Michelangelo*
1561

SEDET AETERNVM
QVE SEDEBIT INFOELIX

RAPHAELIS VRBINATIS INVENTVM.
PHILIPPVS DATVS ANIMI GRATIA
FIERI IVSSIT

TV NE CEDE MALIS: SED
CÔTRA AVDENTIOR ITO

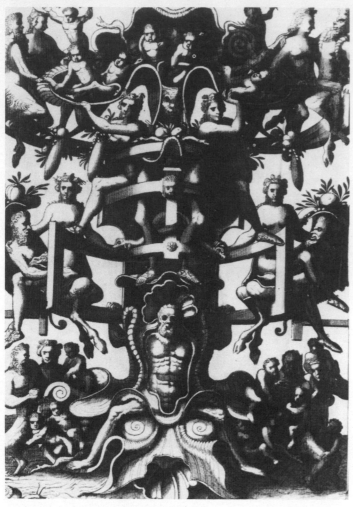

34 CORNELIS FLORIS Decorative motif

35 MARTINO ROTA *The Battle of Truth*

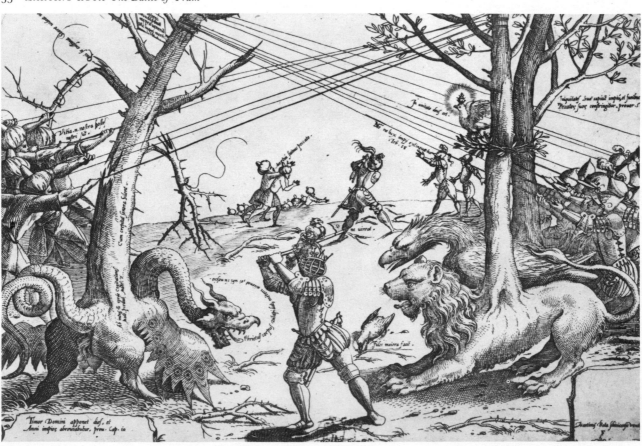

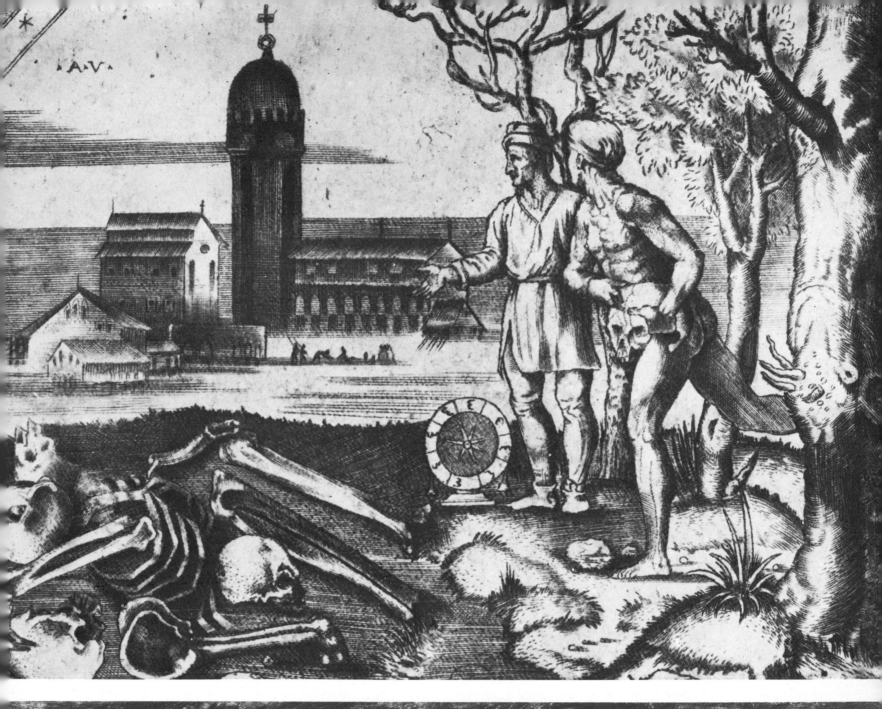
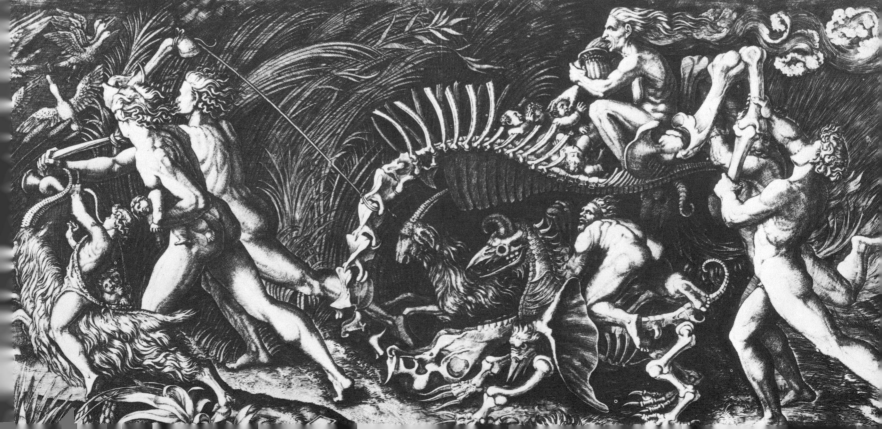

38, 39 JEAN VISET (?)

38 *Acrobat* 1540

39 *Acrobats* 1540

40, 41 JEAN DE GOURMONT

40 *John the Baptist*

41 *Fight between Two Goldsmiths*

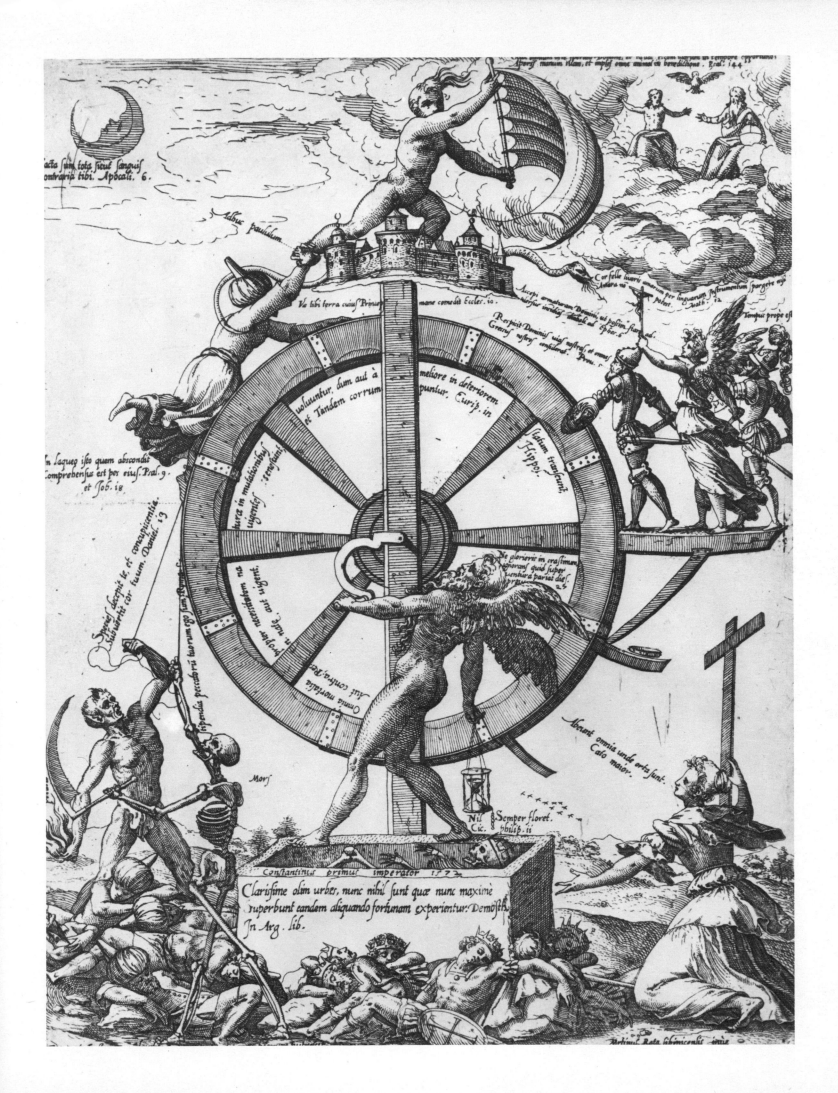

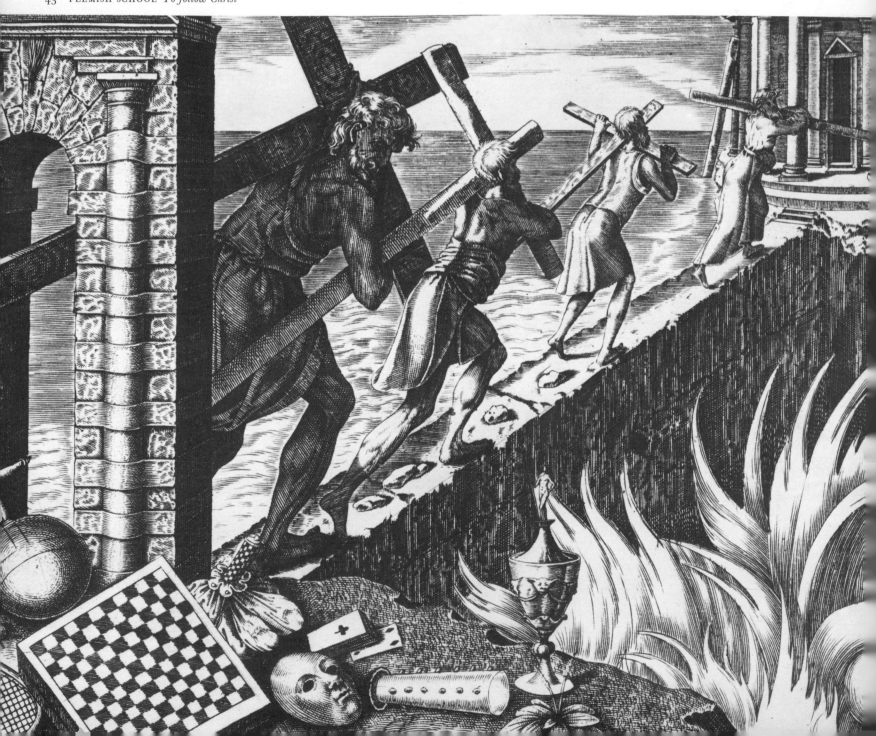

43 FLEMISH SCHOOL *To follow Christ*

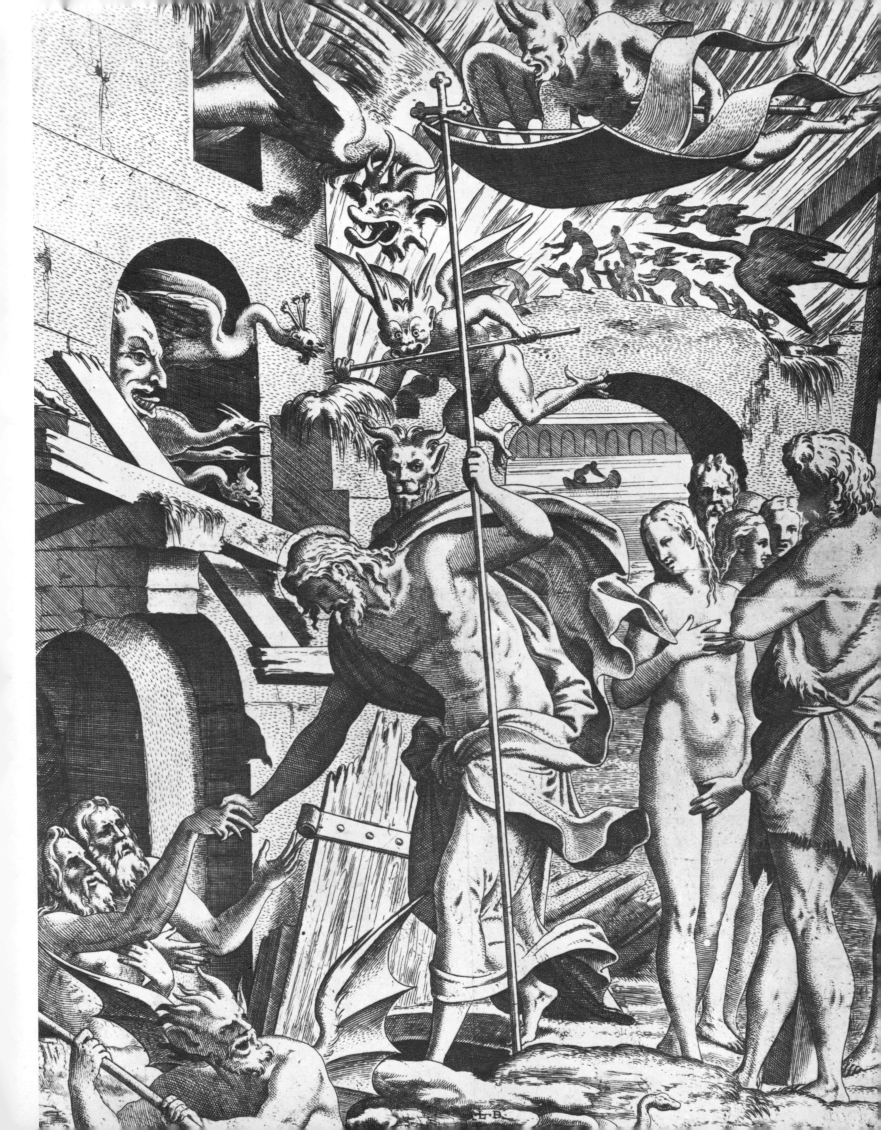

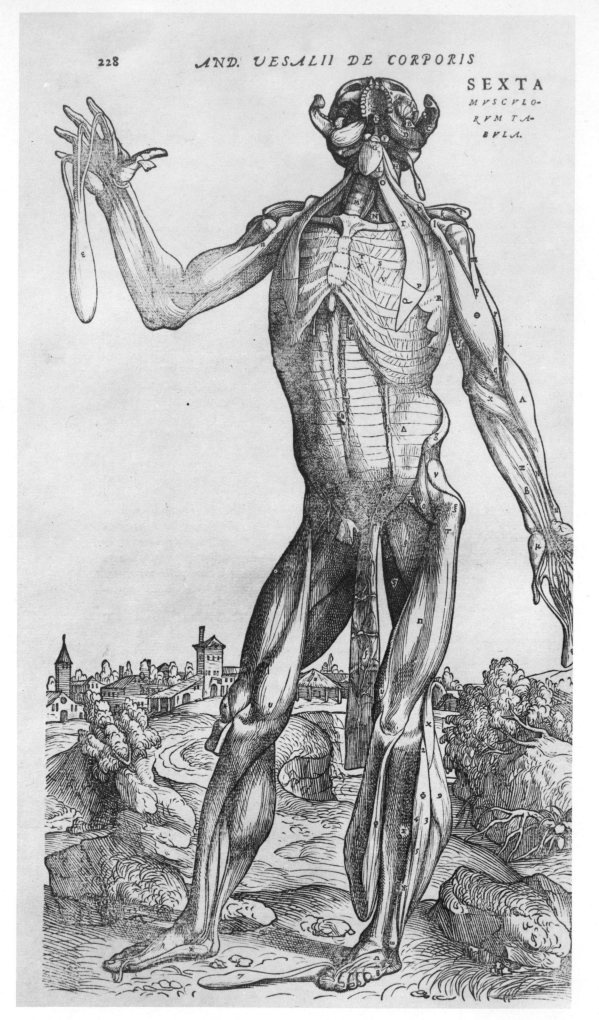

45, 46 Plates
from *De Humani
corporis fabrica* by
Andrea Vesalius,
1543

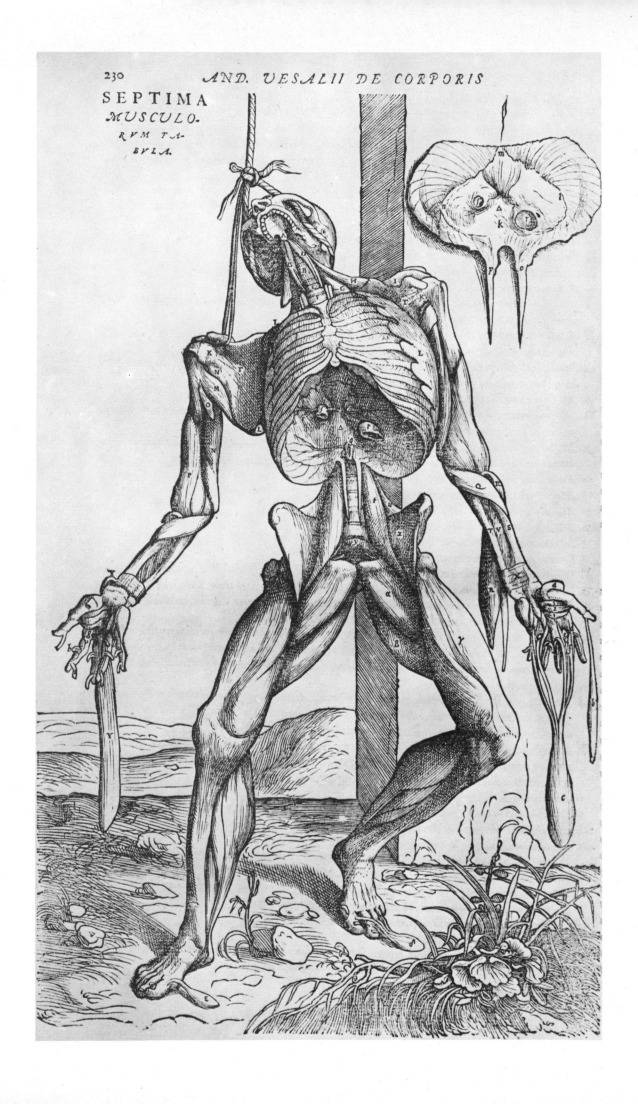

49, 50 Plates from *Horus Apollo de Aegypte*, 1543

47, 48 Plates from the *Prodigiorum et ostentorum chroniconquae, praeter naturae ordinem et in superioribus et his inferioribus mundi regionibus, ab exordio mundi usque ad haec nostra tempora acciderunt* by Conrad Lycosthenes, 1557

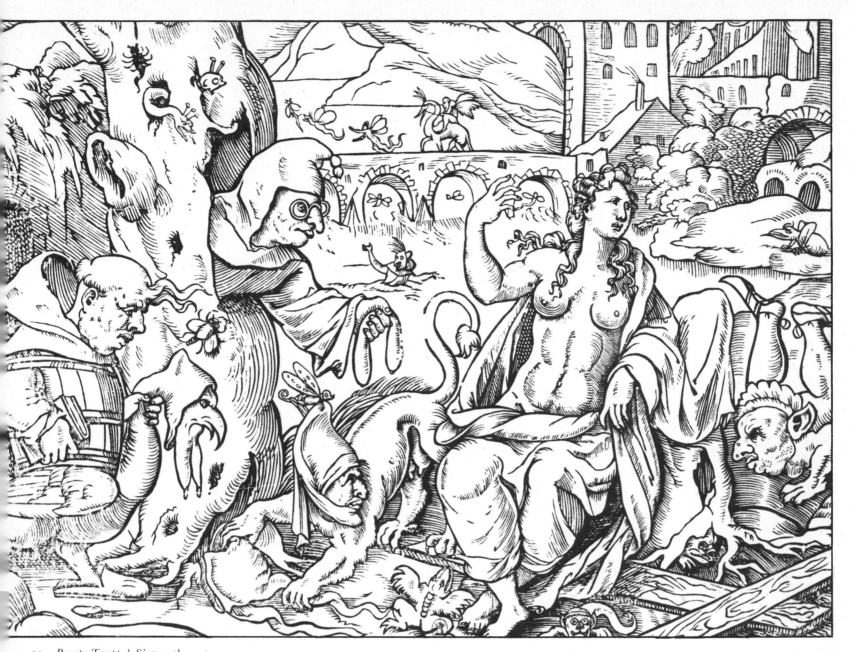

51 *Beauty Tempted.* Sixteenth century

Overleaf
52 Plate from *De dissectione partium corporis humani libri tres* by Charles
Etienne, 1545

53 Plate from *Anatomia del corpe humano* by Juan Valverde, 1560

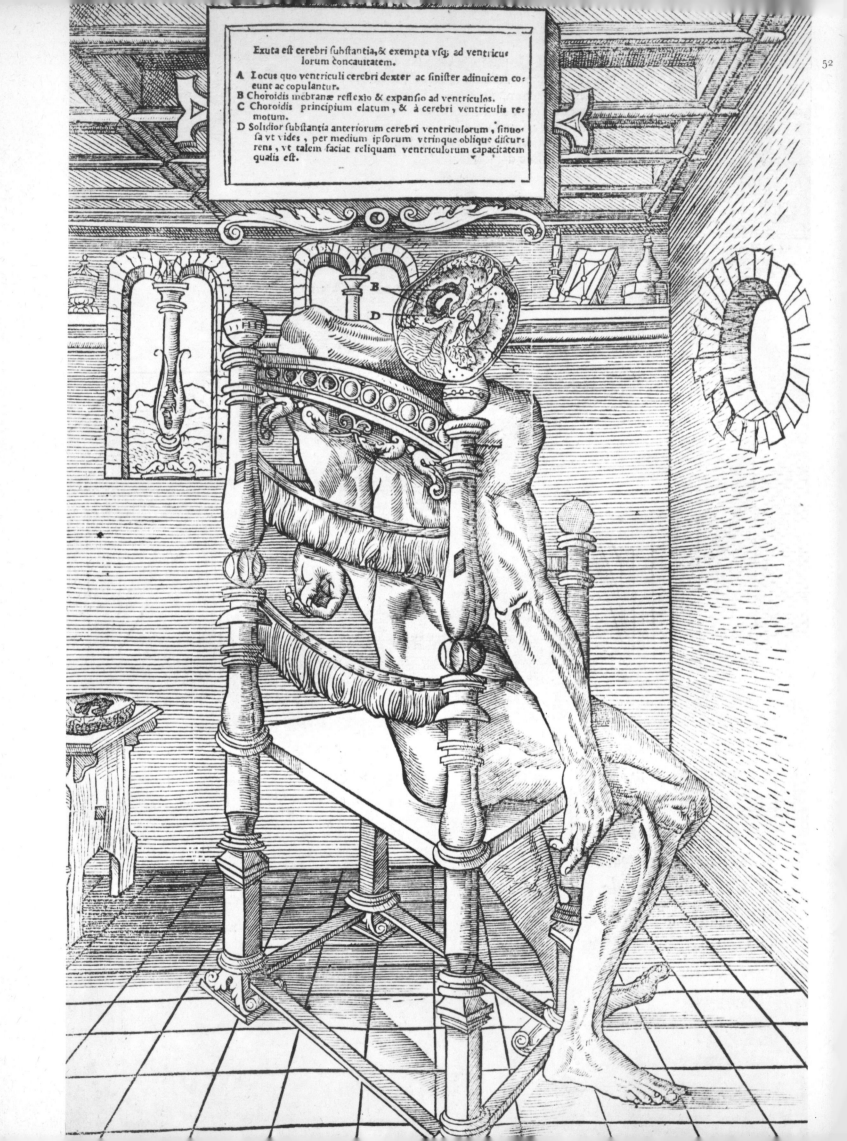

Exuta eſt cerebri ſubſtantia, & exempta vſq; ad ventricu-
lorum concauitatem.

A Locus quo ventriculi cerebri dexter ac ſiniſter adinuicem co-
eunt ac copulantur.
B Choroidis mebranæ reflexio & expanſio ad ventriculos.
C Choroidis principium elatum, & à cerebri ventriculis re-
motum.
D Solidior ſubſtantia anteriorum cerebri ventriculorum, ſinuo-
ſa vt vides, per medium ipſorum vtrinque oblique diſcur-
rens, vt talem faciat reliquam ventriculorum capacitatem
qualis eſt.

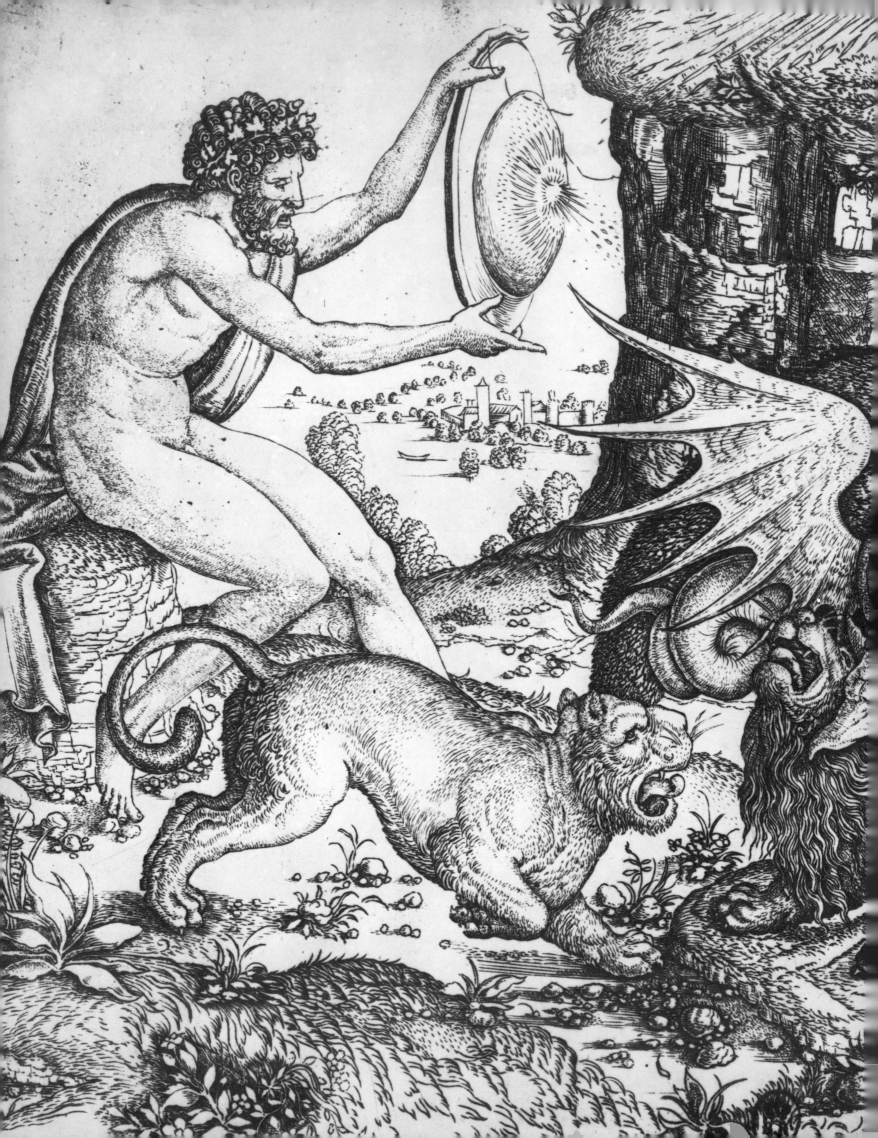

54 JEAN DUVET
Allegory with Monsters

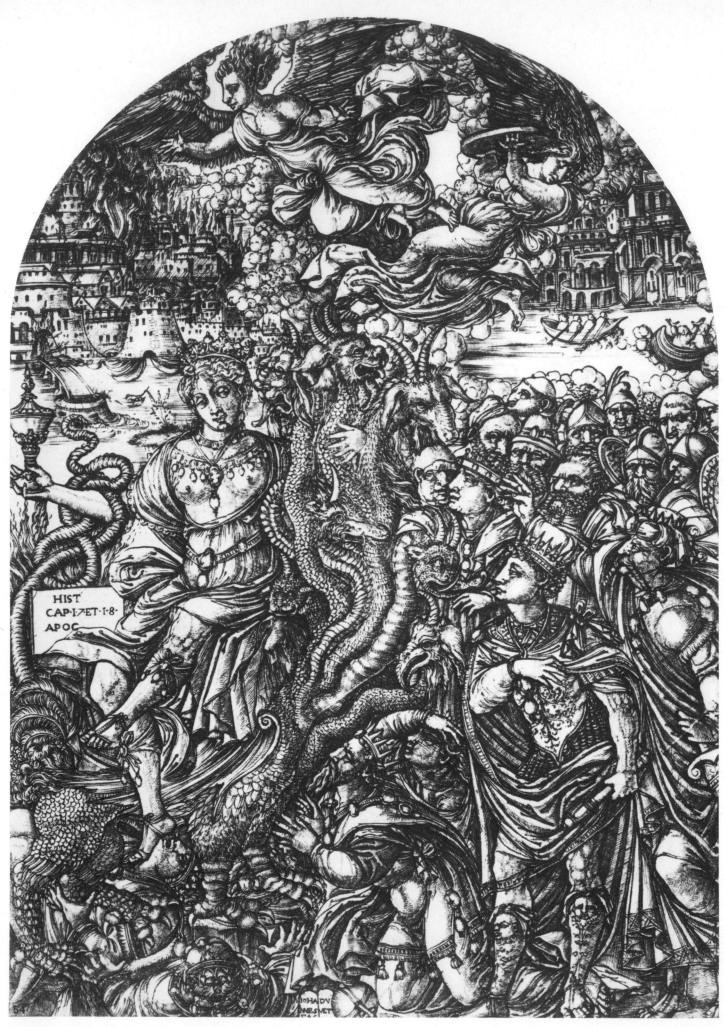

55 JEAN DUVET *The Great Whore of Babylon*

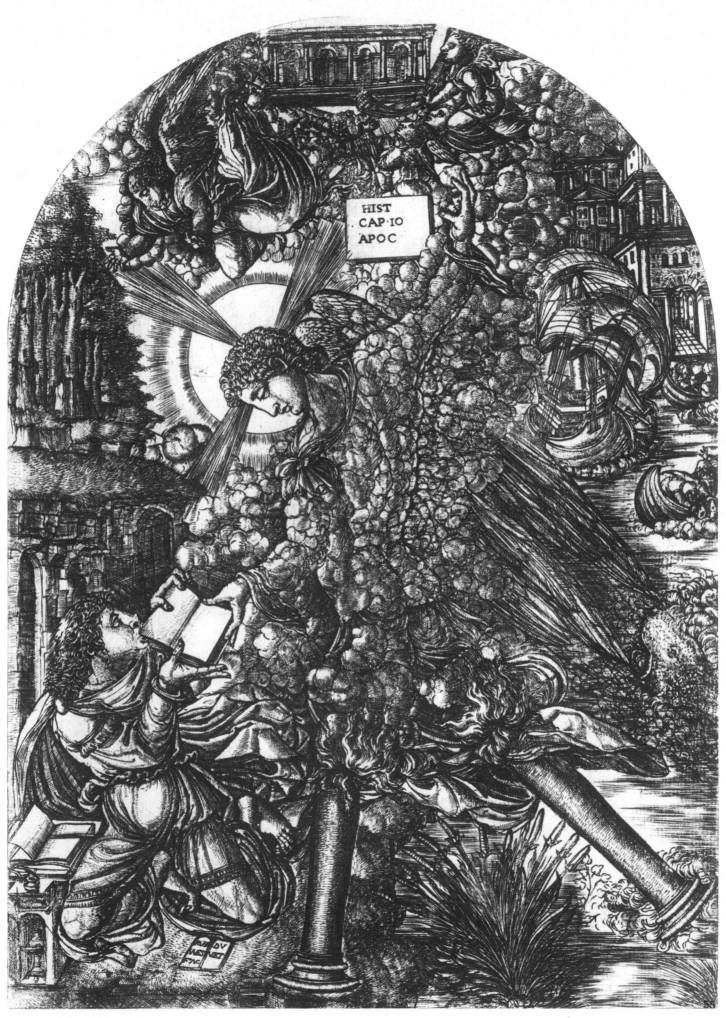

HIST
CAP·IO
APOC

56 JEAN DUVET *St John eating the Book*

57 ROBERT BOISSARD Plate from *Recueil de mascarades,* 1597

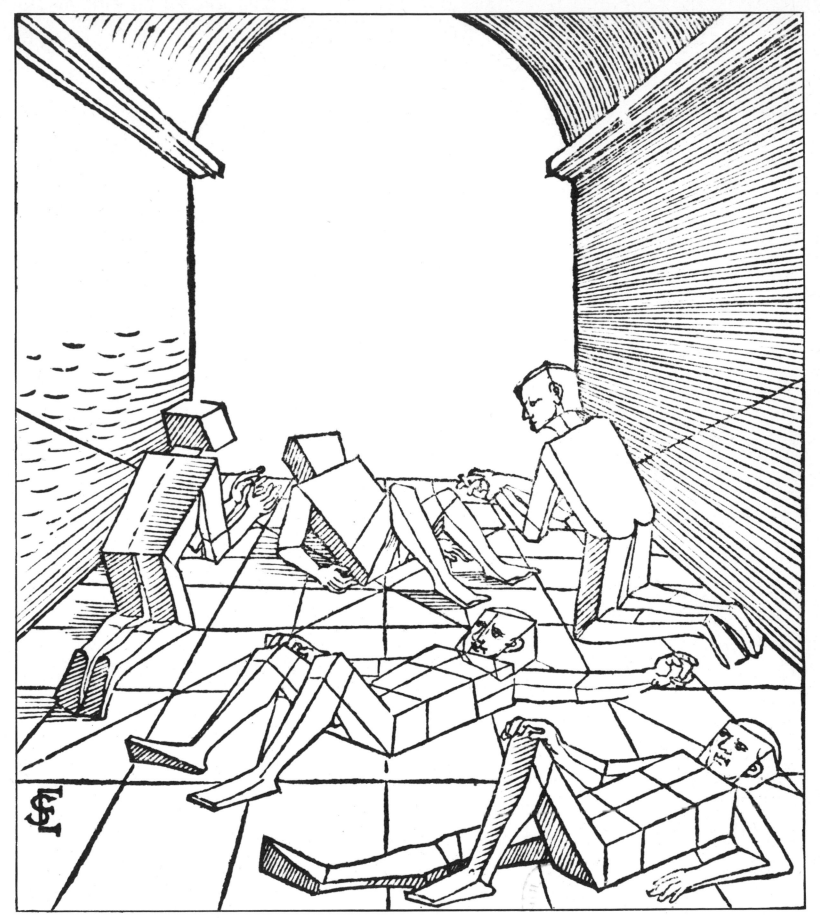

58 ERHARD SCHOEN Plate from *Traité sur les proportions des figures humaines et sur la manière de bien dessiner les écussons d'armes, les heaumes et les chevaux,* 1542

Overleaf
59–67 FRANÇOIS DESPREZ *Songes drolatiques de Pantagruel où sont contenues plusieurs figures de l'invention de Maistre François Rabelais et dernière œuvre d'iceluy pour la récréation des bons esprits,* 1565

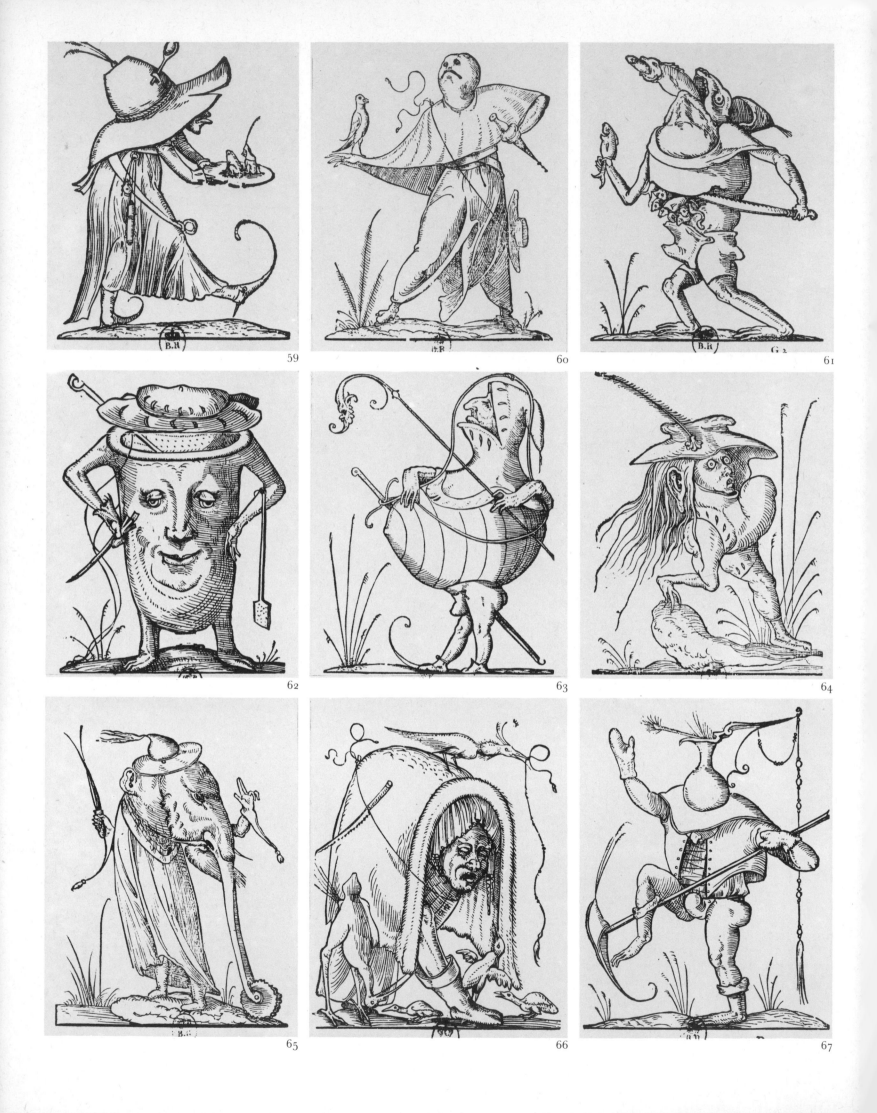

59 60 61

62 63 64

65 66 67

68 *Winter*. Engraving in the style of Arcimboldo, 1580

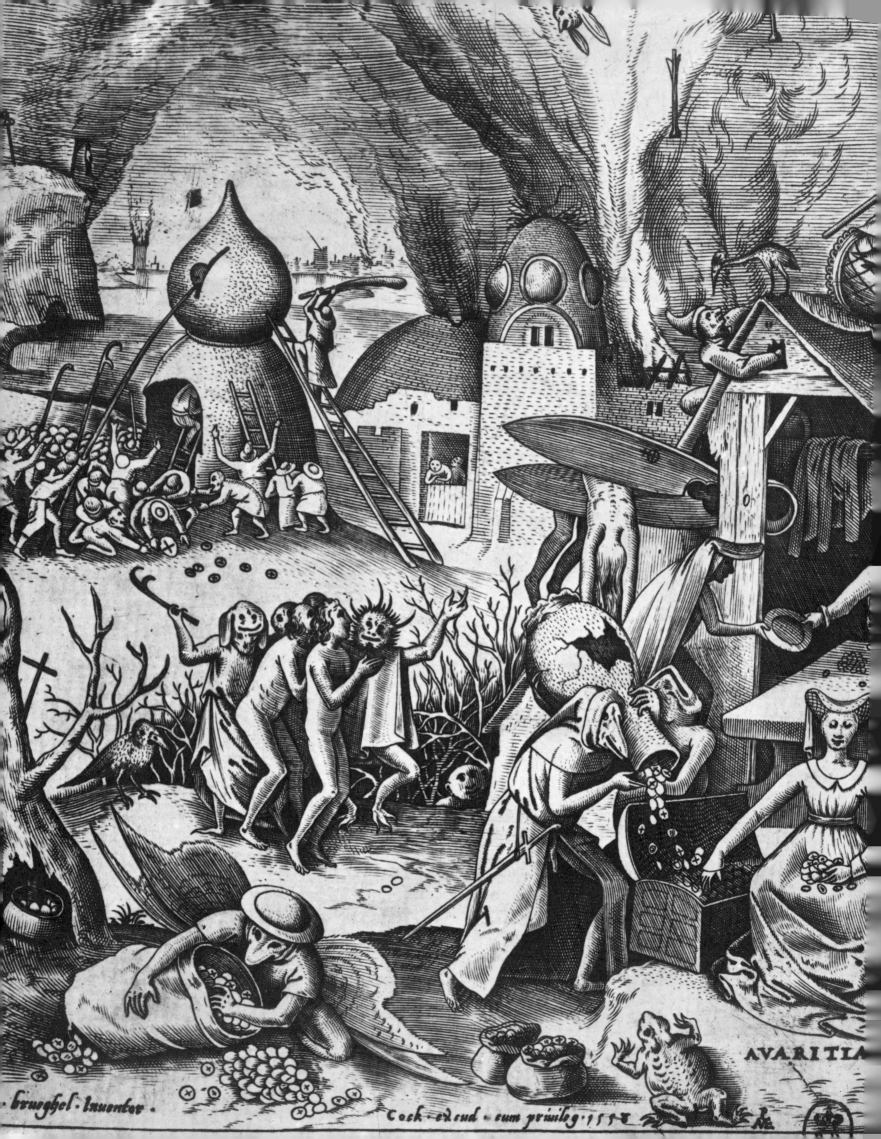

brueghel. Inuentor. Cock. exud. cum priuileg. 1558 AVARITIA

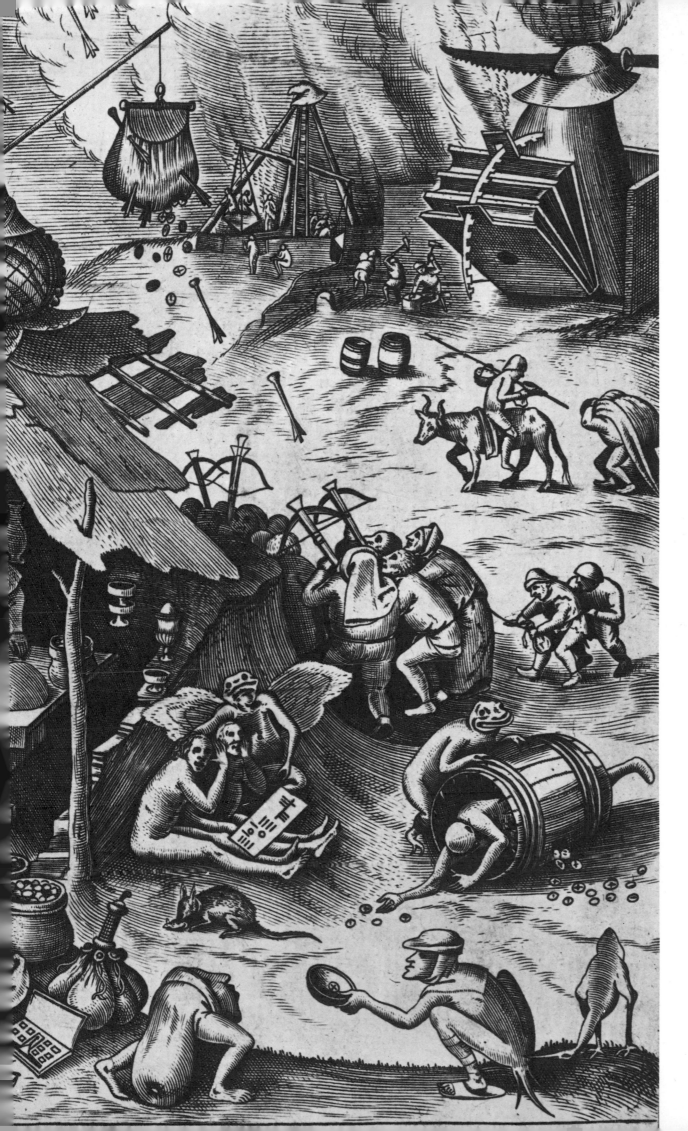

69 PIETER BREUGHEL
The Seven Deadly Sins:
Avarice

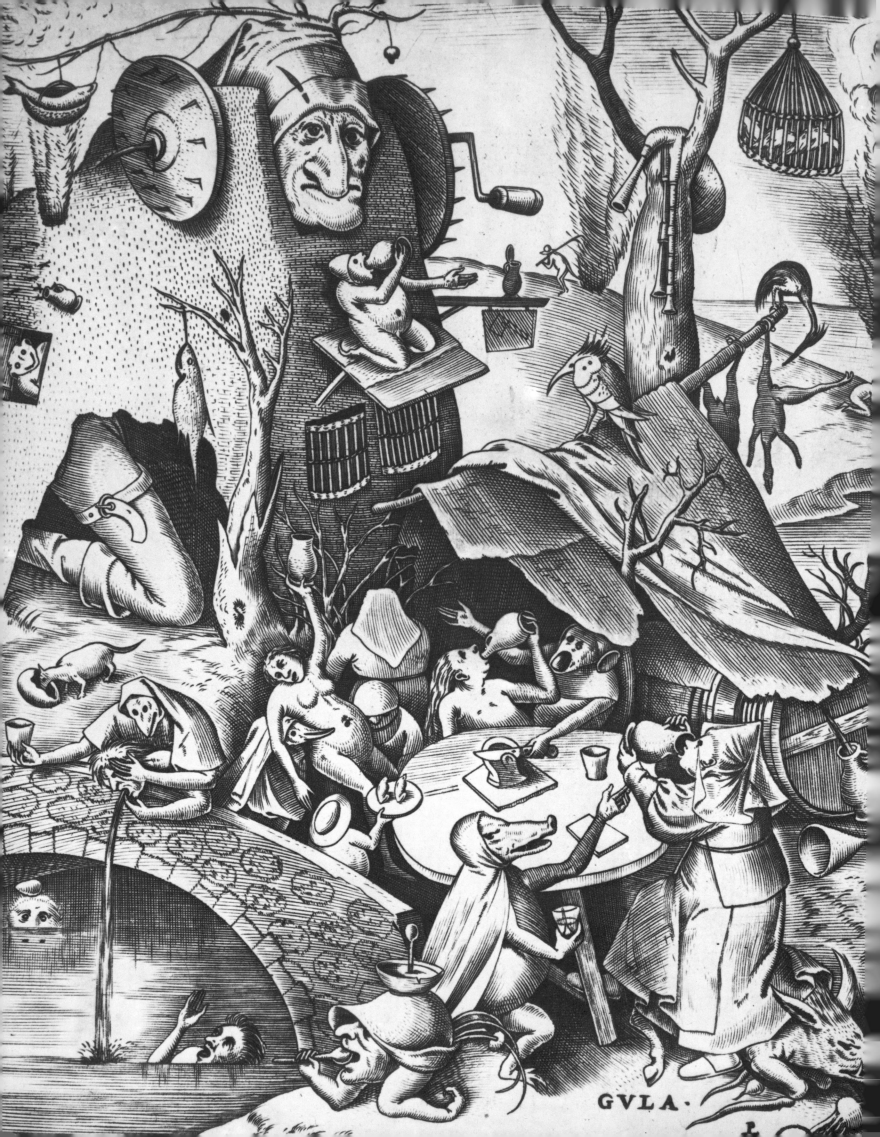

GVLA.

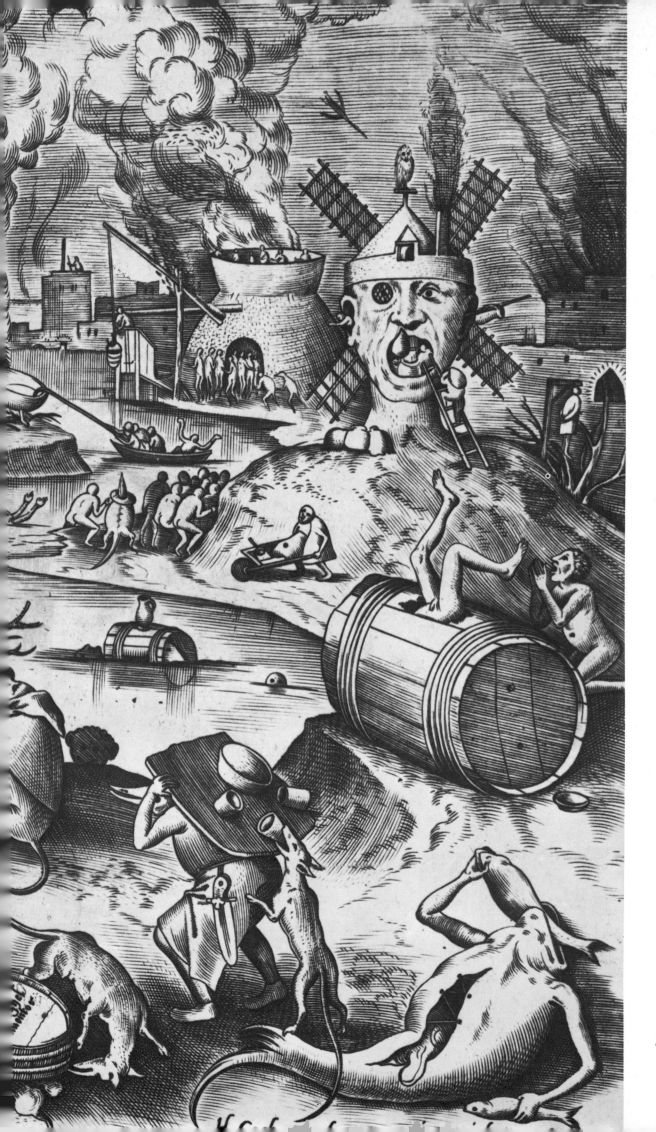

70 PIETER BREUGHEL *The
Seven Deadly Sins: Gluttony*

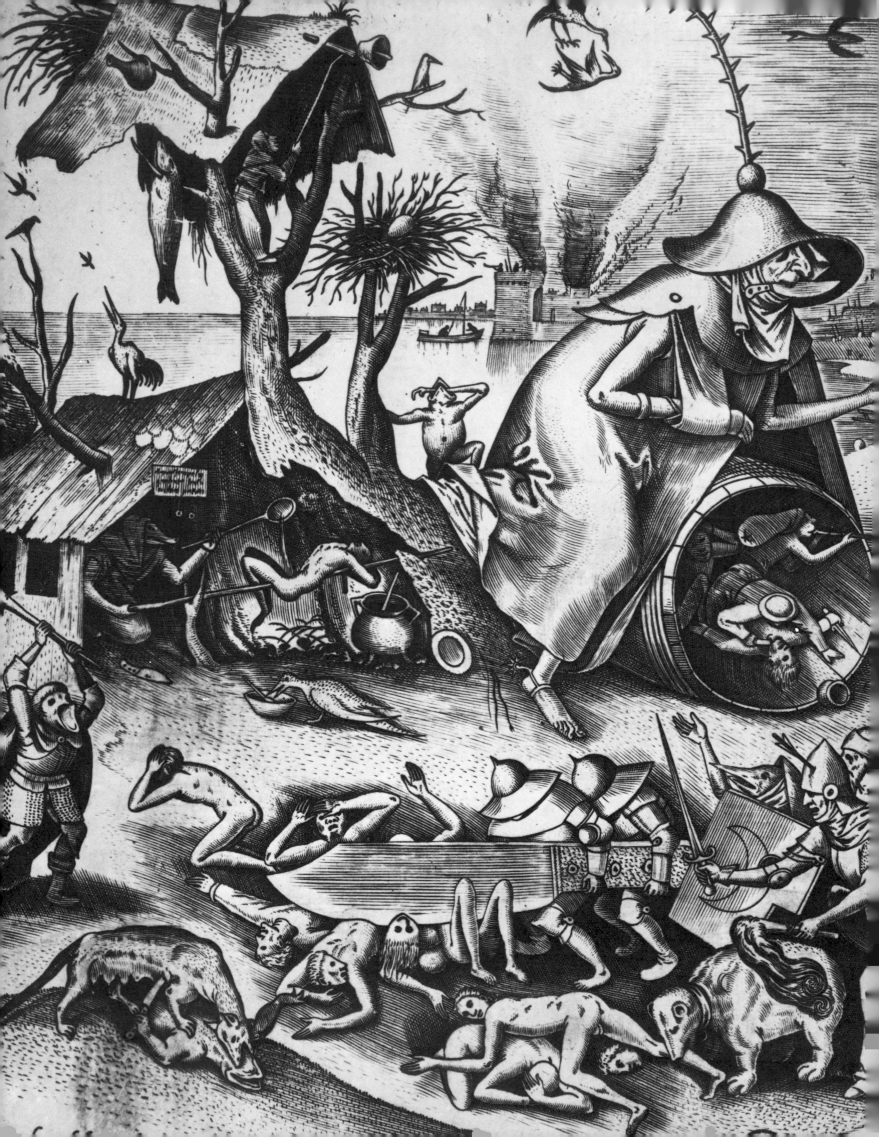

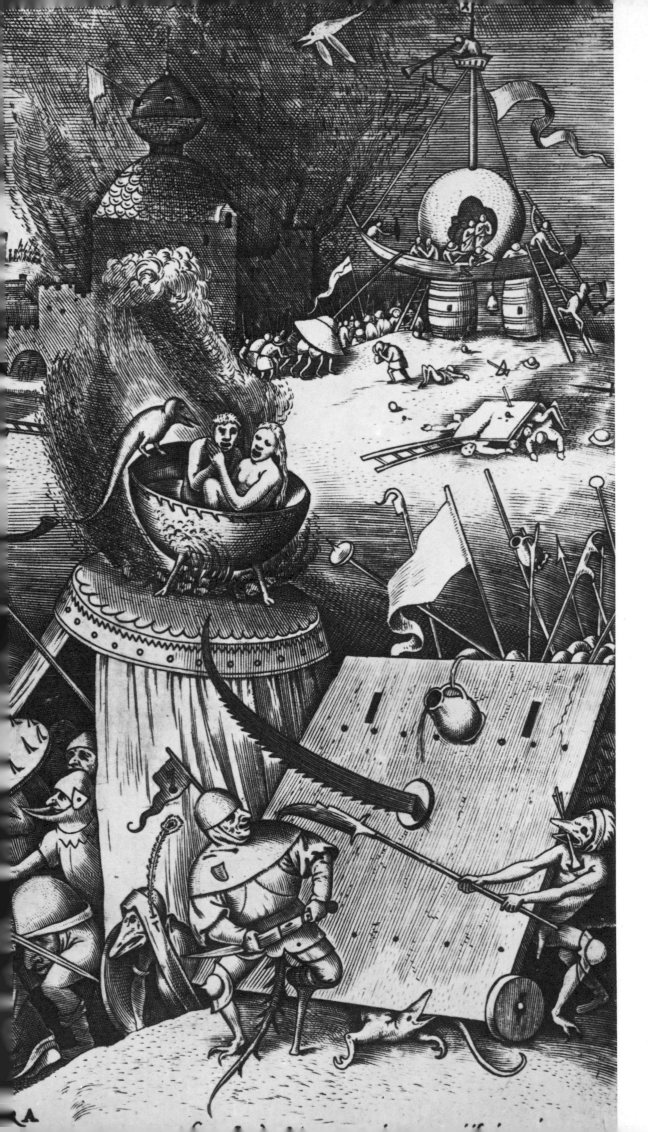

71 PIETER BREUGHEL *The Seven Deadly Sins: Anger*

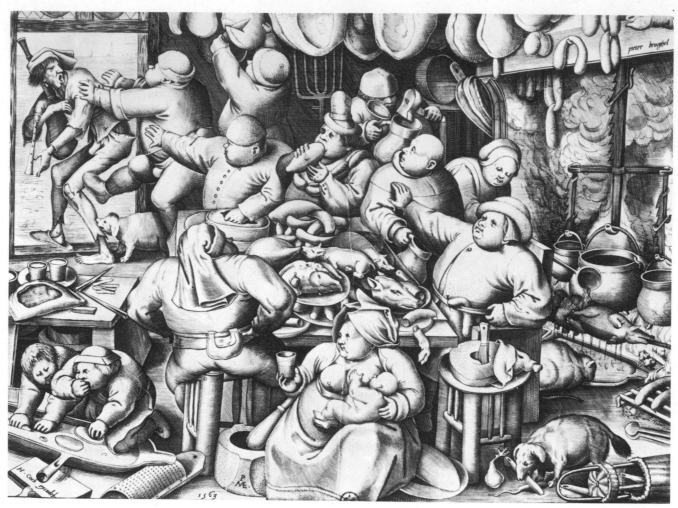

72 PIETER BREUGHEL *The Rich Kitchen* 1563

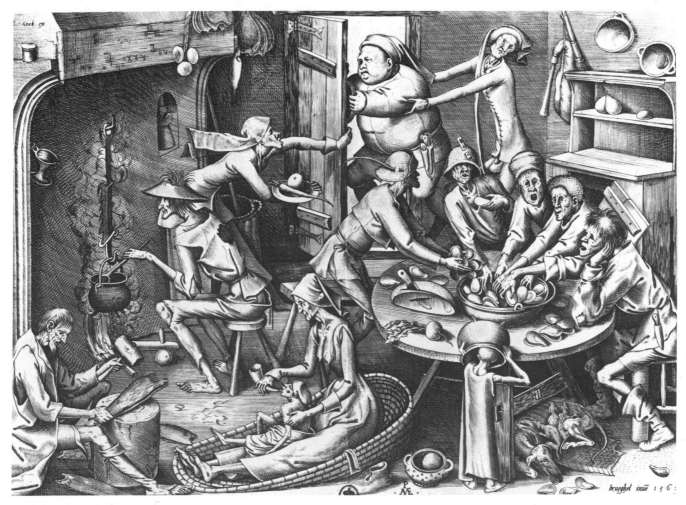

73 PIETER BREUGHEL *The Poor Kitchen* 1563

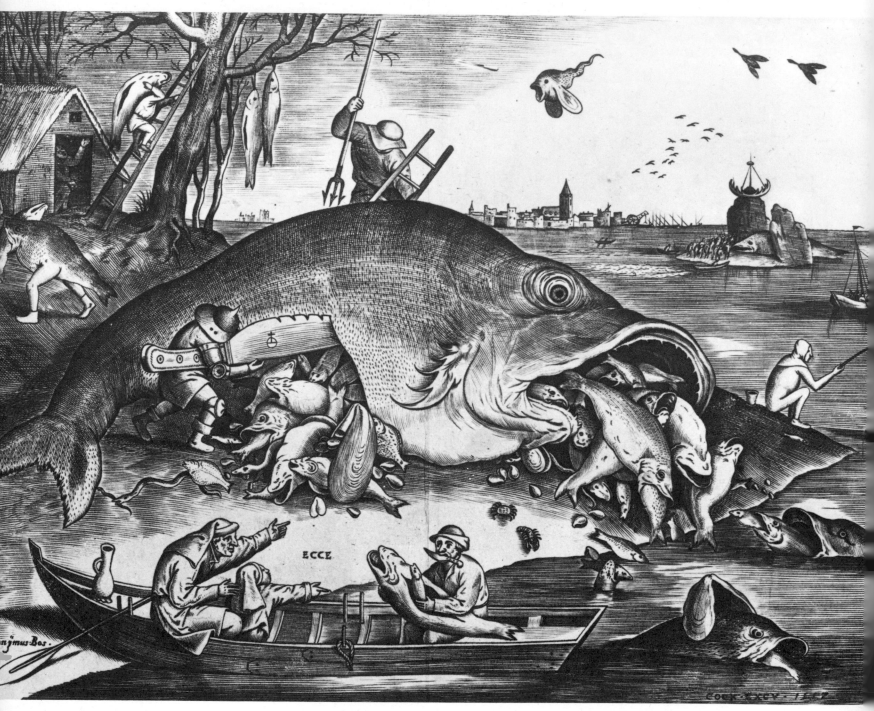

74 PIETER BREUGHEL after Hieronymus Bosch *Big Fish Devour Little Ones*

75, 76 Plates from
Pronosticatio by Paracelsus, 1536

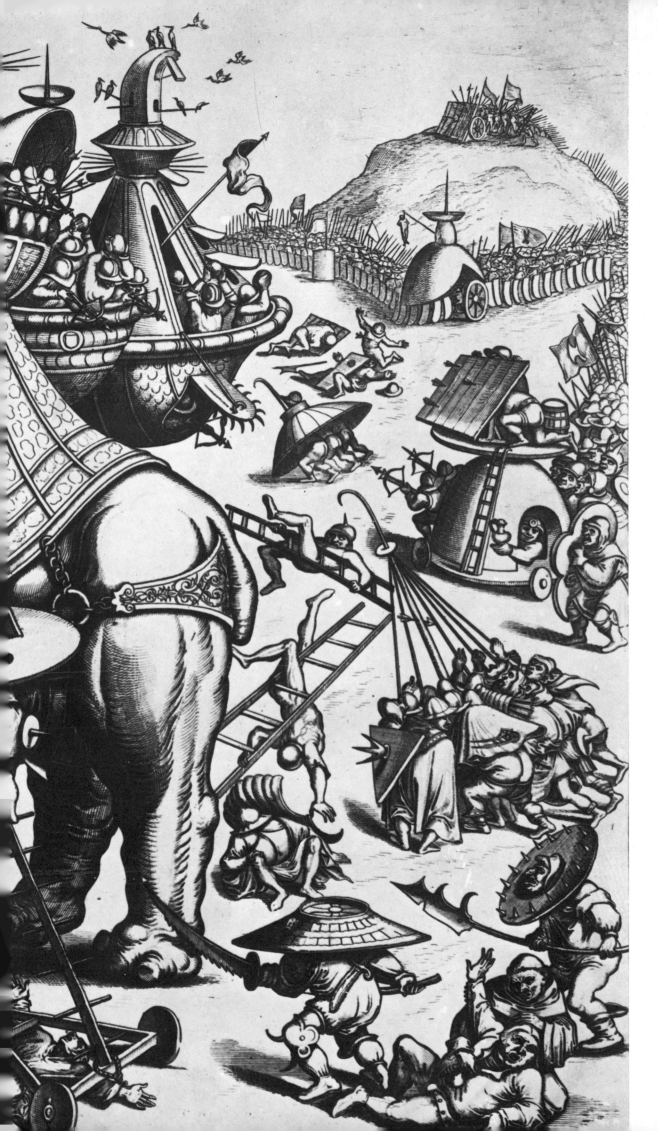

77 After HIERONYMUS BOSCH
The Besieged Elephant 1601

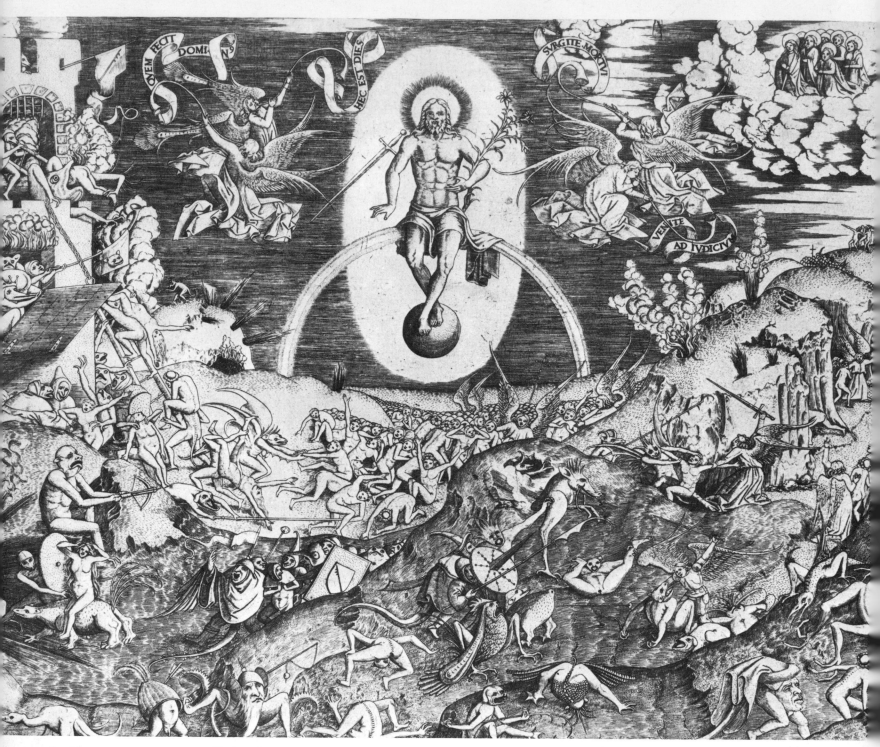

78 After HIERONYMUS BOSCH *The Last Judgment*

79 After HIERONYMUS BOSCH Panel from a triptych of *The Last Judgment*

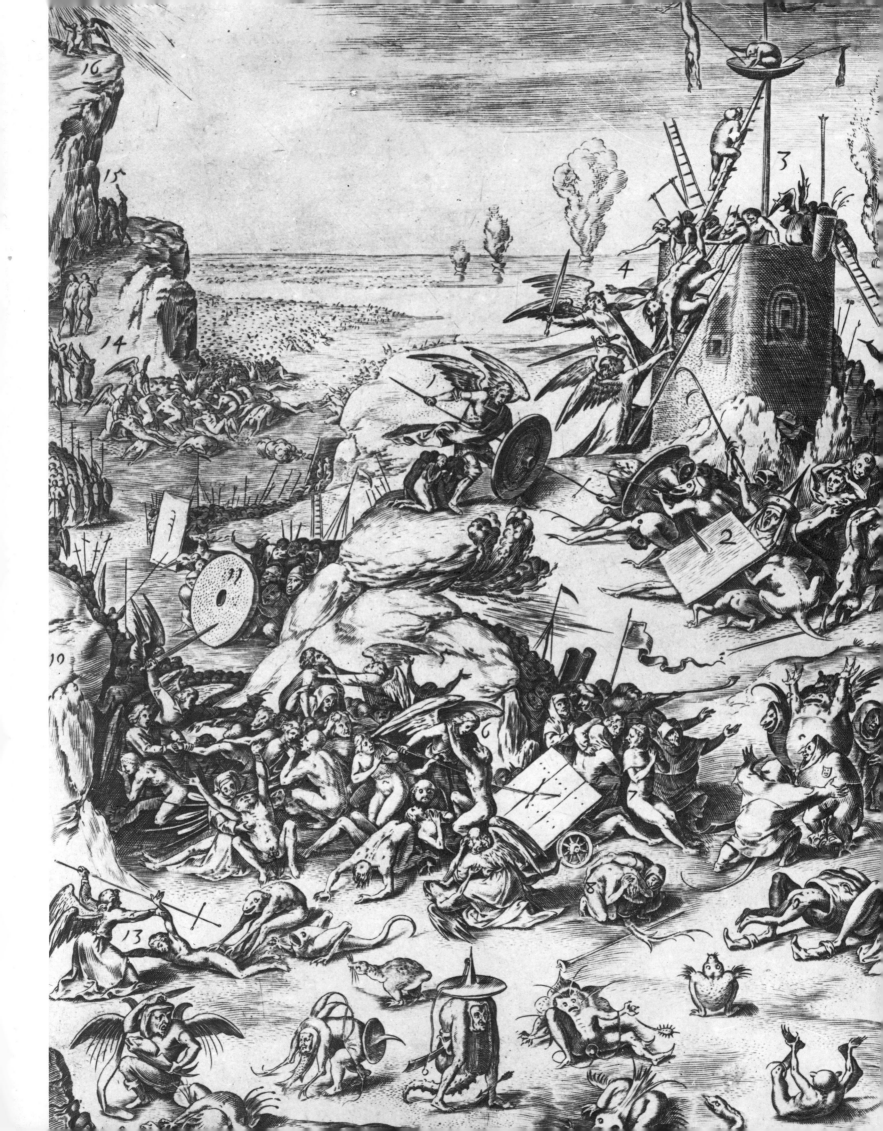

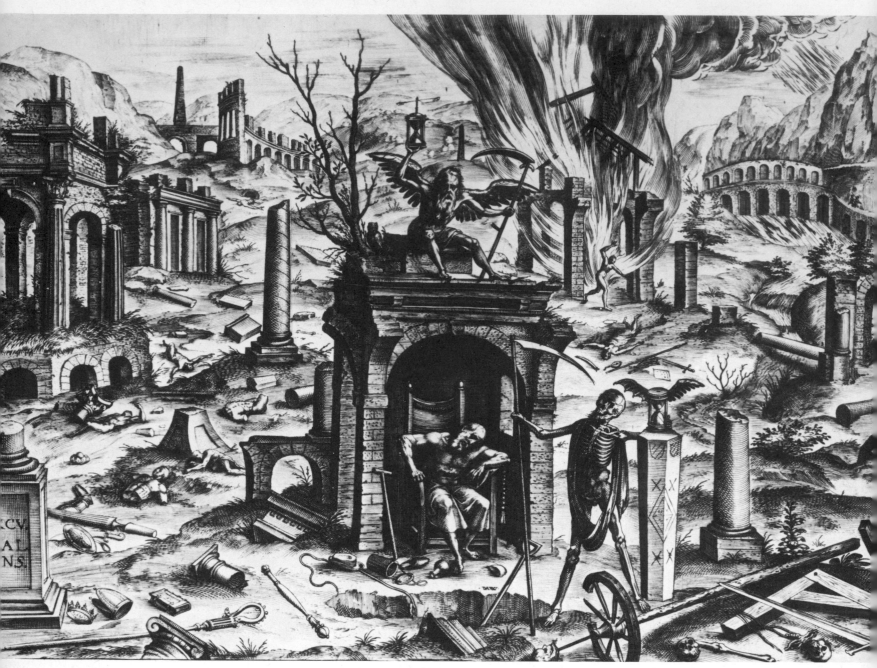

80 HANS VREDEMAN DE VRIES *Ruin 6,* 1600

81 HANS VREDEMAN DE VRIES Plate from *Wells and Perspectives*

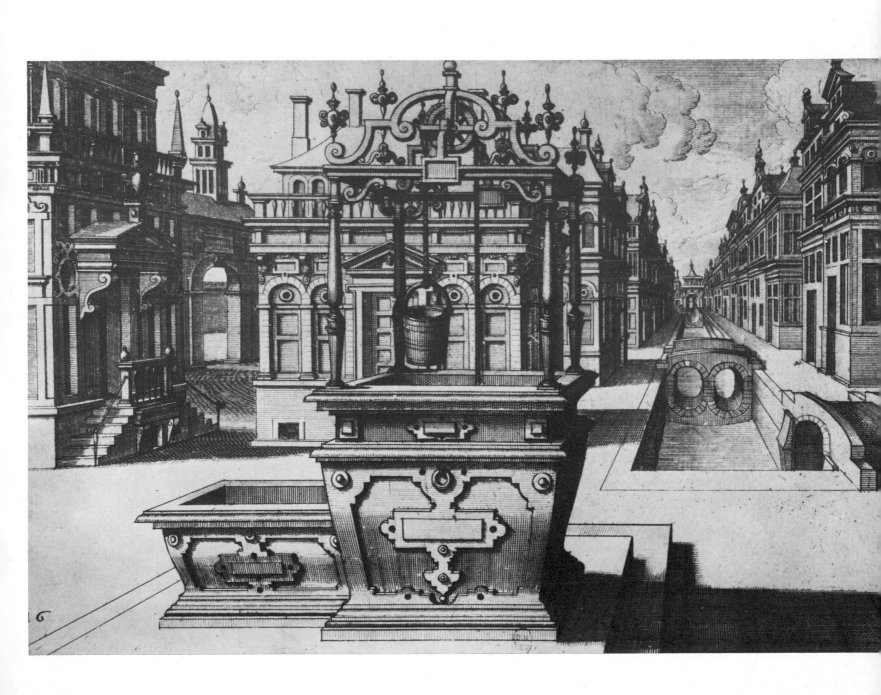

On ne sait comme entrer on veut,
Au trou de cil qui donner peut.

Souden wy niet lachen om dit bedryuen,
Datmen dese groote lobben dus moet styuen?

Ba laetse begaen wy willense beloonen,
En haer met desen lobbe cranse croonen,

83　Flemish engraving. Late sixteenth century

II THE SEVENTEENTH CENTURY

Seventeenth-century prints reiterate a number of themes which were popular in the sixteenth. Yet even where the resemblances are closest, as for example with illustrations to medical treatises and books on anatomy (*pls. 108, 109*), we are aware of the changed sensibility of the age. The images form a contrast with those taken from earlier books of the same kind, but in different ways. The dissection of a pregnant woman is more human, and therefore in a sense more tragic than its predecessors. *Pl. 109*, on the other hand, desecrates the human body in a way that Vesalius does not, and seems to symbolize a more extreme degree of curiosity about the physical mechanism.

It is equally instructive to compare a series of early seventeenth-century perspective designs (*pls. 93–6*) with those of Lorenz Stoër (*pls. 17, 18*) of a century earlier. Stoër's fantasies are cluttered and airless, but Hans Vredeman de Vries impresses us with his glacial purity, and also by the flow of space within his architectural compositions.

But new ideas are not slow to announce themselves. The version of *The Temptation of St Anthony* given us by Callot (*pl. 97*) makes a striking contrast with that given by Martin Schongauer (*pl. 2*). Callot relies for his effect on the infinite sweep of space – the personages and their actions are diminished by the immensity of the setting.

The emphasis on spatial contrasts and spatial interplay continues throughout the century – it is one of the hallmarks of the Baroque. Baroque stage design, in particular, came to have an important influence on printmakers. Many prints, indeed, are actual representations of the elaborate theatrical decors of the time (*pl. 114*). Closely related to these are the prints which record extravagant schemes of interior decoration, such as the canopied bed which appears in *pl. 118* – a monument to princely luxury and conspicuous consumption.

But it is not merely physical space which dominates seventeenth-century composition, there is also a fascination with what we may label metaphysical space – admirably represented here by some of the diagrams which strove to illustrate contemporary theological speculation. *The Creation of the World by the Trinity* (*pl. 99*) has a tremendous abstract grandeur.

For a glimpse of the profound resources of seventeenth-century spirituality, however, we must turn to Rembrandt's *Three Crosses* (*pl. 110*) and to his *Descent from the Cross* (*pl. 111*) and *Presentation in the Temple* (*pl. 112*). Each of these compositions is marked by a sense of brooding mystery which makes any attempt at commentary seem impertinent.

95

84 Plate from *Veridicus Christianus* by Father Jean David, Antwerp 1601.

The engravings of this theological work were done by Theodore Galle (1571–1633) of Antwerp, the son of Philippe Galle.

The plate illustrated is found in the chapter which warns against the glance of temptation. The author traces the history of the catastrophes caused by one glance too many: Eve led into temptation, David watching Bathsheba at her toilet, Dina abducted by Sichem, Lot's wife turned into a pillar of salt.

The man in the form of a house is a conceit which we have already seen in Breughel (*pl. 70*), and recurs throughout the fantastic tradition from Bracelli to Niki de Saint-Phalle. It illustrates literally the phrase: 'Death enters by the eyes, the windows of the soul.'

85–8 CHRISTOPH JAMNITZER (1563–1618). Series of arabesque figures and other ornaments 1600.

A goldsmith and engraver, the grandson of Wenzel Jamnitzer who was the most famous of German goldsmiths, and the son of the Mannerist Hans Jamnitzer, Christoph Jamnitzer was influenced by Italian art and worked for Rudolf II.

This series consists of three books of twenty-one plates representing fights between hybrid figures based on assemblages of objects which are reminiscent of Desprez (*pls. 59–67*), but even more strongly suggest the figures of Jacques Callot (*pl. 97*) and Grandville (*pl. 183*). Despite these references, Jamnitzer has a highly personal style. His taste for tortuous arabesques and calligraphic exaggeration link his work with Mannerism.

89 JACQUES BELLANGE (1594–1638). *The Holy Women at the Sepulchre*, c. 1620.

A painter, draughtsman and engraver from Lorraine, Bellange was one of the chief representatives of Mannerism in France.

This engraving is characteristic of the style: the graceful elongation of the women, the extravagant elegance of their attire, the ambiguous femininity of the angel are all out of keeping with the gravity of the theme of the Holy Women finding Christ's tomb empty. Yet there is no doubt of the artist's religious sincerity.

90, 91 ROBERT BOISSARD (born 1570?)

In the last plate of the first series of *Recueil de mascarades* of 1597 (*pl. 90*), Death accosts an elegant woman, wearing a carnival costume like his victim (*see also pl. 57*). A Latin couplet beneath the engraving warns us that by wasting out time in pleasures we risk not being ready when our time comes.

Boissard also treated classical subjects, as in his *Nymphaeum* (*pl. 91*) showing a group of nymphs at their toilet, which can also be regarded as depicting eight contemporary beauties. The pose of the young woman stretching out a cloth in front of the window is curiously reminiscent of Dürer's *Great Fortune* (*pl. 9*), but the torso is more elongated, the legs and arms longer and slimmer and the head much smaller.

92 DIRK VOLKERTSZ COORNHERT (1522–90). *Gallery of Antiques*.

A draughtsman, engraver and writer, Coornhert settled in Haarlem, whence he had been driven by anti-protestant persecution. He wrote a number of theological works and was a friend of Frans Floris and of Marten van Heemskerck, producing many engravings after the latter.

The engraving shown here undoubtedly follows Van Heemskerck (1498–1574), both in style and in its classical inspiration. Van Heemskerck spread the knowledge of Roman antiquities and contributed much to the popularization of the Italian style in the North.

The style is very classical, but not without a certain feeling of mystery and fantasy. The statues seem about to come to life, and details such as the lantern and the grating in the floor provide a subtle impetus to the imagination.

93–6 HANS VREDEMAN DE VRIES (1527–1604/23). Plates from *Opera mathematica*, 1614, dealing with perspective geometry, architecture and fortifications by Samuel Marolais, with the addition of de Vries' work on architectural perspective.

The perspective drawings are the illustrations to an entirely technical text, and have the cold, clinical beauty of working diagrams (*see also pl. 79*).

97 JACQUES CALLOT (1592–1635). *The Temptation of St Anthony*, 1617.

Born in Nancy, Callot was drawn to Italy when he was still a child. He learned etching from Cantagallina at the age of twelve, then worked for Giulio Parisi. Having been a protégé of Cosimo II de' Medici, he returned to France on the latter's death in 1621, going first to Nancy, then after an interlude in Brussels, to Paris, finally returning to Nancy where he died. Such are the somewhat arbitrary divisions which his travels imposed on his career. In 1633, shortly before his death, he produced his most important work, *Miseries of War*, which prefigures Goya.

The Temptation of St Anthony was produced in Florence, during the first phase of Callot's career in which his style was establishing itself and during which he enriched the technique of etching by a historic innovation. This was the substitution of a hard varnish for the soft varnish used previously, which produced a cleaner and sharper line.

The idea for the *Temptation* was no doubt inspired by the interludes which he engraved for a play by Andrea Salvadori, particularly the second, in which he had shown Hell taking up arms to avenge Circe. Here, indeed, it is Hell in its entirety which has turned out to tempt the saint, and one has some difficulty in finding him, tucked into a corner on the right of the engraving. In this, Callot follows the tradition of Bosch and Breughel, and he reproduces many of their monsters, but the scene is treated like an opera. Satan vomits out a cloud of miniature devils, suspended as if over a stage, and details such as the gaping-jawed monster serving as a ferry contribute to an impression of comedy and burlesque (Victor Hugo called Callot 'the Michelangelo of burlesque').

At the end of his life, in Nancy, he returned to this subject and produced another engraving which has many elements in common with this one, but is more intense and concentrated.

97

98, 99 JOHANN-THEODORE DE BRY (1561–1623). Plates from *Utriusque cosmi maioris scilicet et minoris metaphysica, physica atque technica historia* by Robert Fludd, Openheim 1617.

The title page (*pl. 98*) has a curious little figure with the feet of a goat, who is both Time and Destiny, unravelling the universe like an immense ball of wool. The wheel contains a series of inscribed circles which represent the macrocosm, the universe, and the microcosm – man. It illustrates the doctrine of Paracelsus which draws parallels between the outside world and the different parts of the human organism (the heart corresponds to the sun, for instance, and the brain to the moon). The four smallest circles contain the four humours: choleric, sanguine, phlegmatic and melancholic.

The Creation of the World by the Trinity (*pl. 99*) has been most completely explained by Grillot de Givry (in *Witchcraft, Magic and Alchemy*, London 1931):

A cloud representing the Father, the first person of the Divinity whose essence remains hidden, sends forth the Word, represented by the word 'Fiat', as the expression of the creative will; and the dove of the Holy Spirit, proceeding from these two hypostases, takes flight like a breath, which is that of the Ruah Elohim, and circles round the cosmos, inscribing it in a band of light composed of innumerable rays, marking off the infinite space of darkness.

100–5 GIOVANNI BATTISTA BRACELLI (active 1624–9). Plates from *Bizzarerie*, Florence 1644.

Nothing is known of the artist except that he published another series of musicians in the style of Callot, and an engraving of Bernini's *baldacchino* at St Peter's, Rome.

This series of bizarreries consists of forty-eight plates which he dedicated to Duke Pietro de' Medici, all of them extravagantly fantastic compositions. The best known are that of the anthropomorphized port of Livorno (Leghorn), and the galley made up of female bodies.

Even more than Schoen (*pl. 58*), Bracelli gives us a foretaste of surrealism, eventually attracting the attention of Tristan Tzara who published a study of him ('Propos sur Bracelli' in *Bizzarie di varie figure*, facsimile edition of 1624, Paris 1963) with the following comments:

'In the tradition of Arcimboldo and his school, the development or proliferation of shapes and images takes place systematically, i.e. in a given direction, the heterogeneity of the elements used being subordinated to a unification of the line of thought. It is this thread of particularly rigorous systematization in Bracelli's work which forms a link between him and surrealism.' Tzara goes on to remark that his work shows a child-like taste for make-believe; these figures made of wire, springs and bolts act as though they were experiencing feelings of happiness, anger and cupidity (note the reference to the story of the Golden Fleece in *pl. 105*), and, similarly, the flayed figures and skeletons go about their daily occupations – a whole race of dancers, acrobats, gymnasts, wrestlers, illusionists and jugglers showing off their talents to the reader. We cannot fail to note the humour of these compositions; Tzara rejects the comparison with cubism, which is primarily concerned with the exploration of space, while here we are on the level of illustration and imagination.

One finds a similar kind of wit and humour in the work of the sculptor Alexander Calder.

106, 107 *Domesticated Man* and *Domesticated Woman*. French, seventeenth century.

This is an amusing satire on the effects of marriage, on the principle of the composite heads produced by Arcimboldo.

108 Plate from *De formatio fœtu liber singularis* by Adrien van der Spieghel, Pavia 1626.

Spieghel succeeded Julius Casserius (see *pl. 109*) to the chair of medicine at Padua in 1616, and died less than ten years later. This plate is part of a series of nine which in fact originated with Casserius but were added by Spieghel's executor, Daniel Bucretius, to a selection of posthumous works, titled as above. They are rightly celebrated. It is likely that they were drawn by Edoardo Fialetti and engraved by Francesco Valesio, like the plates of the *Tabulae* (*pl. 109*).

109 Plate from *Tabulae anatomicae . . . LXXIIX . . . Daniel Bucretius XX que deerant supplerit et omnium explicationes addidit*, Venice 1627.

The great anatomist Julius Casserius occupied the chair of medicine at Padua from 1606 to 1616. He worked all his life on his *Theatrum anatomicum*, for which Edoardo Fialetti drew the plates, which were engraved by Francesco Valesio. But the work was never finished and the plates were used by Daniel Bucretius, the executor of Casserius' successor Adrien van der Spieghel (*pl. 108*). Bucretius supplemented the twenty-seven plates which he obtained from Casserius' heirs with twenty others, five of which were taken from Vesalius, and entitled the whole collection *Tabulae . . . etc.* He used it to accompany Van der Spieghel's posthumous work *De humani corporis* which had no original illustrations.

These plates and those of *De formatio fœtu* were later collected together in the complete works of Van der Spieghel which appeared in Amsterdam in 1643. (See André Hahn and Paul Dumaître, *Histoire de la médicine et du livre médical*, Paris 1962.) They marked a new era in the history of medical book illustration, and were to become as famous as Vesalius' work had been for its wood engravings.

110–12 REMBRANDT VAN RYN (1606–69)

It was after he returned to Leyden around 1626 that Rembrandt began to produce engravings, and the date coincides with that of his first known paintings. The etchings of Jacques Callot had greatly influenced him when he was very young, and his first manner shows Callot's influence. He then took an interest in the technique of engraving and discovered the possibility of varying the quantities of acid and ink so as to obtain gradations of tone, and began to explore the role of light, which was to become his major preoccupation.

The Three Crosses (*pl. 110*) exists in two versions and in various states. It was the last time that Rembrandt tackled the subject of the Crucifixion. The first version is a kind of theatrical spectacle, with the three crosses illuminated as if by spotlights. It is more anecdotal than the version shown here (dating from after 1653), an illustration of the description in Matthew: 'there was darkness over all the land . . .' and 'the earth did quake, and the rocks rent'.

The Descent from the Cross: by Torchlight of 1654 (*pl. 111*) comes from the Gospel according to St John, where Joseph of Arimathaea buries Christ with Nicodemus on the night preceding the Jewish sabbath.

Once more the scene is one of primordial gloom, split only by a shaft of light which descends from the cloth, envelops the body of the dead Christ, catches a raised hand and falls gently on the shroud beneath as if accompanying Christ to his resting place. The scene is less theatrical than the preceding one, but its intimate nature perhaps increases the impression of grief which emanates from it.

The Presentation in the Temple (*pl. 112*), a mezzotint, is very

characteristic. Using the light, the choice of moment and the attitudes of the characters Rembrandt creates an impression of mystery around this scene of the Presentation in the Temple, which is normally so banal. Rembrandt also produced another version. The high priest leans forward like some sacrificer or sorcerer, looking down at the child presented to him by Simeon, whose destiny he foresees. The scene has an atmosphere of ritual and mystery, with the dark shadows throwing into relief the shining richness of the priestly robes.

113 Plate from *Le Temple des muses orné de XL tableaux où sont représentés les événements les plus remarquables de l'Antiquité fabuleuse*, Amsterdam 1733.
This work repeats the illustrations and even some of the text of the first version of the *Tableaux du temple des muses* 'taken from the chambers of the late M. Favereau, councillor to the king on his board of excise and engraved on copperplate with descriptions, remarks and annotation composed by Michel de Marolles, Abbé of Villeloin', published in Paris in 1655. The plates for the latter had been engraved by Nathan and Bloe after the drawings by Abraham van Diepenbeeck (1591–1675); they were both Baroque and Romantic in flavour. Those of the new version of 1733 were engraved by Bernard Picart (1673–1733). A pupil of Sebastian Le Clerc, he was one of the foremost exponents of Dutch engraving at the beginning of the eighteenth century, though greatly influenced by France.

Chaos, the plate illustrated, is described by Michel de Marolles as 'that which cannot have been', for the author of the drawing cares nothing for logic but 'has been content to lose himself in poetical imaginings which often resemble the dreams of a sick man. That is why, supposing that boundless darkness lies behind these clouds, he makes an agreeable jumble of water, fire, earth, smoke, winds and diverse constellations which he represents confusedly on separate parts of the zodiac, so that Aquarius sprinkles the celestial lion, although they are at present far apart, the Archer looses his bolts at the little twins, Capricorn fights against Cancer and Taurus against Scorpio, the Virgin tramples the fishes underfoot, the ram upsets Libra's scales, the Dog-star yaps at the Serpent, which threatens it with its venomous fangs, and the Bear tries to lodge itself in the sky, stars of the first magnitude are attached to rocks like shells beside the sea, others are in water and some in fire.'

114 ISRAEL SILVESTRE (1621–91). Theatre scene after a drawing by Giacomo Torelli de Frano for *Les Noces de Thétis*, Paris, 1654.
A painter and engraver and native of Nancy, Silvestre was a great admirer of Callot, whom he copied when very young in the establishment of his uncle Israel Henriet, who was Callot's publisher. Silvestre is well known for his illustrations of celebrations at the court of Louis XIV and his topographical views of Paris. He engraved the scenes for operas produced by Torelli, including *Les Noces de Thétis*, which was put on in the Salle du Petit-Bourbon at Versailles and dedicated to Cardinal Mazarin. The theatre and its scenery played a large part in the aesthetic view of the Mannerists, since it embodied their taste for illusionary, *trompe-l'œil* architecture, such as is shown here in this building lodged in the clouds.

115 *The Knight of the Culverin dancing with Monsieur Rigaudon.* Etching in the style of Jacques Callot.
This personification of the cannon (the culverin was a cannon with a long, tapering barrel) and the dance (the rigadoon was a seventeenth-century dance, perhaps named after its inventor, Rigauld), shows all the wit and lightness which is characteristic of Callot. The paradox of the subject itself, linking cannons and violins, war and dancing, is also typical of Callot. The engraving in any case bears witness to Callot's rapid success, of which plagiarism is the penalty.

116 After DAVID TENIERS THE YOUNGER (1610–97). *The Caterwaulers' Concert.*
Teniers the Younger was the son of Teniers the Elder and stepson of Jan 'Velvet' Brueghel. He is known for his paintings of war scenes and excelled particularly in pictures of sabbaths, alchemists, the Temptation of St Anthony and other hermits, and tavern scenes. He also made a speciality of representations of cats and monkeys in costume. Such is the subject here, and its satirical intention is obvious; like La Fontaine with his all too human animals, Teniers is commenting on their masters. The engraving was made from one of his paintings by Coryn Boel, who like Teniers lived in Brussels, and was one of his chief pupils.

117 *The Man in the Moon.* Seventeenth century.
Together with many others, this engraving was left to the British Museum by Sir David Salomons, the British railway magnate who had built up a collection of prints on means of transport. The character shown here is rising towards the heavens in a contraption which has something of the kite about it, and is powered by a team of birds. We are still in the realm of pure, poetic fantasy, far from the striking anticipations of Jules Verne.

118 PIETRO SANTO BARTOLI (1635–1700). *Bed made for the birth of the first child of Countess Colonna* in 1663. After G. P. Schor of Innsbruck (1615–74).
Schor decorated the halls of the Vatican and the Borghese and Colonna palaces in Rome, and also produced stage sets and designs for various buildings in Innsbruck. Bartoli was antiquarian to the Pope and to Queen Christine and worked a great deal in Rome, chiefly producing engravings after Raphael.

Mannerism yields to triumphant Baroque in this sea-shell bed, which suggests a design for a fountain rather than a piece of furniture, and in which the lightness of the motif contrasts with the heavy drapery.

119 CHARLES LEBRUN (1619–90). *The Fall of the Rebel Angels.* Engraved by Nicolas Loir.
Lebrun was not only official painter to Louis XIV, but also organizer and co-ordinator of all the royal works. He was the director of the French Academy of painting and sculpture and also collaborated in the creation of the Gobelins tapestry manufactory. Apart from his paintings, he was responsible for the Galerie d'Apollon in the Louvre and the Galerie des Glaces at Versailles. He was a protégé of Colbert, but did not get on so well with the latter's successor, Louvois.

This engraving is made from a sketch (to be found in the Louvre) for the ceiling of the old chapel at Versailles; it represents Satan dragging with him all the angels who have revolted against God as he falls from Heaven. Bolts of lightning send them on their way as they tumble in a mêlée of bodies and horrendous beasts. Jouin has shown that this was only a sixth of the original decoration.

The fact that the composition draws the eye towards the centre and above all the foreshortening of the bodies reminds one that this is part of a ceiling, and therefore designed to be seen from an unusual angle. Nicolas Loir (1624–79) was

Louis XIV's official engraver and an academician. He is chiefly known for religious or mythological subjects.

120 Plate from *China monumentis . . . illustrata* by Athanasius Kircher, Amsterdam 1667.
Athanasius Kircher (1602–80) was a Jesuit who was possessed of a universal curiosity. Born in Thuringia, a scholar and collector of curiosities, he took an interest in Egypt, in China, in the behaviour of light, in ciphers and anamorphic perspectives.

This work, in which he links the Chinese and Egyptian civilizations, owes more to fantasy than fact and is full of highly questionable information about their exotic populations.

This plate occurs in the chapter on Chinese gods and seems to contain a mixture of Cybele, Buddha and Vishnu. Its theme is the lotus, which generally blooms on the surface of stagnant waters (rather than in the middle of the sea) and thus symbolizes purity, since it is uncontaminated by the mud and foul waters of its environment.

It is linked not only with purity, but firmness (the rigid stem), prosperity (its luxuriant growth), numerous offspring (its abundant seeds), conjugal harmony (two flowers grow on the same stem), the past, present and future (it is found simultaneously in its three different states: bud, open flower, seed). All these combine to make it the emblem of wisdom.

121 Plate from *Mundus subterraneus in XII libros digestus* by Athanasius Kircher, Amsterdam 1664–5 (detail).
This is yet another of Kircher's 'scientific' works. The earth is seen in cross section, with the four winds blowing at the corners, and the outer surface covered by sea and mountains. In the centre, the fire at the heart of the globe reaches out towards underground water-courses, reminding one of the jagged suns to be found in the tapestries of Jean Lurçat.

122 HENRI PICQUOT (active *c.* 1640). *Brutish man, similar to the frog . . .*
A pupil of Simon Vouet, Picquot engraved religious subjects and genre scenes, chiefly from works by Chapron and Dorigny.

There is a foretaste of Grandville in this assembly of frogs, some holding forth while others dance in a ring in the background. It is difficult to see why this creature should be considered a symbol of all abominations.

The tone of the engraving is comic rather than moralizing, but perhaps this may have been the author's intention, and one should perhaps see it as a satire on some sermon of the time.

123 Frontispiece of *Anatomia reformata* by Thomas Bartholin, Leyden 1651.
This book by Thomas Bartholin is a new edition of *Institutiones Anatomicae* by his father Gaspar Bartholin.

The first re-publication, in 1645 and illustrated with plates

derived once again from Vesalius, was so successful that a third edition had to be brought out. The engraving shown here only makes its appearance in 1651, and is absent from earlier versions of the book.

The figure is simpler than the flayed forms which we have seen hitherto, and almost abstract in its composition; the head with its anguished expression gives a tragic and realistic impression which we have not found elsewhere.

124 SEBASTIEN LE CLERC (1673–1714). Plate from *Mémoires pour servir à l'histoire naturelle des animaux*, by 'MM. de l' Académie royale des sciences', Part I, 1671.
A French engraver and the son of a goldsmith, Le Clerc developed great facility very early on and produced a large number of works. He follows the tradition of the picturesque established by Jacques Callot, but it is perhaps unjust to describe him merely as a follower of the latter.

This rather personal engraving serves as a tail-piece to the description of the lioness. A skeleton is seated on an architectural bracket between a couple of apothecary's flasks. One foot is resting on a trophy composed of bucranes and surgical instruments. Two cupids, whose chubby flesh contrasts with the skeleton, stretch out a piece of drapery behind him with obvious signs of alarm, while two skeletons of deer, their antlered heads hanging pathetically over the edge, complete the symmetry of the composition. Le Clerc had done a previous design for this engraving, drawn in sanguine, with a few variants: the cupids were in the air, and carried an animal skin.

125–8 NICOLAS DE LARMESSIN (1640–1725). Plates from *Costumes grotesques*, La Pomme d'Or, 1695. *Mason*, *Turner*, *Cooper* and *Potter*.
There is considerable doubt as to which of the three Nicolas de Larmessins who engraved between 1650 and 1755 should be credited with this series of engravings.

Roger Armand Weigert (in 'Sur les Larmessin et les costumes grotesques', *Nouvelles de l'Estampe*, Paris 1969, No. 4) attributes them to the second Nicolas, the younger brother of the proprietor of La Pomme d'Or, who died in 1694. There were originally seventy-seven plates, to which the widow of the first Nicolas Larmessin added a further twelve.

Adopting the principle of Arcimboldo's composite heads, Larmessin applies it systematically to different trades and professions, but, unlike Bracelli's designs (*pls. 100–5*), once one has got over the surprise caused by the graphic effect, the image remains a very rational one. It even has a certain documentary value, informing us about the tools used at the time, almost a century before the plates of the *Encyclopedia*. The series was a great success; it was imitated in Germany and reprinted in the eighteenth century by Gabriel Huquier.

The same principle can be found in some modern pictures. In *The Game of Tennis* by the Futurist Carlo Carrà, the head of the female player is formed by a tennis racket.

Plates 84–128

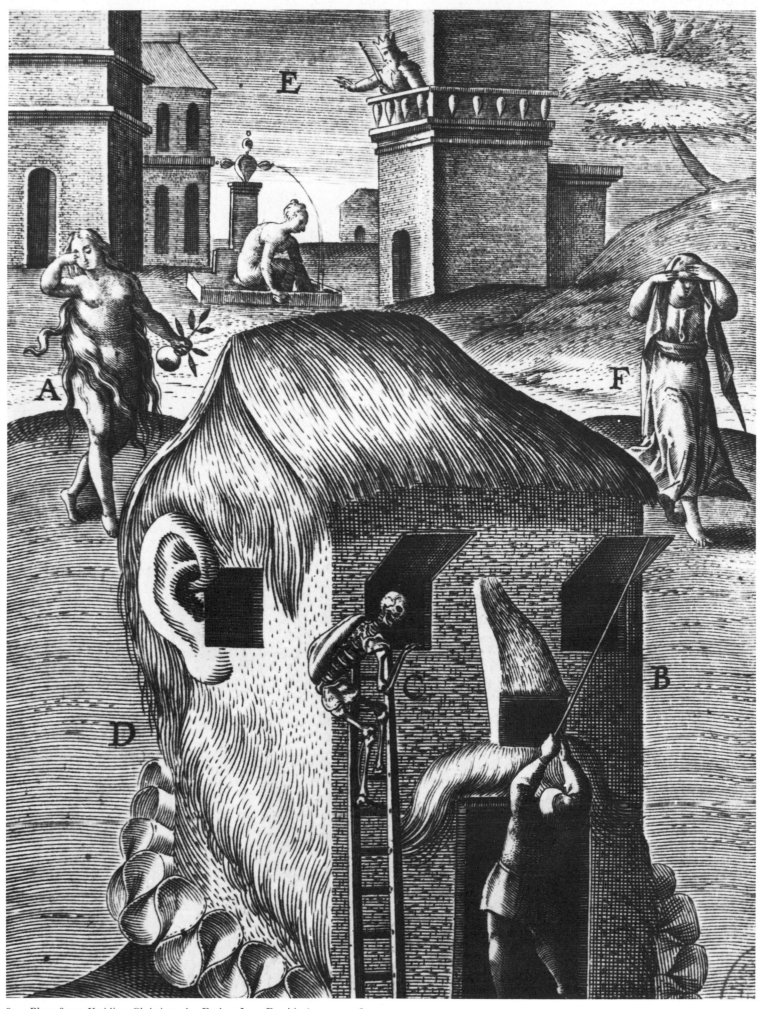

84 Plate from *Veridicus Christianus* by Father Jean David, Antwerp 1601

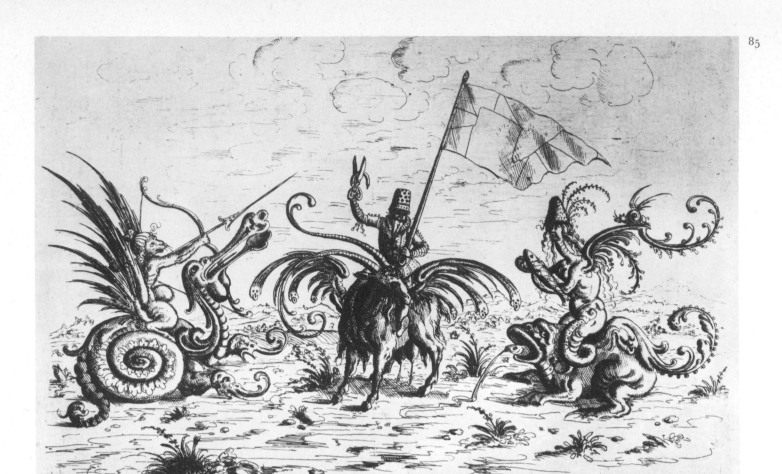

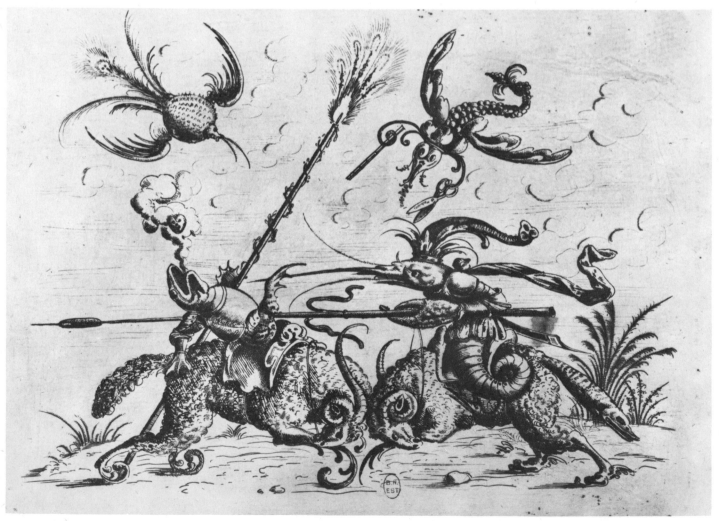

85–8 CHRISTOPH JAMNITZER Series of arabesque figures and other ornaments, 1600.

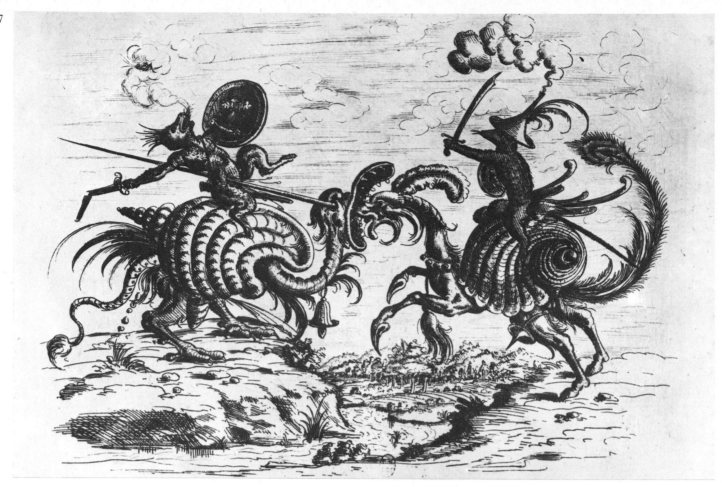

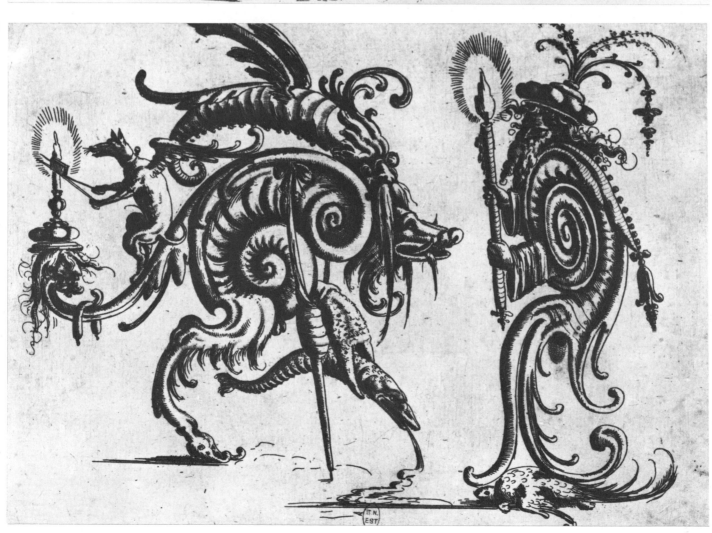

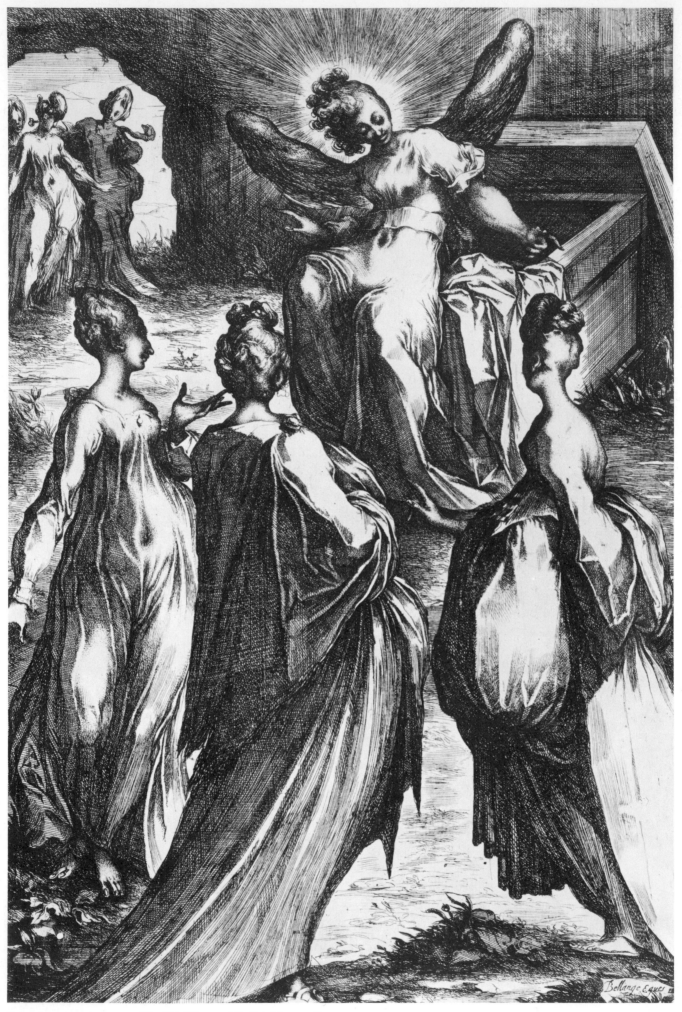

89 JACQUES BELLANGE *The Holy Women at the Sepulchre, c.* 1620

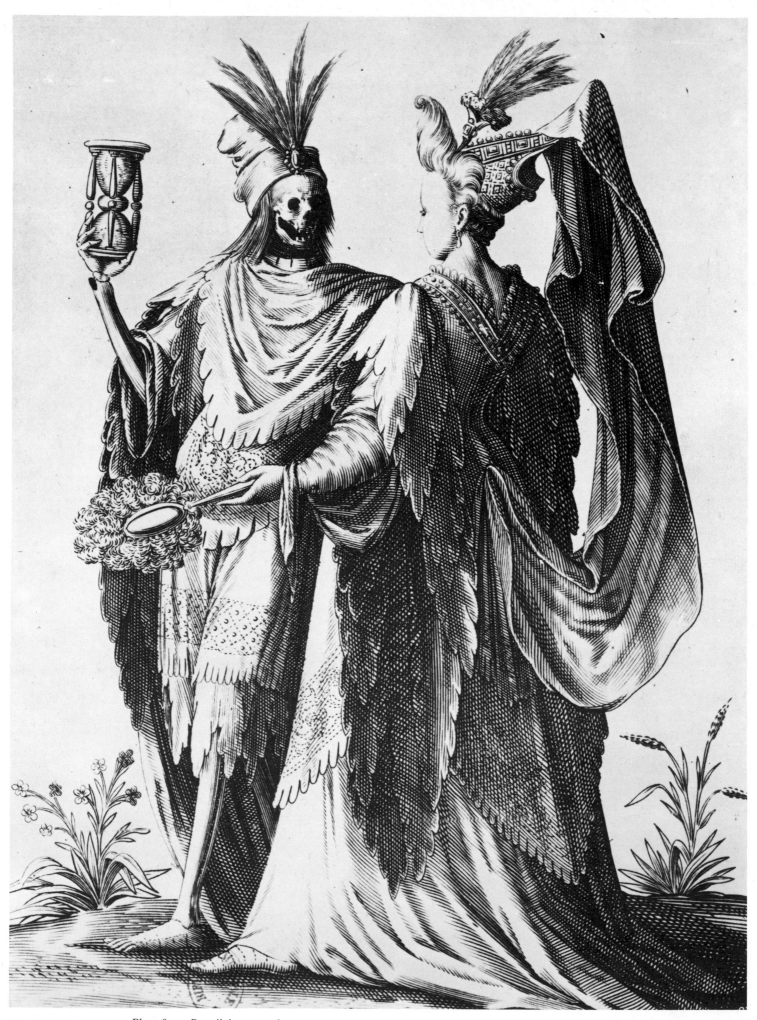

90 ROBERT BOISSARD Plate from *Recueil de mascarades*, 1597

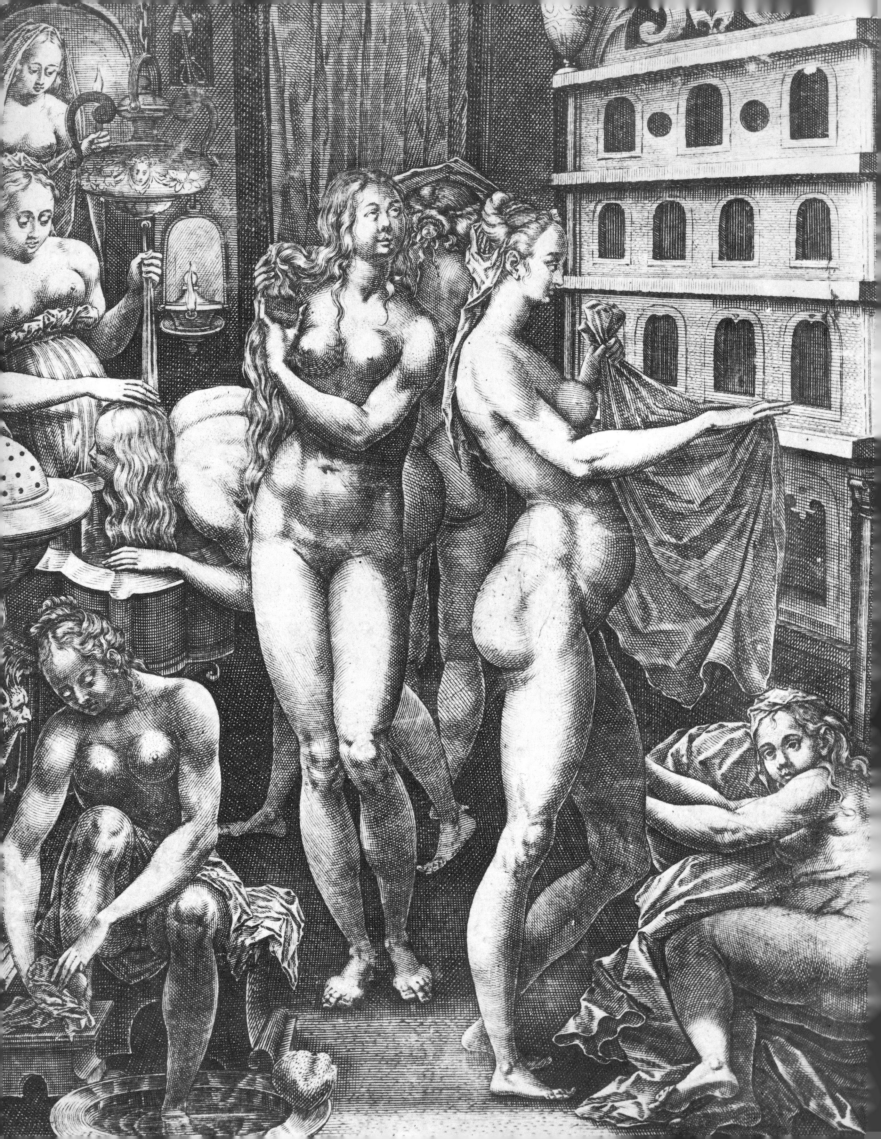

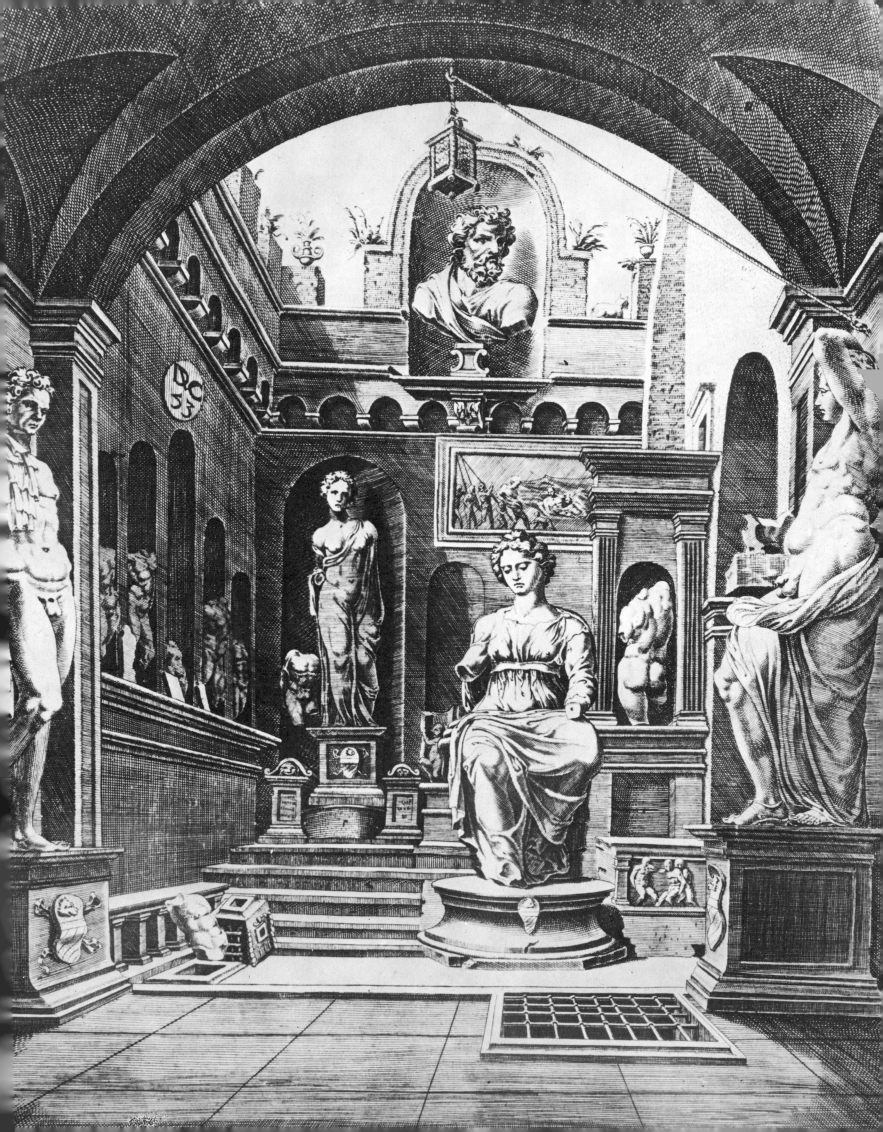

Overleaf
91 ROBERT BOISSARD
Nymphaeum

92 DIRK VOLKERTSZ
COORNHERT *Gallery of Antiques*

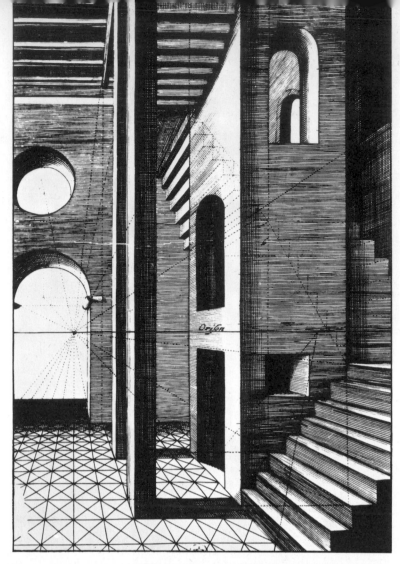

93–6 HANS VREDEMAN DE
VRIES Plates from *Opera
mathematica*, 1614

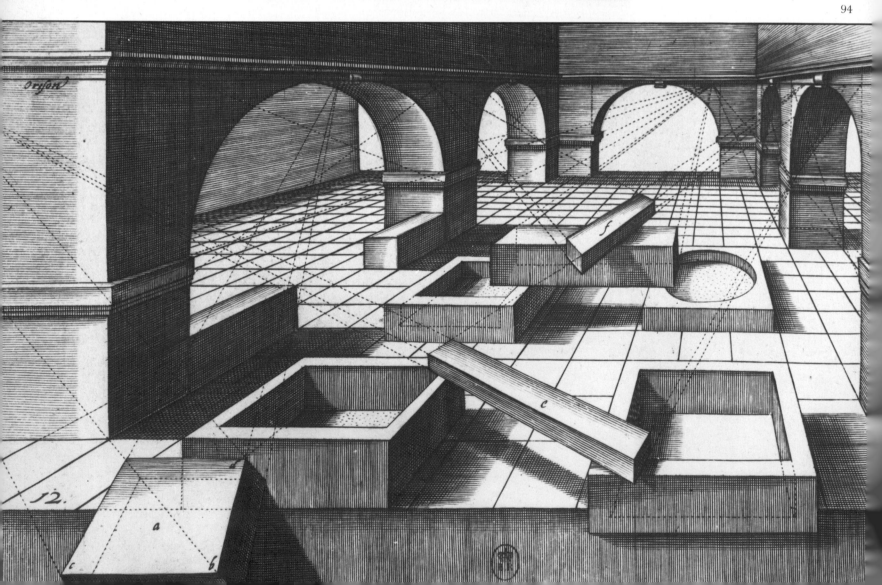

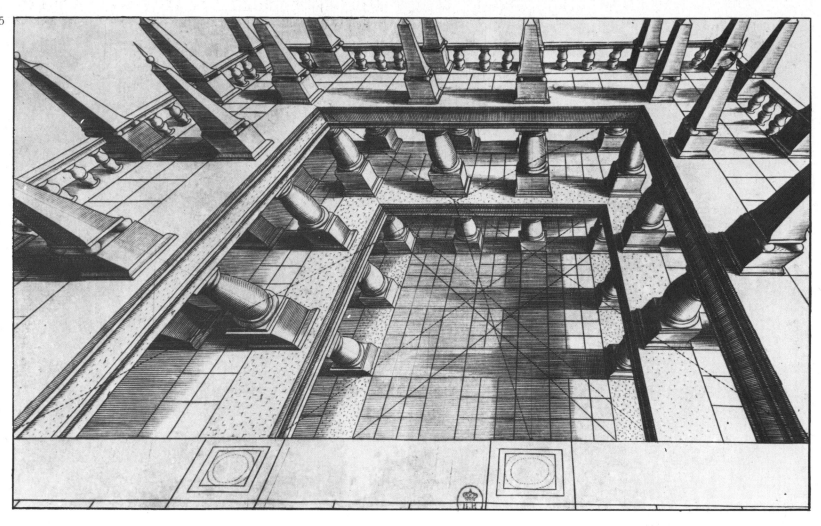

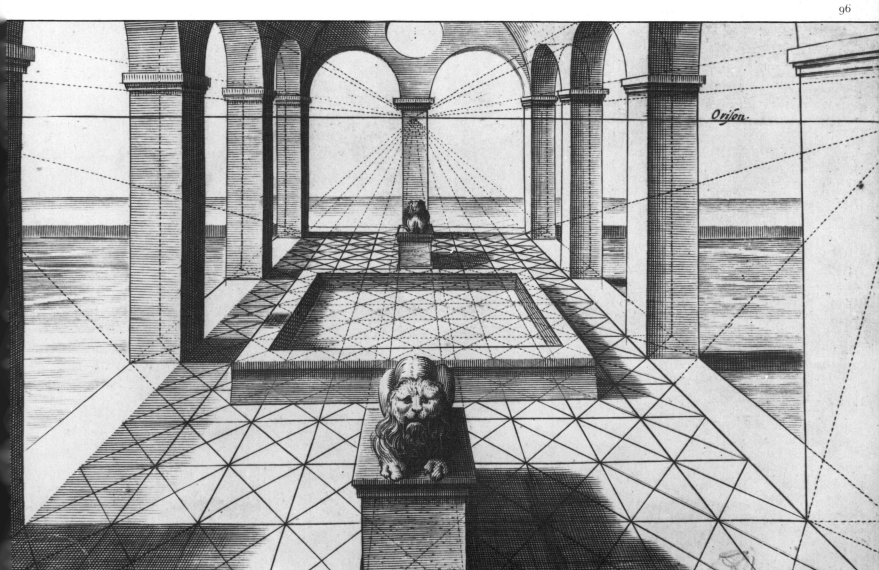

Orison.

97 JACQUES CALLOT *The Temptation of St Anthony* 1617

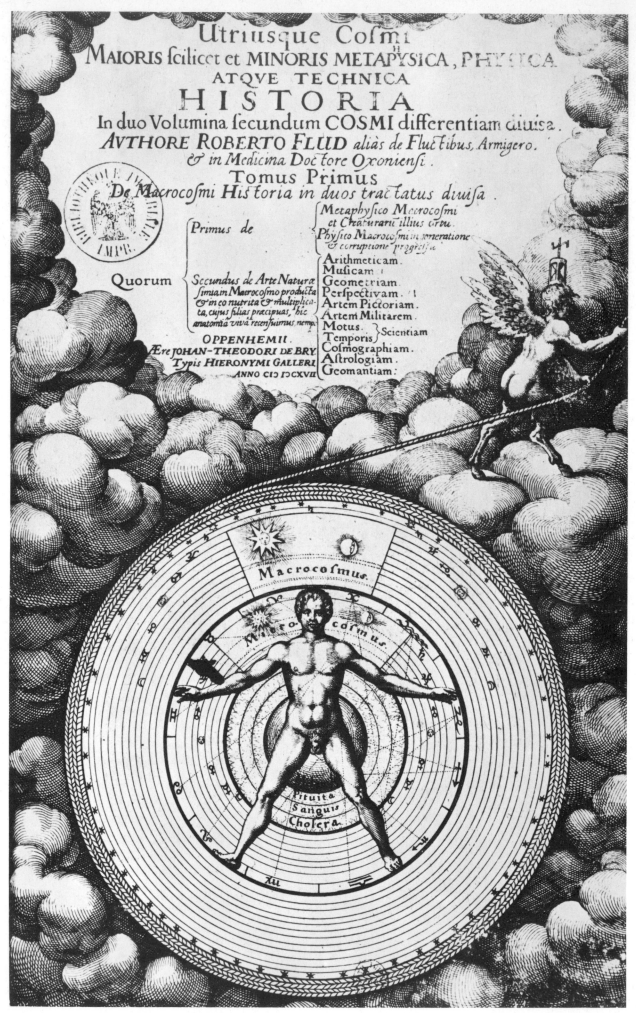

FIAT

98, 99 JOHANN-THEODORE DE BRY Title-page and *The Creation of the World by the Trinity* from *Utriusque cosmi maioris scilicet et minoris metaphysica, physica atque technica historia* by Robert Fludd, 1617

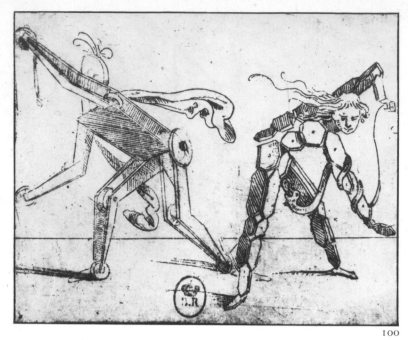

100

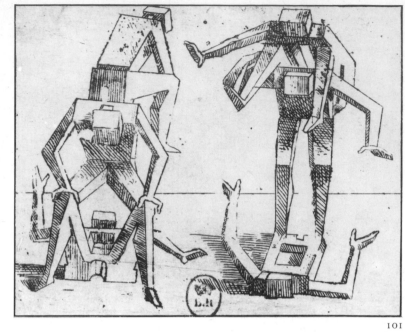

101

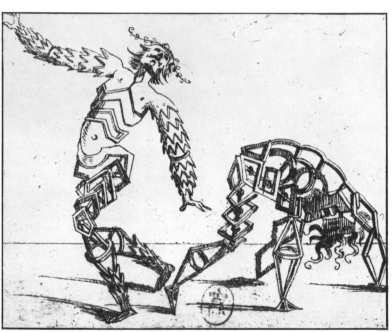

102

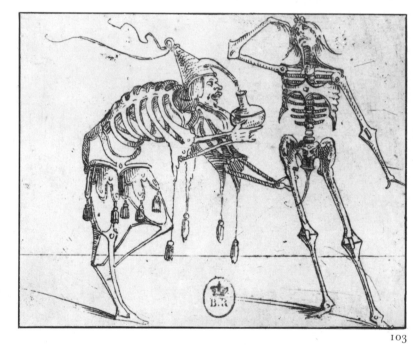

103

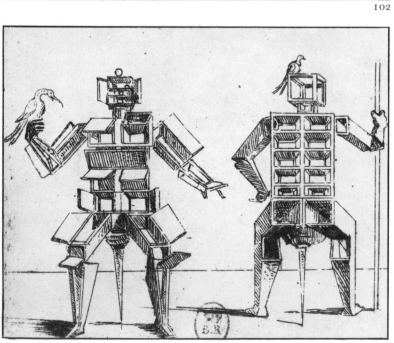

104

105

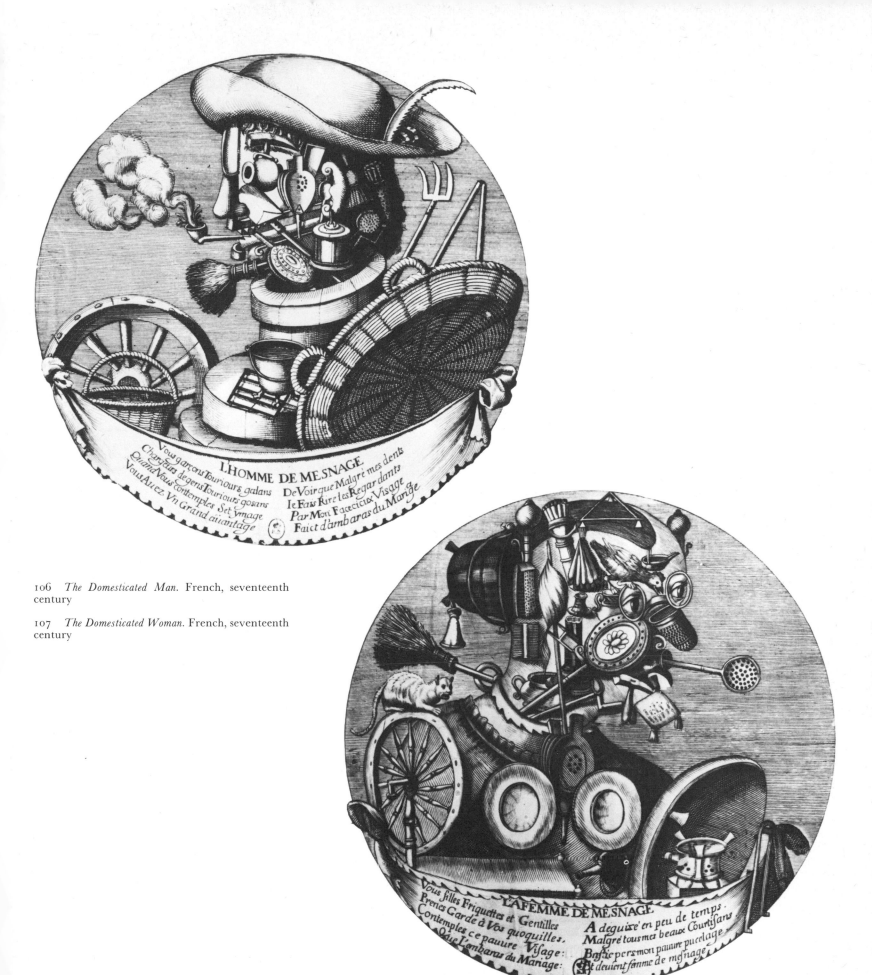

LHOMME DE MESNAGE

Vous garçons Touriours galans
Charmeurs de gens Touriours gosans
Quand Vous Contemples Set Vinage
Vous Auez Vn Grand auantage

De Voir que Malgré mes dents
Ie Fais Rire les Regardans
Par Mon Facecieux Visage
Faict d'ambaras du Mariage

106 *The Domesticated Man*. French, seventeenth century

107 *The Domesticated Woman*. French, seventeenth century

LA FEMME DE MESNAGE

Vous filles Friquettes et Gentilles
Prenes Garde à Vos quoquilles.
Contemples ce pauure Visage:
Que L'ombaras du Mariage:

A deguixé en peu de temps.
Malgré tous mes beaux Courtisans
Brise per mon pauure pucelage
Et deuient femme de mesnage.

Opposite
100–5 GIOVANNI BATTISTA BRACELLI Plates from *Bizarrerie*, 1644

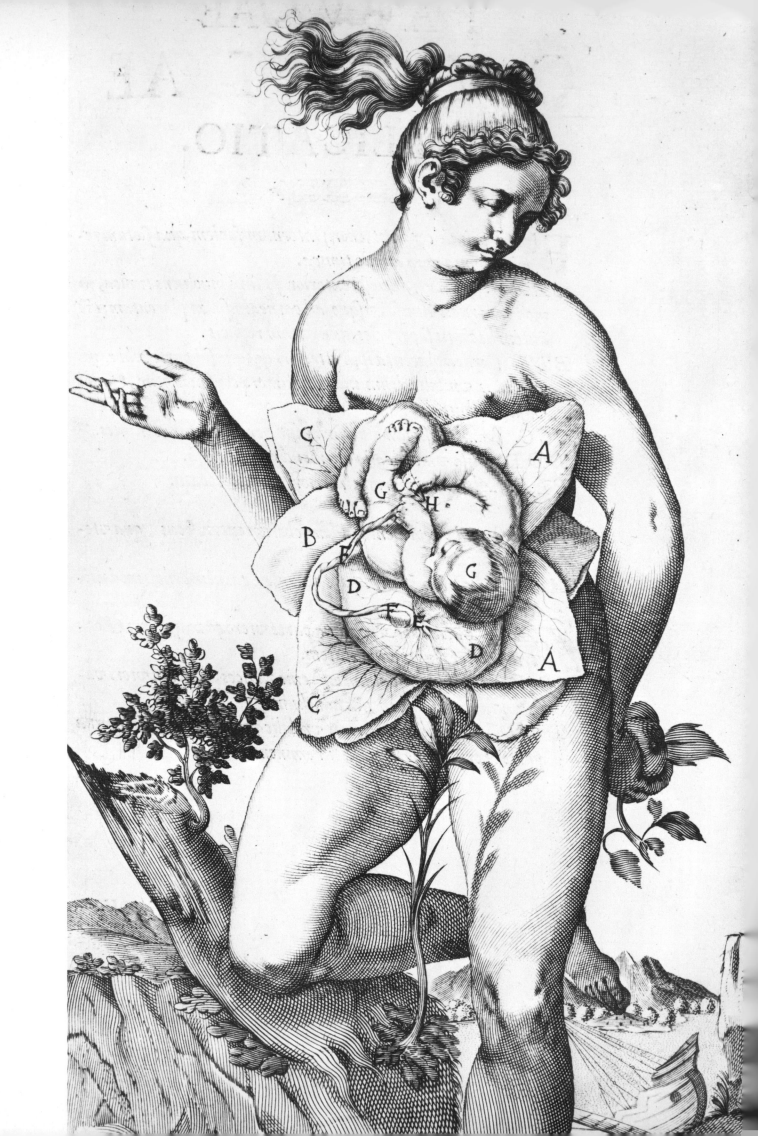

108 Plate from *De formatio fœtu liber singularis* by Adrian van der Spieghel, 1626

109 Plate from *Tabulae anatomicae . . . LXXIIX . . . Daniel Bucretius XX que deerant supplerit et omnium explicationes addidit*, 1627

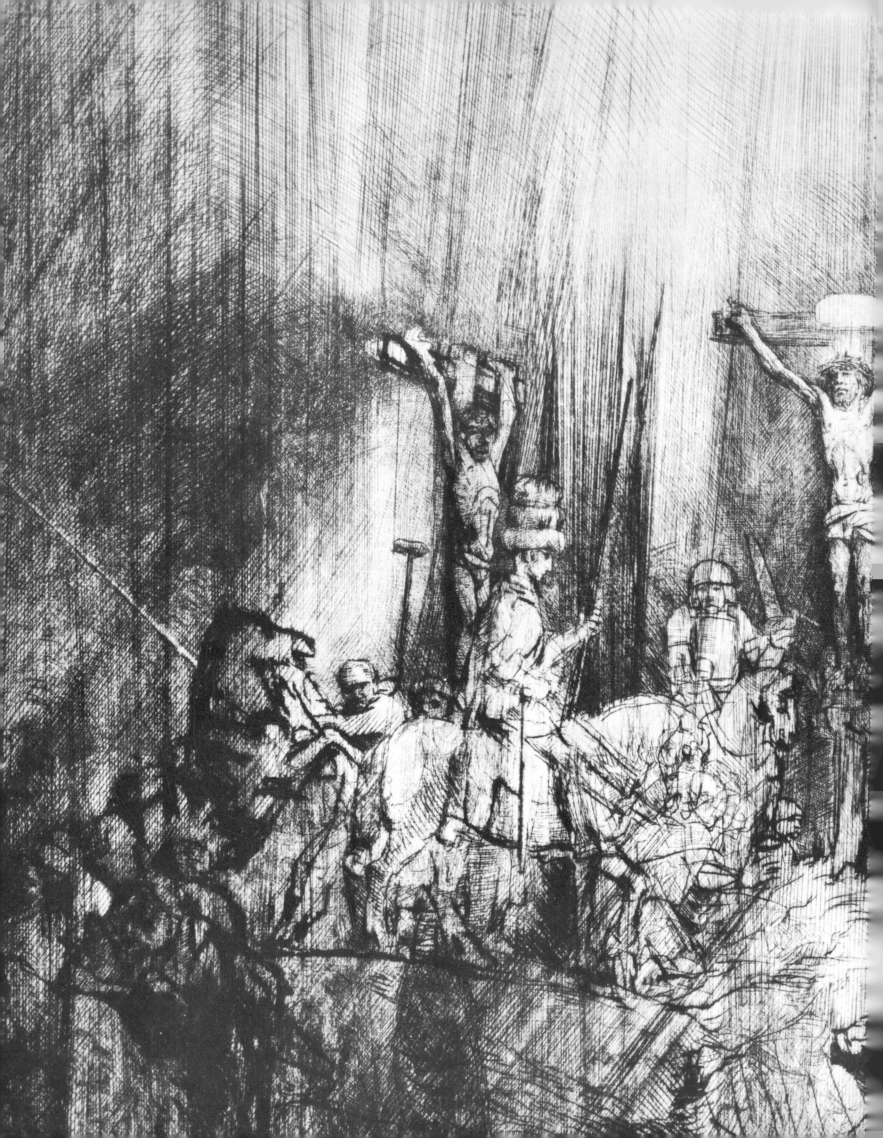

110 REMBRANDT *The Three Crosses*. After 1653

Overleaf
111 REMBRANDT *The Descent from the Cross: by Torchlight* 1654

112 REMBRANDT *The Presentation in the Temple*

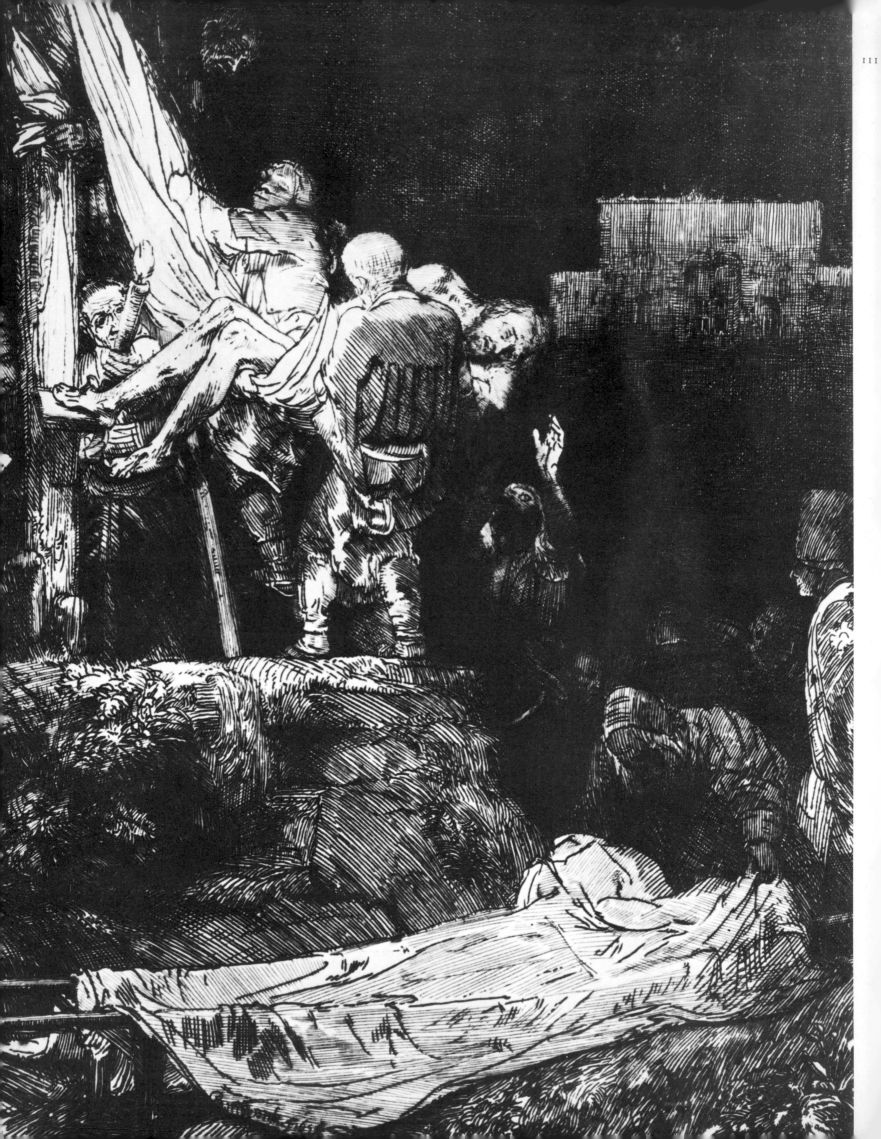

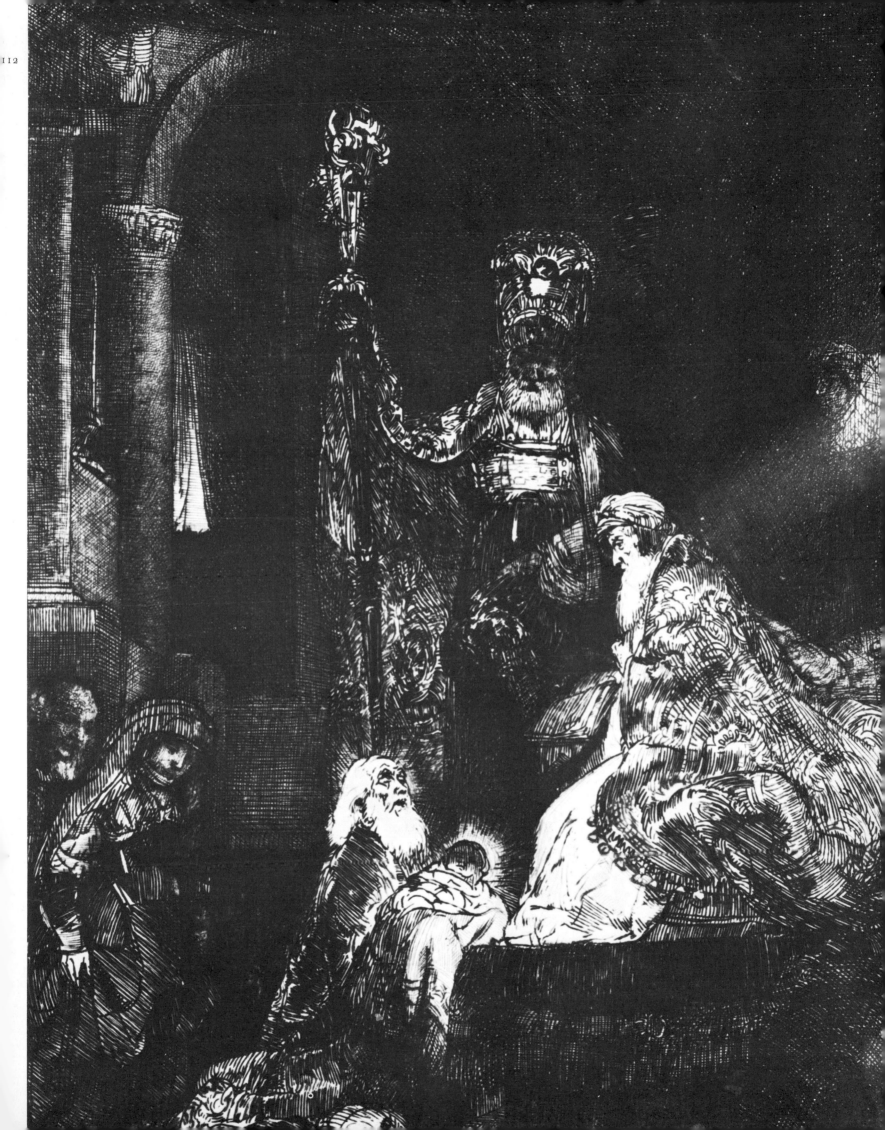

114 ISRAEL SILVESTRE Theatre scene after a drawing by Giacomo Torelli
de Fano for *Les Noces de Thétis*, 1654

113 Plate entitled *Chaos* from *Le Temple des muses orné de XL tableaux où sont
représentés les événements les plus remarquables de l'Antiquité fabuleuse*, 1733

115 *The Knight of the Culverin dancing with Monsieur Rigaudon.* French, seventeenth century, style of Jacques Callot

116 After DAVID TENIERS THE YOUNGER
The Caterwaulers' Concert

L'HOMME
DANS
LA LVNE

120 Plate from *China monumentis . . . illustrata* by Athanasius Kircher, 1667

121 Plate from *Mundus subterraneus in XII libros digestus*, 1664–5, (detail) by Athanasius Kircher, 1664–5

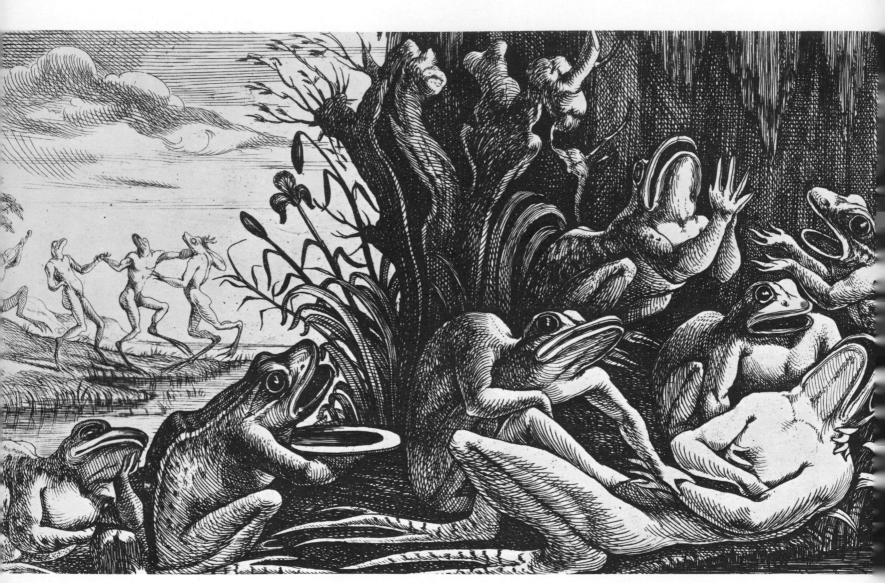

122 HENRI PICQUOT *Brutish man, similar to the frog ...*

123 Frontispiece of *Anatomia reformata*
by Thomas Bartholin, 1651

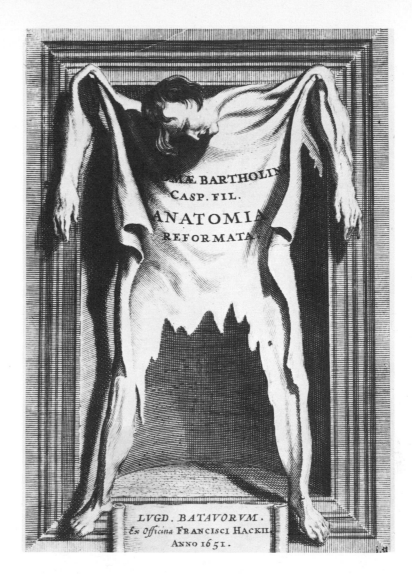

MÆ BARTHOLIN
CASP. FIL.
ANATOMIA
REFORMATA

LVGD. BATAVORVM.
Ex Officina FRANCISCI HACKII
ANNO 1651.

124 SEBASTIEN LE CLERC Plate from
*Mémoires pour servir à l'histoire naturelle des
animaux*, by 'MM. de l'Académie royale
des sciences', Part I, 1671

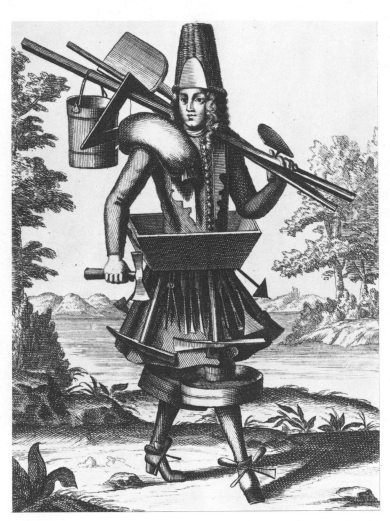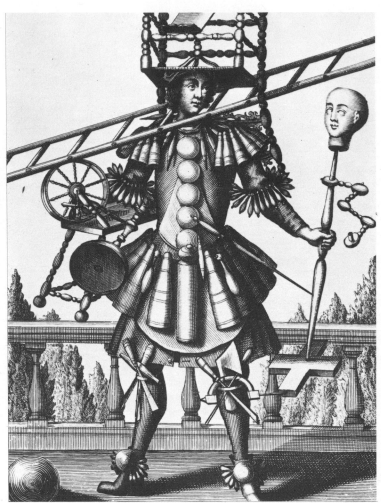

125–8 NICOLAS DE LARMESSIN Plates from *Costumes grotesques*, 1695: *Mason, Turner, Cooper* and *Potter*

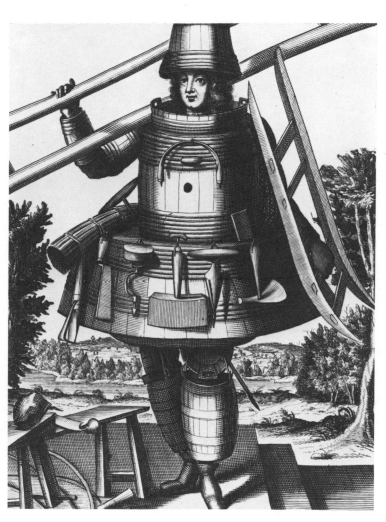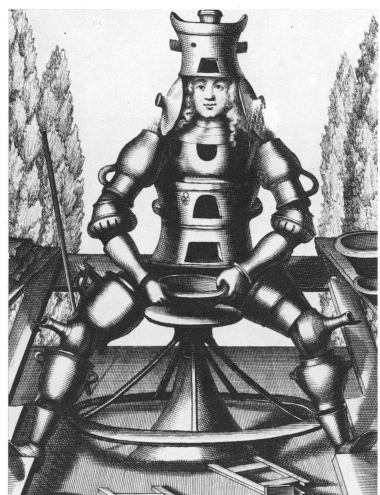

III THE EIGHTEENTH CENTURY

We tend to think of the eighteenth century as the age, if not of reason, then of conscious rationality. But under the bland surface are powerful currents. The specimen-jar shown in *pl. 131*, for example, has a gratuitous horror which may remind us of the savage disgust that fills some of Swift's writing. The horror is reinforced by the literalism which relates this to other kinds of eighteenth-century still-life – to Chardin's bowls of eggs, and copper pots and pans, for instance.

Piranesi's *Carceri* (*pls. 140–2*), on the other hand, make no pretence at blandness. The prints in this series, with their cavernous recesses, rough stonework, instruments of torture, and, above all, their wilful distortions of scale, have been universally recognized as being among the most powerful images of hallucination ever created. More external, less mysterious, but still impressive in their vehemence, are Fuseli's *Three Witches* (*pl. 145*), and the engraving after his celebrated painting, *The Nightmare* (*pl. 146*). In the latter, incongruous elements are combined in a curiously calculating kind of way, in order to make a statement about the powers of unreason.

One of the ways in which eighteenth-century art tried to resolve the tension between the rational and irrational was through caricature. The convention of caricature enabled the artist to evade demands for consistency and literalism. A simple example can be found in *pl. 147*. The artist is satirizing the 'unreasonable' fashion for high-piled hair-dos, but this allows him, at the same time, to indulge in a delightful piece of irrational fantasy, in which the towering coiffure becomes a refuge for a flock of birds. *Pl. 148*, also a satire on elaborate coiffures, carries the process further, and offers us an involuntary glimpse of the artist's subconscious. Here the huge wig takes on a distinctly sexual air, and its form is reminiscent of a vagina.

Meanwhile, certain traditional themes retain a surprising vitality. G. B. Tiepolo revives that of sorcery (*pl. 134*), injecting a characteristically sardonic note. And the *danse macabre* reappears, with, if possible, even more brio than formerly, in a series of illustrations to a treatise on osteology and myology (*pl. 135*).

The Blake illustrations to the Book of Job (*pls. 149–51*) with which this section closes do, however, serve to illuminate, by contrast, the aridity of a great deal of eighteenth-century art. Blake's draughtmanship can be criticized in detail – he relies little on his observation of nature, and much on his experience of art (particularly reproductive engravings after Michelangelo). But he combines these conventional elements so as to create complex symbols of the inner life. The Job illustrations have an energy which makes most of Fuseli – Blake's friend and plagiarist – seem factitious.

129 F. BONANNI. Plate from *Museum Kircheriarum* by Athanasius Kircher, Rome 1709.

This is another of Kircher's collections of curiosities (*see also pls. 120–1*). The 'museum' presents a collection of objects which are as varied as may be – idols, instruments of sacrifice, bracelets, sandals, etc. The plate shown here is the opening page of the fourth section, in which the illustrator shows all the shells that are described gathered together in an object which reminds one of the souvenirs sold at seaside towns today.

130–2 CORNELIUS HUYBERTS (1669–1712). Plates from *Thesaurus anatomicus* by Fred. Ruyschius, 1702.

The frontispiece engraving (*pl. 130*) represents a pile of human organs and viscera. It is framed by three children's skeletons with anguished expressions. One of them is beating its rib-cage, another is wiping its empty eye-sockets with a hand-kerchief which would appear to be composed of a membrane. A bird perching on a branch, and the necklaces held by the topmost skeleton complete the disconcerting impression given by the picture, as does the scalpel which the third skeleton is holding as nonchalantly as if it were a cigarette holder.

In the context of the work, the plate has an entirely scientific purpose, for engraved letters refer the reader to a detailed explanation of the organs which are represented. But the engraver goes well beyond the bounds of his subject to draw us into his world of 'guinea-pig' children.

In *The Jar* (*pl. 131*) the purely scientific intention underlying the portrayal of intestines in preserving fluid is again overriden by the engraver's imagination. The child's hand grasping an indistinct fistful of viscera, the amputated forearm carefully bandaged in a piece of braid, combine to create a sensation of morbid horror, which the inscription *ad vivum fecit* (done from life) does nothing to diminish.

The Fœtus (*pl. 132*) is, according to the text, an exact representation of a seven-month-old hydrocephalic fœtus, holding part of its placenta in its arms. But here, unlike the previous two plates, Huyberts has used this natural monstrosity to create a composition which is intensely poetic and has a strange power of fascination. Concentric circles radiate from the tip of the nose across the entire head, which takes on the dimensions of a world. The dreamy, inward-looking expression of the fœtus suggests some communication with the beyond and a contemplation of the mysteries of pre-natal existence.

133 Plate from *Tabulae sceleti et musculorum corporis humani* by Bernhard Siegfried Albinus, Leyden 1747.

In 1719, at the age of twenty-two, Albinus was appointed professor of anatomy and surgery at the school in Leyden, replacing his teacher, Rau. *Tabulae* is his masterpiece, which he brought out after many years of research, embellished by forty plates which were engraved by Wandelaer and which combine scientific exactitude with artistic boldness.

Here a flayed figure, almost reduced to a skeleton, stands in an elegant pose against the unexpected background of a rhinoceros. Albinus justified its presence as a means of bringing out the anatomical relief of the skeleton, and the effect of the contrast between the grainy, wrinkled skin and the bony elegance of the figure is indeed striking.

134 GIOVANNI BATTISTA TIEPOLO (1692–1770). *Two Magicians and a Boy.*

This, no. 22 of the *Scherzi di fantasia* series, executed between 1755 and 1765, reveals some of Tiepolo's attitudes towards the graphic medium. Many of his drawings, and nearly all of his prints, were made in series, and are exercises in virtuosity. Tiepolo is like a musician, who shows his skill in improvising on a set theme, or group of themes. Nevertheless, his prints do have a characteristic content. In part, they are a commentary on the great Venetian art of the past, particularly Veronese. In a more personal sense, they offer a very Venetian blend of the sardonic and the superstitious. When we examine Tiepolo's prints of necromancers, we are reminded of the contemporary notoriety of men such as Cagliostro.

135 Plate from *Nouveau recueil d'ostéologie et de myologie dessiné d'après nature* by Jacques Gamelin, Toulouse 1779.

Jacques Gamelin was director of the Académie des Beaux-Arts in Montpellier, taught in Rome, then established himself in Toulouse. There he set up a studio for both engraving and dissection, and surrounded himself with assistants, including Martin and Lavallée, in order to produce this remarkable book. It was one of the finest of eighteenth-century publications, though it had little success at the time.

The scenes transcend the genre of anatomical drawing, and have often been compared to the work of Goya.

The theme of the dance of death (*pl. 135*) is repeated a number of times, with skeletons sowing panic among the living against a variety of unexpected backgrounds.

136–8 WILLIAM HOGARTH (1697–1764)

In boyhood Hogarth was apprenticed to a silverplate engraver, and as a painter and engraver he retained the sense of line and love of Rococo curvature instilled by this early training. His prints were much pirated, until he successfully agitated for the passing in 1735 of an Act of Parliament to protect his copyrights.

The Anatomy Lesson (*The Reward of Cruelty*) is the last plate in *The Four Stages of Cruelty*, 1751, the tragic tale of Tom Nero. Starting as a malicious child who tortures animals, he becomes a brutal adult; he kills his mistress after having driven her to theft, and finishes his miserable existence on the dissecting table. He still has the noose with which he was hanged around his neck, and his heart is on the point of being eaten by a dog. But neither does Hogarth spare the doctors; observe the pontificating air of the president, seated under the Academy's emblem (a hand feeling a pulse) and the faces of the doctors gathered round the table. On either side of the room stand the skeletons of a pugilist and a well-known highwayman.

Credulity, Superstition and Fanaticism of 1762 (*pl. 137*) is a satire on sorcerers and swindlers as much as on repression. Hogarth shows how the two are linked, and how one encourages the other. The engraving is full of references to contemporary people and events. Thus we have the ghost of Cock Lane, the young William Perry who falsely accused an old woman of having bewitched him, and Mary Toft, who produced several litters of rabbits, but was discovered to be a fraud. The preacher (modelled on George Whitfield) wears a harlequin's costume under his cassock and a Jesuit's tonsure under his wig; the thermometer gives the temperature

of the congregation, which can rise to convulsions and madness. Hogarth had originally drawn a satire on Methodism, entitled *Enthusiasm Delineated*, 1761, but when this was refused publication because of its violent anti-clericalism, he altered the title and many of the details.

Finis; or The Bathos (*pl. 138*) is Hogarth's last print (March 1764), completed a few months before his death.

It is inspired by Dürer's *Melancholia*, being intended as a kind of Rococo counterpart of that engraving, and also by the Hargrave monument in Westminster Abbey, sculpted by Roubiliac in 1753.

The engraving shows us Time expiring, leaning against a ruined column. Around him are gathered all the signs of devastation: a broken scythe, hour-glass and pipe, a worn-out besom, part of a crown, the butt of a musket, a skull, the lightning-blasted tree, ruins, a cracked bell, the sun in eclipse. In the sky we see the death of Apollo, while a pirate hangs from a gibbet by the shore. With his last breath, Time utters 'Finis'. He is still holding his will by which he leaves everything, and 'all and every atom thereof to chaos whom I appoint my sole executor'; it is witnessed by the three Fates – Clotho, Lachesis and Atropos. The text beneath the engraving continues the theories of Hogarth's *Analysis of Beauty*, proclaiming that only aesthetic values last for ever.

139 C. FRUSSOTTE, *En vain tu me regardes* ('You look at me in vain'), 1786.
The picture is a reversed copy of an engraving by Jan van de Velde entitled *The Sorceress*, 1626, which represents her amid the customary paraphernalia of potions, powders and monsters, preparing some spell.

Frussotte has added a set of typographical variations on the phrase *En vain tu me regardes* which suggests a comment on the credulity of sorcerers' clients.

140–2 GIOVANNI BATTISTA PIRANESI (*c.* 1720–1780). Plates from *De Invenzioni Capricci di Carceri*, Rome 1745.
Piranesi was indeed the kind of personality one might expect from the style of his engravings. Headstrong and passionate, he worked with both panache and skill. His perfect knowledge of the techniques of etching, which he reworked in drypoint, were used to convey the secret world of ruins, and the sense of the colossal which pervades the Roman monuments.

This series of imaginary prisons is remarkable for the combination of realistic detail, gigantic scale and the treatment of space which Piranesi uses to convey their oppressive architecture. They are oppressive not because of the confinement they suggest, as is usually the case, but because of their immensity; the prisoners wander through vast, endless spaces, with unseen sources of light, forming a world which they have no purchase on, because it is not to their scale. One senses the atmosphere of anguish of some metropolis of torture, which led Aldous Huxley to talk of 'metaphysical prisons', and which has a greater effect on us now than the array of gigantic instruments of torture which must have been more frightening for the artist's contemporaries.

143, 144 CHARLES-GERMAIN DE SAINT-AUBIN (1721–86). *Essai de papillonneries humaines*, 1750. *Ballet champêtre* and *Fireworks*.
Charles was the brother of Gabriel and Augustin de Saint-Aubin, and the son of Gabriel-Germain who was the Royal embroiderer. His only known works are this delightful

series of etchings, which he also painted, and some books of embroidery designs.

We find the familiar comic principle of animals indulging in typically human activities – here a dance and the letting off of fireworks. But with Saint-Aubin one does not feel that there is any satirical intention, merely a striving after grace and lightness for their own sake.

145, 146 HENRY FUSELI (1741–1825)
An aristocrat from Zurich, who settled in London after visiting Italy, Fuseli revealed his talents in his paintings of *The Nightmare, The Three Witches* and *Lady Macbeth*. In 1790 he joined the Royal Academy in London and taught painting until the end of his life. After a period of neglect, he was rediscovered fairly recently by the Surrealists, who claimed him as one of their forerunners.

The Three Witches (*pl. 145*), an illustration to *Macbeth*, was engraved by Barathier. The theme was popular with the French Romantics (*see pl. 187*). The painting was exhibited in London in 1783, and Fuseli may be looked upon as one of the earliest Romantics. Delacroix admired him greatly.

The Nightmare (*pl. 146*) was engraved by Laurède. The painting, which dates from 1781, may be compared to *The Succubus* by the same artist, in which we also find the horse as a symbol of night and dreams. The demon sitting on the chest of the sleeping woman gives bodily form to the nightmarish sense of oppression.

The engraving does not unfortunately convey the magic of the painting, which is largely due to the delicate colours and the opalescence of the horse.

147, 148 *Indictments of eccentric hairstyles.* Eighteenth century.
The extravagance of feminine fashion has ever been a subject of mirth for males and a goldmine for caricaturists.

Here the pictures speak for themselves, mocking the exaggerated size of hairstyles which are as tall again as the wearer and compete with the treetops as a suitable perch for birds.

149–51 WILLIAM BLAKE (1757–1827)
Blake was apprenticed for seven years, up to the age of twenty-one, to an engraver, Basire, who sent him out to make studies of the Gothic architecture and sculpture of the churches of London, and in particular of Westminster Abbey. Blake next enrolled in the newly-founded Royal Academy, practising life-drawing and drawing from the Antique. He rejected this copying as worthless, however, and scorned the Academicians, including Reynolds. In the Academy library he saw prints from Raphael and Michelangelo, and these joined Gothic as sources of inspiration to him. He was always to be violently opposed to the prevailing artistic modes, with the exception of the Greek Revival, and enjoyed very little worldly success to the end of his life.

The series of engravings of *Illustrations of the Book of Job*, published in 1825 (*pls. 149–51*), are Blake's masterwork. He had executed watercolours of the *Job* illustrations for his patron, Thomas Butts, in 1821, and the twenty-two engravings were commissioned by Blake's friend the artist John Linnell. They were completed over a period of three years.

All the engravings illustrated – '*Then the Lord answered Job out of the Whirlwind*' (*pl. 149*); '*Job's Evil Dream*' (*pl. 150*); and '*Behold now Behemoth*' (*pl. 151*) – are surrounded by engraved borders with text and fanciful decorative embellishments (not reproduced).

Plates 129–151

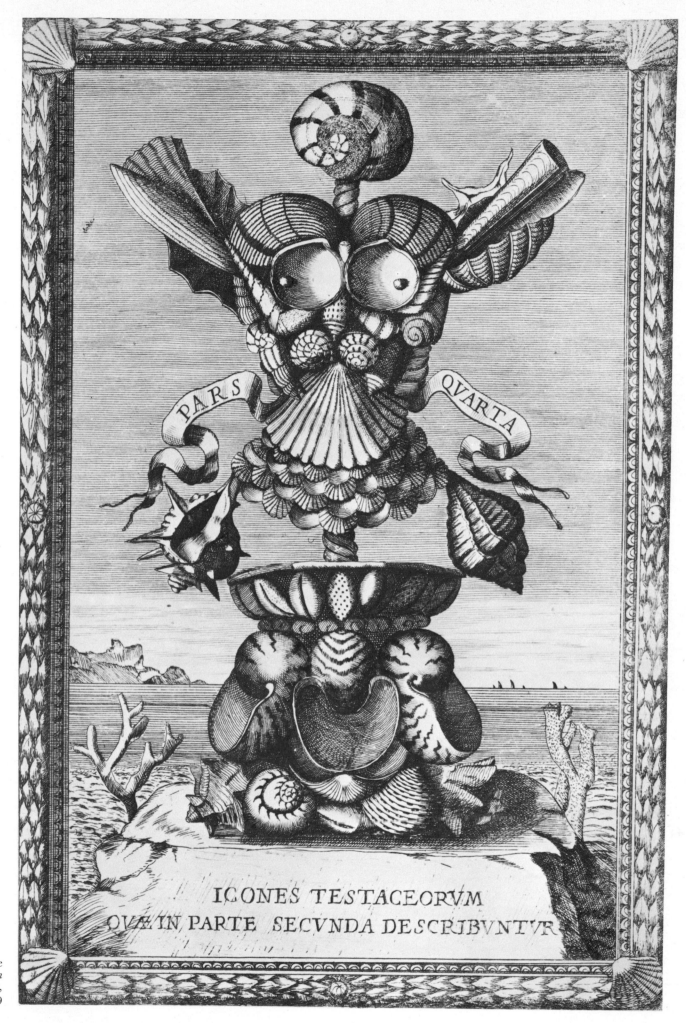

ICONES TESTACEORVM
QVÆ IN PARTE SECVNDA DESCRIBVNTVR

129 F. BONANNI Plate
from *Museum Kircheriarum*
by Athanasius Kircher,
1709

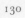

130–2 CORNELIUS HUYBERTS Frontispiece and plates from *Thesaurus anatomicus* by Fred. Ruyschius, 1702

130 Frontispiece

131 *The Jar*

132 *The Fœtus*

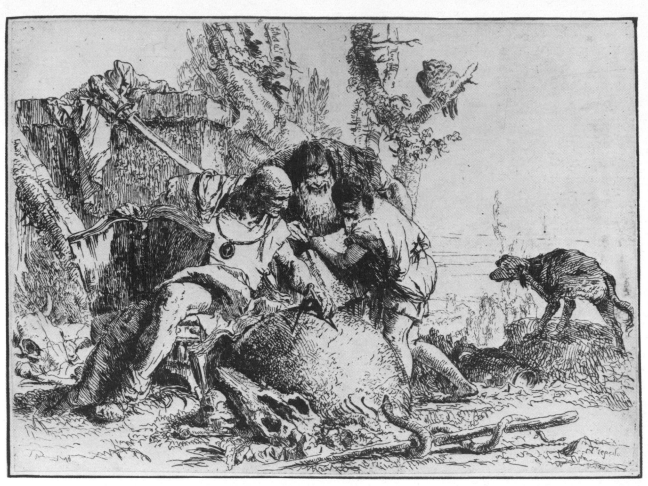

134 GIOVANNI BATTISTA TIEPOLO *Two Magicians and a Boy* 1755–65

135 *Skeletons and the Living*. Plate from *Nouveau recueil d'ostéologie et de myologie dessiné d'après nature* by Jacques Gamelin, 1779

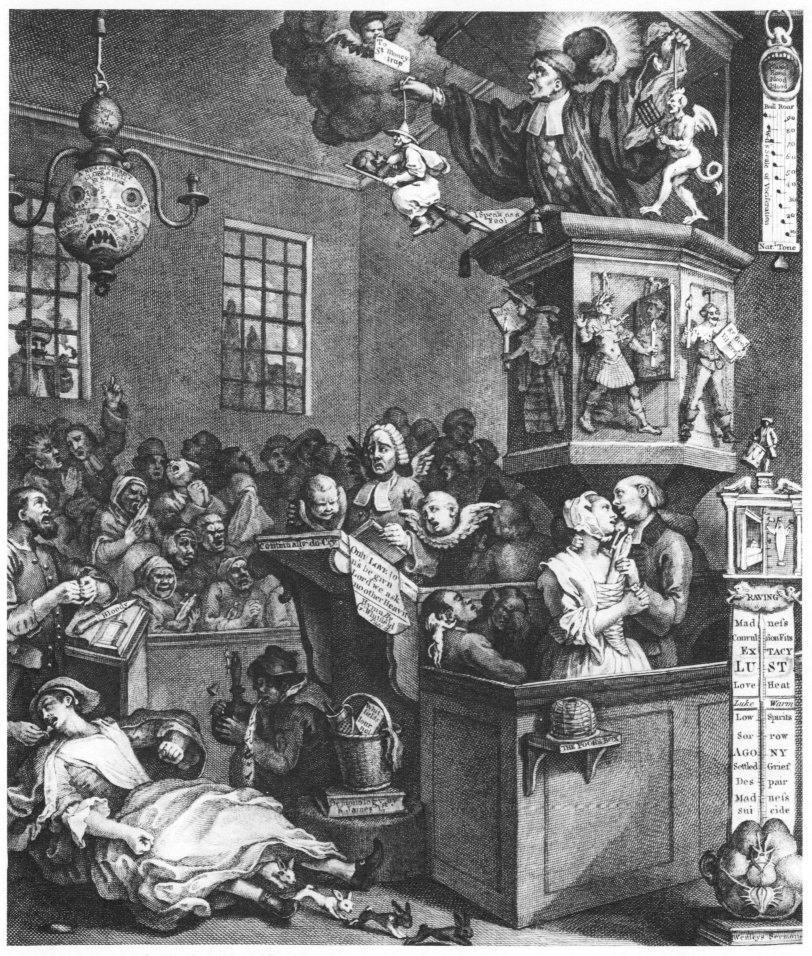

137 WILLIAM HOGARTH *Credulity, Superstition and Fanaticism* 1762

136 WILLIAM HOGARTH *The Anatomy Lesson (The Reward of Cruelty)* 1757

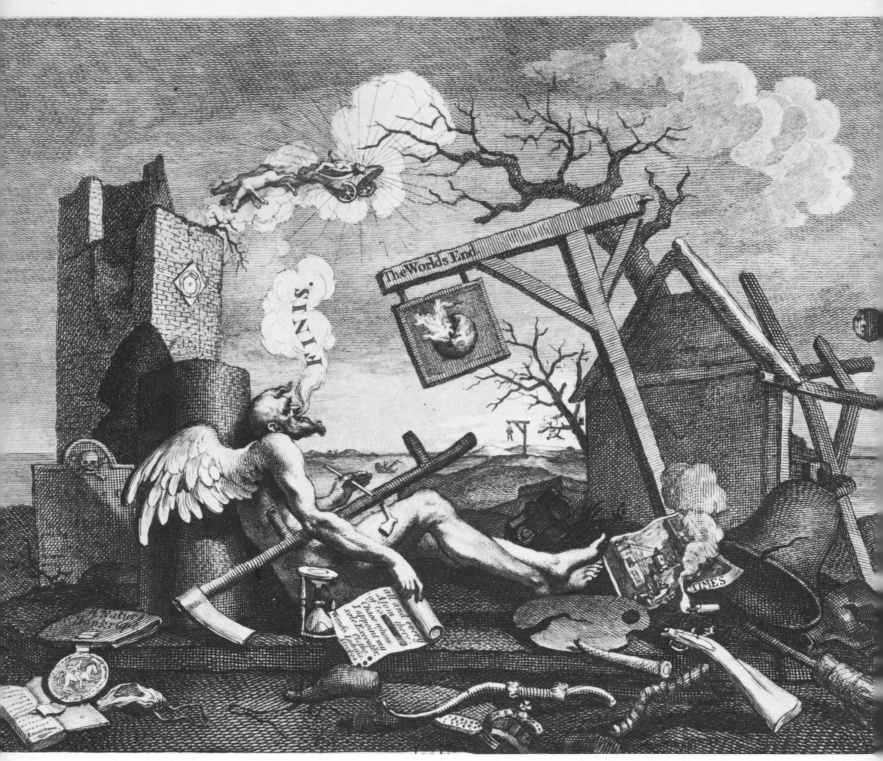

138 WILLIAM HOGARTH *Finis; or, The Bathos*, March 1764

139 C. FRUSSOTTE *En vain tu me regardes* ('You look at me in vain') 1786

```
E D R A G E R E M U T U M E R E G A R D E
D R A G E R E M U T N T U M E R E G A R D
R A G E R E M U T N I N T U M E R E G A R
A G E R E M U T N I A I N T U M E R E G A
G E R E M U T N I A V A I N T U M E R E G
E R E M U T N I A V N V A I N T U M E R E
R E M U T N I A V N E N V A I N T U M E R
E R E M U T N I A V N V A I N T U M E R E
G E R E M U T N I A V A I N T U M E R E G
A G E R E M U T N I A I N T U M E R E G A
R A G E R E M U T N I N T U M E R E G A R
D R A G E R E M U T N T U M E R E G A R D
E D R A G E R E M U T U M E R E G A R D E
```

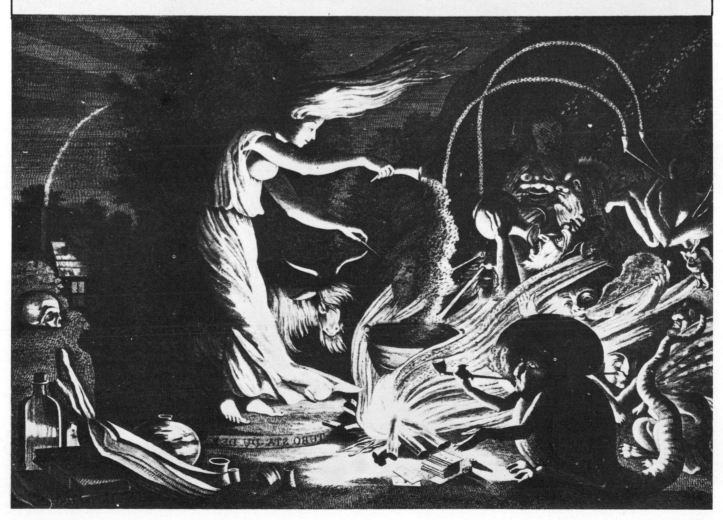

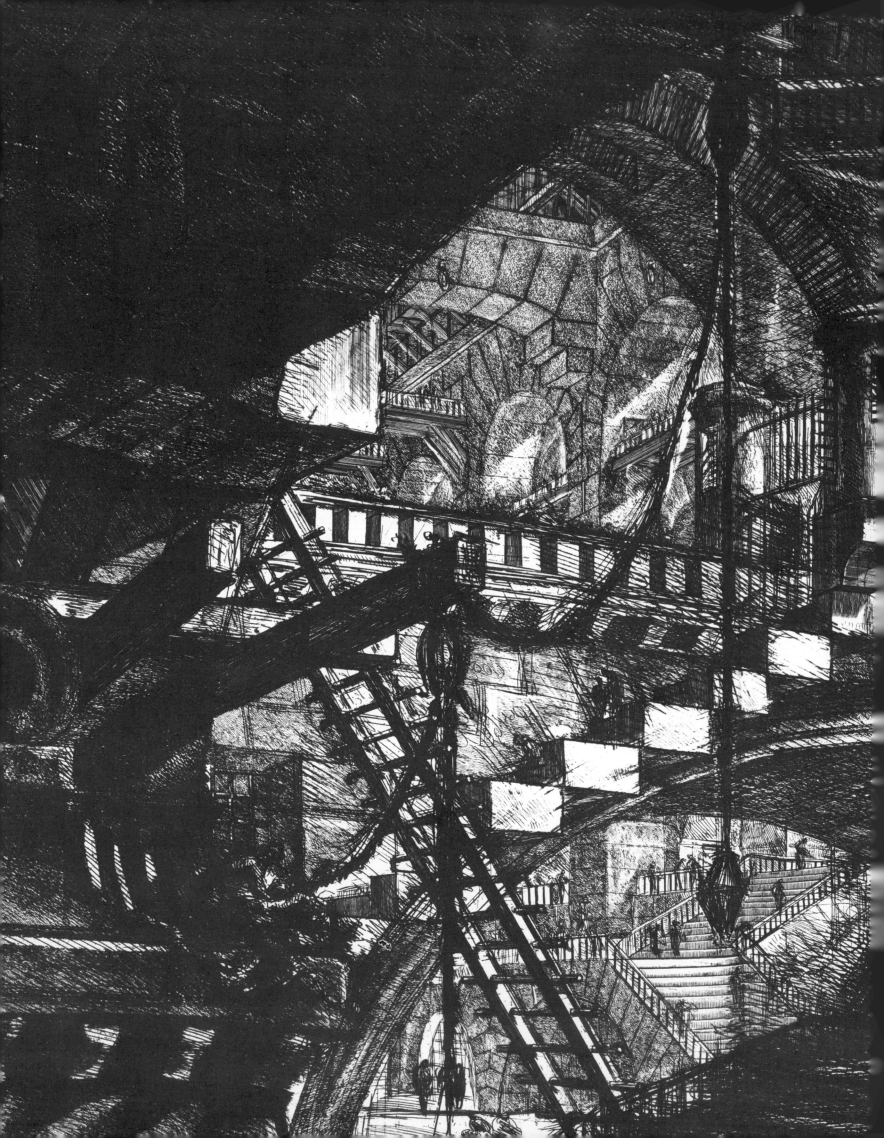

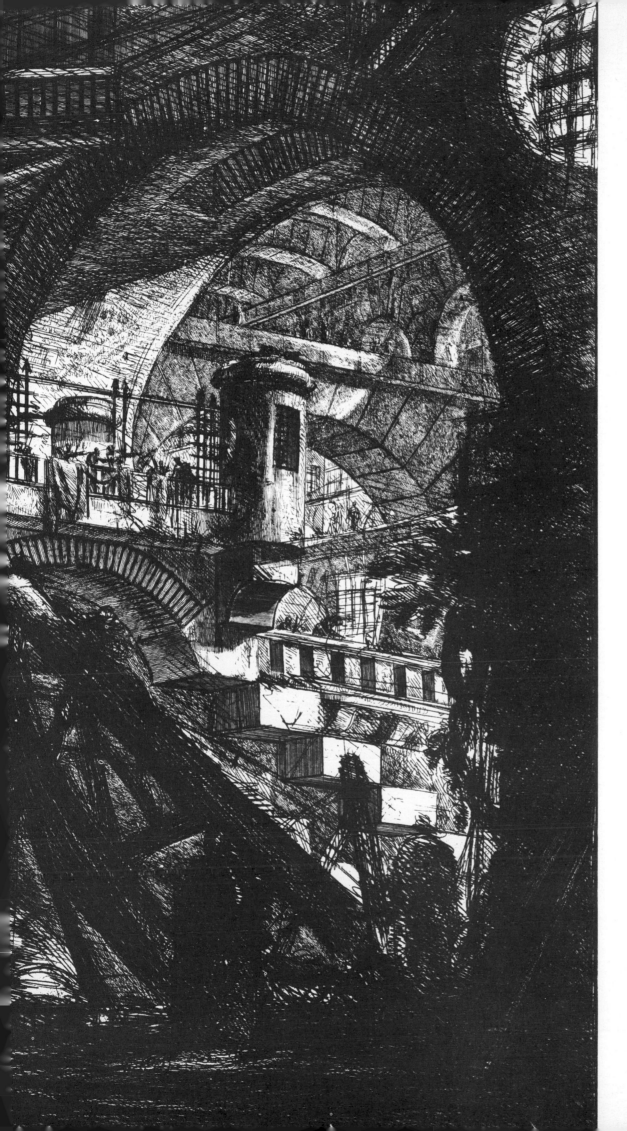

140 GIOVANNI BATTISTA PIRANESI
Plate from *De Invenzioni Capricci di Carceri* (Imaginary Prisons), 1745

Overleaf
141, 142 GIOVANNI BATTISTA
PIRANESI Plates from *De Invenzioni Capricci di Carceri* (Imaginary Prisons),
1745

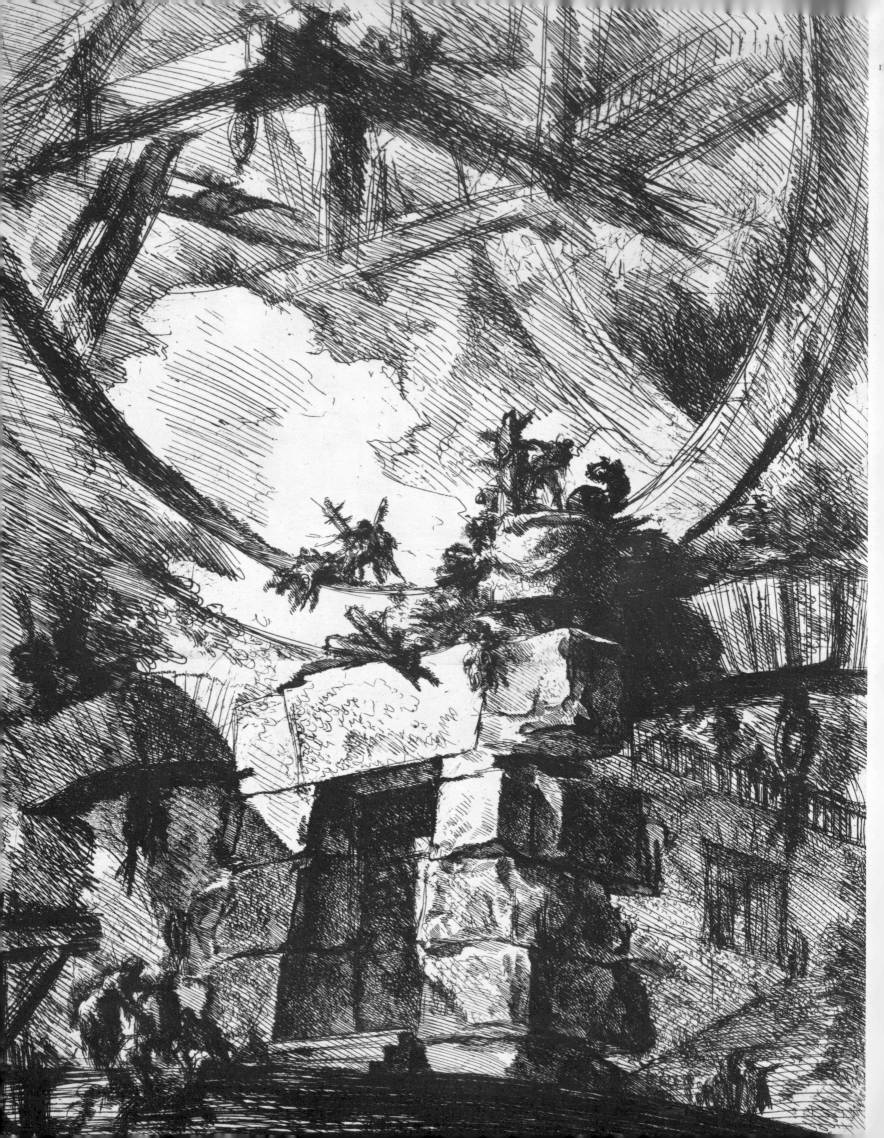

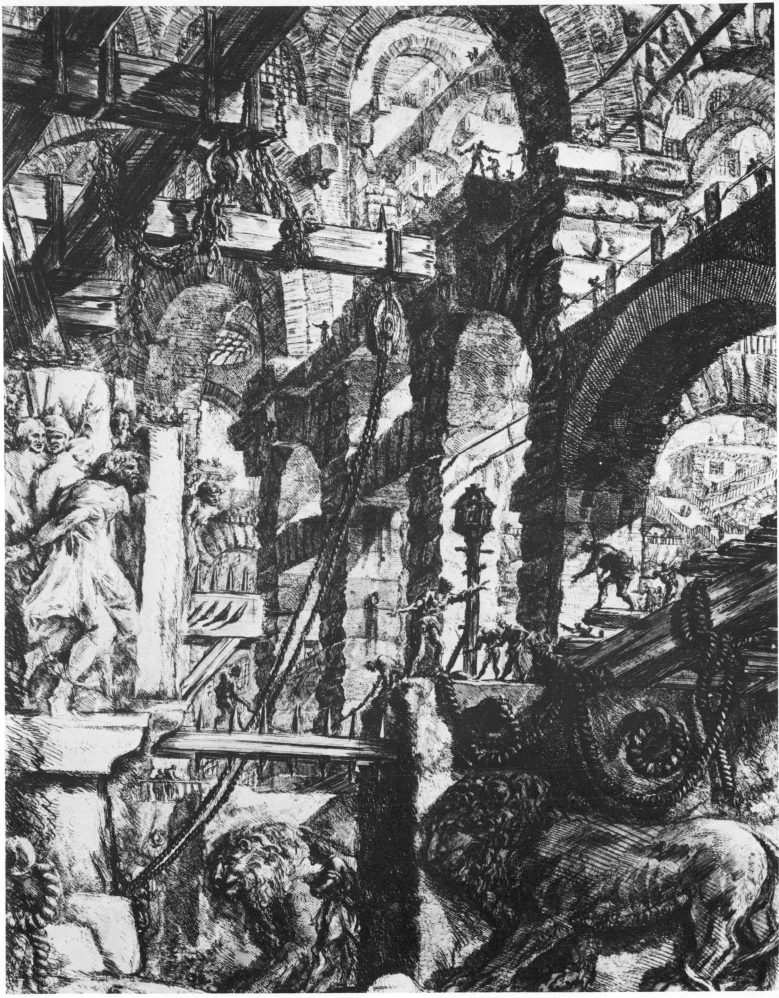

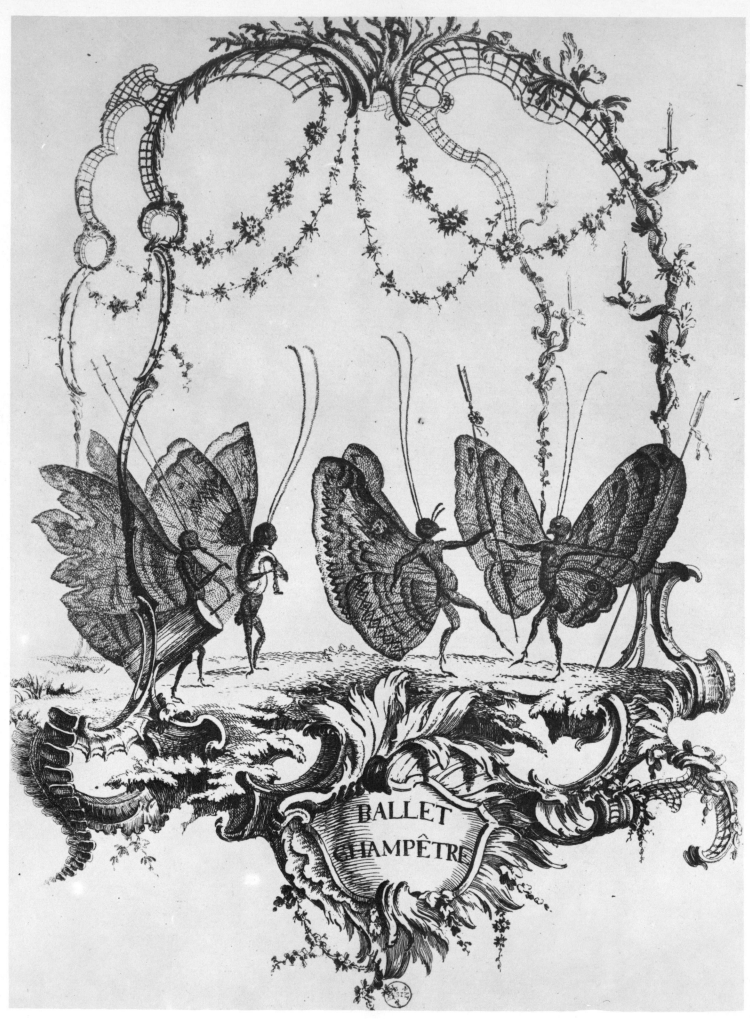

143, 144 CHARLES-GERMAIN DE SAINT-AUBIN *Essai de papillonneries humaines* 1750: *Ballet champêtre* and *Fireworks*

145 HENRY FUSELI *The Three Witches*. Engraved by Barathier

148

147, 148 *Indictments of eccentric hairstyles.* Eighteenth century

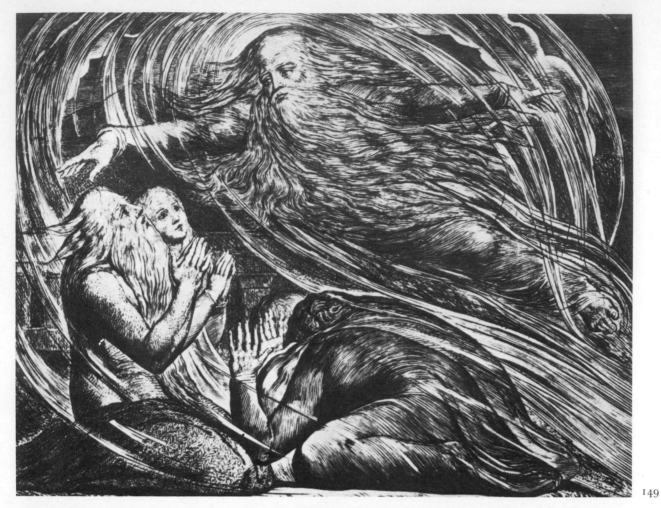

149

150

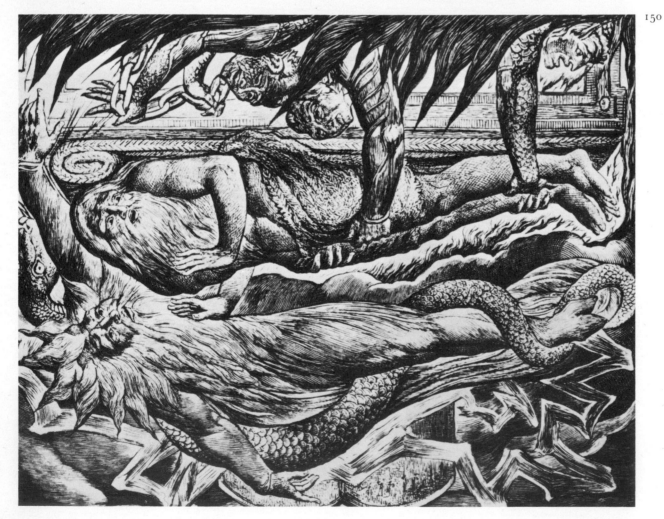

149–51 WILLIAM
BLAKE *Illustrations of the
Book of Job* 1825

149 '*Then the Lord
answered Job out of the
Whirlwind*'

150 *Job's Evil Dream*

151 '*Behold now
Behemoth*'

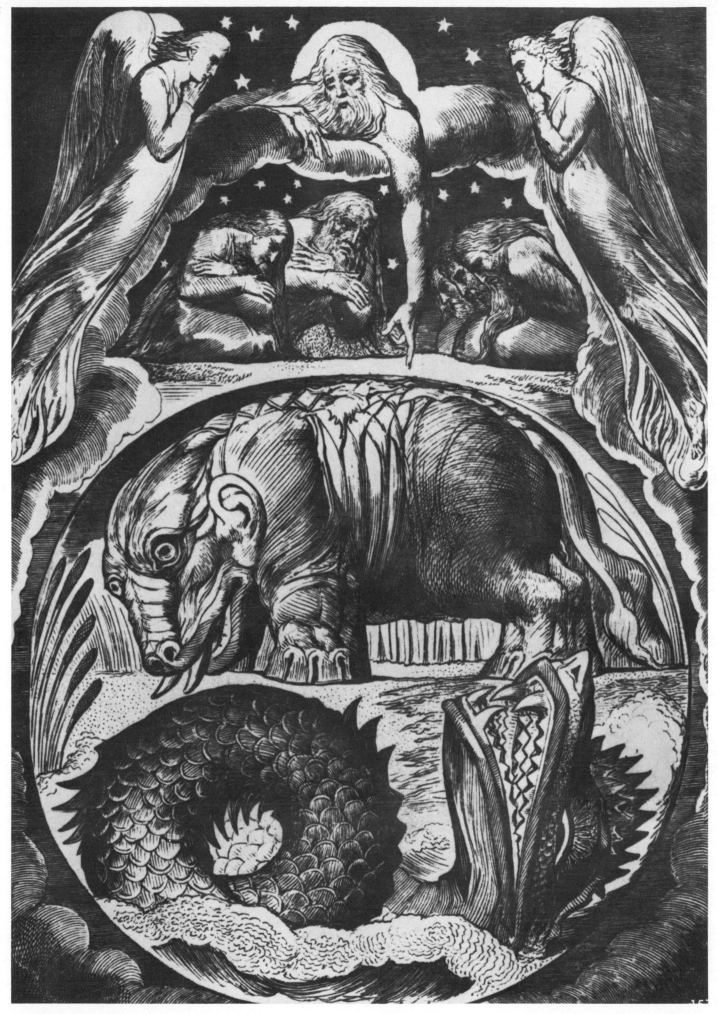

IV THE NINETEENTH CENTURY

It is not surprising that the nineteenth century forms, together with the sixteenth, the great epoch of fantastic images. Nineteenth-century artists draw upon many sources for their inspiration. Sometimes, though rarely, they are inspired by things which they themselves had witnessed. This is the case with Goya's *Disasters of War* (*pls. 160–3*), which embody the artist's reactions to the horrors of the Napoleonic campaigns in the Peninsula. More often, they offered a reaction to a literary text – this is the case with Delacroix's illustrations to Goethe's *Faust* (*pls. 184–8*), or Gustave Doré's to Dante (*pls. 191–3*).

But in any case, the emergence of literature as the dominant influence in Romanticism encouraged artists to think in terms of images, and to make the originality and strangeness of the image the yardstick of the originality of the work of art itself. Thus Charles Meryon expresses his response to Gabriel's *Ministère de la Marine* (*pl. 196*), a typical piece of eighteenth-century 'classic' architecture, by filling the clear sky above it with a flock of tiny figures, some in a chariot, others mounted upon dolphins.

In some of the greatest graphic work of the century, the medium becomes a vehicle for personal statements which rise directly from the creative unconscious. Goya sets the example, with his *Caprichos* (*pls. 154–7*) and *Proverbs* (*pls. 158–9*). The artist here claims total liberty for himself. He does not seek to impress by his fancifulness, or skill in combining incongruous elements, as a Mannerist master would have done. The images seem to rise up and impose themselves, as if they had as much claim to be 'natural' as nature itself. A good instance of this is supplied by the famous *Proverb* which shows a cluster of human figures perched like birds on a dry branch. It is thought that this is intended as an allusion to the complacent fatuity of the court of Spain, but the image goes far beyond any merely satirical intention.

The freedom we find in Goya reappears in the work of men such as Bresdin, Redon and Ensor. Bresdin is the least known of the trio, though his work fascinated men like the great Symbolist author J. K. Huysmans. One striking characteristic of his work is the fact that he achieves strangeness without resorting to what is overtly strange. If the *Comedy of Death* (*pl. 201*), which Huysmans described in *A Rebours*, has elements which recall the *Dance of Death* or the *Temptation of St Anthony*, as these were envisioned by sixteenth-century engravers, other plates, such as *The Port* (*pl. 202*), or *The City Beyond the Defile* (*pl. 205*), are apparently naturalistic. But here the whole landscape becomes an emblem for the mental climate the artist wishes to evoke.

Redon (*pls. 207–10, 216*) is one of the most evocative artists who ever lived. A print such as *Limbo* (*pl. 207*) defies analysis. One can only recognize its brooding mystery.

James Ensor (*pls. 213–15*) is a less consistent artist, but on occasion an equally powerful one.

In this case it is fascinating to recognize his affinities with the art of the past. *The Triumph of Death* (*pl. 215*) has a family resemblance to Callot's *Temptation of St Anthony* (*pl. 97*), and there is an even closer likeness between some of the figures in the so-called 'auricular' style by Christoph Jamnitzer (*pls. 85–8*) and Ensor's insect personages (*pl. 211*). Yet we must recognize, I think, that the latter make a greater impact because they are freed from any allegiance to the concept of ornament – they make a direct attack on the spectator's sensibility, and conjure up atavistic terrors. Anyone acquainted with the psychiatric textbooks devoted to the subject will see the resemblance between Ensor's vision and certain standard patterns of hallucination.

Notes on Plates 152–216

152–63 FRANCISCO GOYA (1746–1828)

Goya was born near Zaragoza in Spain and travelled to Italy around 1770. His first commission as a painter was a fresco for the church of Nuestra Señora del Pilar in Zaragoza in 1771. He began making tapestry cartoons in 1775 and executed etchings after the works of Velasquez in 1778. In 1789 he was appointed official painter to Charles IV. A turning point in his career came in 1792 when he fell seriously ill and afterwards was left with permanent deafness. The series of *Caprichos* (*Caprices*) were produced between 1794 and 1799 during one of the blackest periods of his life. His biting satire and pessimism are to be found in each of the engravings (*pls. 152, 154–7*).

The Sleep of Reason produces Monsters (*El Sueño de la razon produce monstruos*) of 1799 (*pl. 152*) is no. 43 of the *Caprichos* but originally intended as the frontispiece. Goya's full commentary is: 'Imagination, deserted by reason, begets impossible monsters. United with reason she is the mother of all the arts, and the source of their wonders.'

The Colossus of 1810–17 (*pl. 153*) does not form part of *Caprichos*, and only a few copies are known. It is like a less extreme companion to the painting of 1808 entitled *Panic* in which a colossus bestrides the countryside, putting the population to flight. Here the giant sits in a melancholy reverie, apparently wrapped in his solitude and cut off from the beauties of the universe; an allusion, perhaps, to Goya's own isolation.

To Rise and to Fall (*Subir y bajar*), no. 56 of the *Caprichos* (*pl. 154*), shows Fortune ill-treating those who court her. 'She rewards efforts to rise with hot air and punishes those who have risen by downfall.

All will Fall (*Todos caeran*), no. 19 of the *Caprichos* (*pl. 155*), illustrates: 'Those who are about to fall will not be warned by the example of those who have fallen. But there is nothing to be done. All will fall.' Winged young men flutter round a female creature who serves as a snare, and end up plucked and roasted in the feast of marriage. Rather than disillusioned comment at the time of his supposed passion for the Duchess of Alba, one should perhaps see this plate as demolishing established social values at a time when, for Goya, everything was crumbling, and the easy life of the preceding years was coming to an end. It was a point at which he felt profoundly that truth and falsehood were indistinguishable and even the values held most sacred could be a pretext for evil.

First Attempts (*Ensayos*), no. 60 of the *Caprichos* (*pl. 156*), is captioned: 'Little by little progress is made. She is starting to take her first steps and soon she will know as much as her mistress.' The apprentice witch shows that the pleasant face of youth can hide the evil of hideous and experienced old age.

What Illness will He Die Of? (*De que mal morira?*) is no. 40 of the *Caprichos* (*pl. 157*). 'The doctor is excellent, thoughtful, circumspect, serious. What more can one ask?' Possibly this is an allusion to Goya's doctor, Galinsonga. Goya had fallen seriously ill in Cadiz at the house of his friend Sebastian Martinez, and had been convinced that his last hour had come.

Disparates, also called by Goya *Los Sueños* (*Dreams*) and known in English as *Proverbs*, were probably executed in 1819 (*pls. 158, 159*).

Strange Folly (*Disparate ridiculo*), no. 3 (*pl. 158*), is said to be an allusion to the court of Charles IV of Spain, thinking itself safe on a dead branch.

Matrimonial Folly (*Disparate matrimonial*), no. 7 (*pl. 159*), shows a composite monster, a husband carrying his wife like a sack of coals under the critical eye of the hideous onlookers.

The series *The Disasters of War* (*Los desastres de la guerra*) was begun in 1810 and not published until after Goya's death, in 1863 (*pls. 160–3*).

They Escape through the Flames (*Escapan entre las llamas*), no. 41 (*pl. 160*), probably depicts the burning of the village of Torquemanda when Lasalle's troops passed through. The cataclysmic nature of the disaster is emphasized by the composition, the main features of the drama being drawn within a semi-circle of light, radiating from the centre. The effect is to remove the incident from real life to some flaming hell in which fiery figures seem to surge up from a burning crater.

Charity (*Caridad*), no. 27 (*pl. 161*), is an ironic description of those who bury the casualties of fighting, but first strip the bodies of their valuables and then toss them naked into a communal grave.

Truth is Dead (*Murió la verdad*), no. 79 (*pl. 162*), can be read as a comment on the course of Spanish history. Restored to Spain in 1814 by the victory of the Spanish resistance, Ferdinand VII abolished the liberal Constitution and returned to absolutism. The composition is organized round the radiant figure of truth, which a group of clerics and gravediggers are hastening to bury, forming a sombre screen to her brightness. The sky is black, increasing the stifling atmosphere of the picture.

There is No One to Help Them (*No hay quien los socorra*), no. 60 (*pl. 163*), shows one figure standing out like an accusation against a hellish glow, emphasizing the predicament of the dying, abandoned after the holocaust. The use of black and white accentuates the pathetic effect of the scene by cutting out all realistic detail which might have the effect of reducing the allegory to a simple description of a common misfortune.

164 *Mother and Child*. Nineteenth century. Anamorphic lithograph published by Decugis, Marseilles (*see also pl. 168*). Anamorphosis is derived from the science of perspective. The theory of the latter supposes that objects are drawn on a vertical plane, facing the observer. (On this subject, cf. Dürer's engravings entitled *Instructions for Measuring*, 1525.) If the plane bearing the image slanted, the picture must be viewed from an angle to be decipherable.

Before being a game, anamorphosis was a necessary technique; frescoes and paintings on domes forced the artists to make a serious study of the distortions produced by perspective. The Greeks took into account the distortions caused by the angle of vision and deliberately adjusted their architecture and sculpture to compensate for it.

During the Renaissance, the fashion for anamorphoses spread to paintings and engravings, and the first artist to produce them systematically was Erhard Schoen, around 1535 (*see pl. 58*).

Shakespeare makes an allusion to anamorphoses in *Richard II* when grief is said to be 'Like perspectives, which rightly gazed upon show nothing but confusion; ey'd awry

Distinguish form.' (See J. Baltrušaitis in *Anamorphoses ou magie artificelle des effets merveilleux*, Paris 1969.)

The two lithographs illustrated (*pls. 164, 168*) are very late examples, since the vogue for anamorphoses was at its height in the sixteenth and seventeenth centuries.

165 *The Donkey and the Doctor*. Eighteenth century.
This is a simpler kind of visual trick – the portrait can be looked at either way up. Here the right way up shows the 'Portrait of Doctor Quilira' and the other the picture of an ass.

166 MATHAUS MERIAN THE ELDER (1593–1650). *Death and the Bourgeois*.
Death, dressed in 'bourgeois costume', appears more like a figure from a comedy than a tragedy. The Merians, father and son, were Swiss engravers who produced a large number of prints relating to social customs and topography. They were also responsible for a famous map of Paris, known as the Basle map. The same engraving is found illustrating the famous proverbs of Jacques Lagniet (1657) accompanied by the following quatrain: *L'homme remply de vanité/n'a point l'esprit effleuré/je suis bien fort, je suis beau/et demain je serai au tombeau.* ('Man so full of vanity/never the thought has he:/I am strong and handsome, yet/Tomorrow I may be dead'.)

167 J. H. GLASER (1595–1673). *The Fall*, Basle 1638.
Here the anamorphosis is used more subtly; looked at from the front it forms a kind of filigree pattern which does not interfere with the rest of the scene. The picture represents the Garden of Eden after Eve has picked the apple. If one looks at the engraving from the left, the head of Christ wearing a crown of thorns appears out of the landscape. Thus from the Fall we look forward to the redemption of man through Christ's sufferings.

168 *The Violinist*. Nineteenth century. Anamorphic lithograph published by Decugis, Marseilles (*see also pl. 164*).

169 *Women and Men*. Nineteenth century. Trick heads on the same principle as those in *pls. 165 and 166*.

170 Plate from *A Series of Engravings Explaining the Course of the Nerves* by Charles Bell, London 1803.
The brothers Charles and John Bell were English surgeons who engraved the illustrations for their publications themselves. Charles Bell was a great specialist in the nervous system, and the plate illustrated showing the nerves of the neck also demonstrates his talents as an engraver.

171 JOSEPH DE CISSE. Illustration to Claude Ambroise Seurat, *The Anatomical Man* or *The Living Skeleton*, 1827.

172, 173 LOUIS BOULANGER (1806–67)
Boulanger was apprenticed early as a lithographer. He was greatly influenced by Deveria, Géricault and above all Delacroix, whose *Faust* illustrations (*pls. 184–6, 188*) made a deep impression on him. He was a member of the small circle of artists which gathered round Victor Hugo, and was subsequently considered as the latter's 'official' engraver. But his Romanticism is very superficial, and his style is essentially restrained.

He illustrated *Le Dernier Jour d'un Condamné* ('The last day of a condemned man') by Victor Hugo in 1830 (*pl. 172*). This was a work of Hugo's youth, but it is nevertheless of some importance, for in it he already declares himself

violently against the death penalty, which he continued to attack to the end of his live as unworthy of a civilized society.

Boulanger produced eight tinted engravings for the work. The one shown here depicts the prisoner's vision of the previous occupants of the death cell: 'The cell seemed to be full of men, strange men who carried their heads in their left hand, and held them by the mouth, because there was no hair; all of them showed me their fists, except for the parricide.'

The Phantoms of 1829 (*pl. 173*) is from the same period and illustrates a poem by Victor Hugo from *Les Orientales*, which relates the touching story of a young Spanish girl who dies of pneumonia in the chill of the early morning after returning from a ball: *Elle est morte à quinze ans,/Belle, heureuse, adorée,/Morte au sortir d'un bal qui nous mit tous en deuil/Morte hélas et des bras d'une mère egarée/La Mort aux froides mains/La prit toute parée/Pour l'endormir dans le cercueil.* ('She died at the age of fifteen,/Beautiful, happy and adored,/Died on leaving a ball which left us all in mourning/Died, alas, and was lost to a mother's arms/Death with his icy hands/Took her in all her finery/And laid her to sleep in a coffin.')

174 JOHN MARTIN (1789–1854). *The Fall of Babylon*, 1834.
An English painter, Martin was largely forgotten until recently. J. Seznec (*John Martin en France*, Oxford 1964) has, however, shown that Balzac, Dumas, Gautier, Michelet and Hugo all knew and admired him.

Of humble origins, he began as a painter on porcelain. He took lessons from an Italian, Bonifacio Musso. He found his true metier in painting historical or biblical subjects, treated in a grandiloquent and at the same time personal fashion, as is the case here. The engraving is made from a canvas painted in 1819. Here we find Martin's chief characteristics: his carefully composed ensemble views, the large-scale 'production' of lighting and crowds, the whole theatrical aspect of his works which was accentuated even further by the way in which he presented his paintings, using special optical effects. Finally, the taste for architecture on a grand scale – he had a project to raze old London in order to build a splendid new city – links him with Monsu Desiderio, although their works are very different in spirit. The city of Babylon shown here contains a multi-storey 'block' which would not be out of place in a present-day capital. But Martin's talents are better revealed in his pictures illustrating man's loneliness in the face of the vastness of nature, in which his Romanticism is given a freer rein than in this somewhat academic composition.

175 PAUL GAVARNI, real name GUILLAUME-SULPICE CHEVALLIER (1804–66). Plate from Hoffmann's *Contes fantastiques*, Paris 1843.
Gavarni began working for fashionable periodicals after a journey to the Pyrenees which he made in the same spirit as others went to Rome, and which supplied him with his pseudonym. In 1837 he began contributing to *Le Charivari* and adopted his true style. He became the creator of 'the comedy of manners in pencil' (Goncourt); at first full of lightness and brilliance, his art gradually moved towards cruelty and bitterness. During his visits to London between 1848 and 1852, he discovered the misery of the poor quarters and slums. The end of his life was overshadowed by personal sorrows.

He was at the height of his powers when he produced this delightful edition of the *Tales of Hoffmann*, decorated with vignettes engraved on wood, inserted in the text itself, which is the prototype of the Romantic book. The illustration shown

here comes from the duel between the magician Albanus and the fairy Rosenschoen, each of whom is protecting a claimant for the love of the heroine. The duel is a battle of spells, and while the fairy prevents Albanus from opening his book, when she tries to do so herself the pages come out and fly away, growing to an enormous size. The incident is worthy of Lewis Carroll.

176 DAVOINE. *Nightmare*, 1859.
Davoine generally produced drawings and this *Nightmare* is his only known lithograph. It is an homage to Tony Johannot and includes all the characters from the latter's *Voyage où il vous plaira* (*pls. 177–9*), or at least all those who form part of the narrator's dream. In the doorway on the left we see the sinister characters from *pl. 179*, while near the centre is the farm-hand with his lantern, of whom Musset says 'he was not handsome, but what use would it have been to him if he had been?' In front of him is 'the best tailor in town' and beside him 'the hideous figures in whom I was distressed to recognize a large number of my friends', then his friend Jean with his hair standing on end, who is also found on top of the wall; and finally the brain operation, although Davoine has changed the patient's head and it is not the man in the straw hat whose brain gets smaller, but a 'Romantic', perhaps Musset himself. Above is the 'guard who keeps watch from the top of the bell-tower' with his horn, and on top of the wall the political candidates and their electors. The whole is embellished with various monsters, among which the animated letters forming the word *cauchemar* are a charming feature. The word 'Panadar' written on the box from which a gnome is emerging is perhaps a reference to the famous *Panthéon de Nadar*, in which Nadar brought together a whole constellation of contemporary celebrities, and which had begun to appear in 1854. The engraving with its collection of monstrous creatures is perhaps intended as a satire on the Romantic celebrities, as well as a celebration of Johannot's talents.

177–9 TONY JOHANNOT (1803–52). Plates from *Voyage où il vous plaira* ('Journey for your pleasure') by Alfred de Musset, Paris 1843.
This work is one of the most charming of Romantic books. In his preface, Musset states modestly that the idea originated with Johannot and that the text was merely intended to follow the course of the latter's imagination. Johannot was a highly prolific illustrator (he left more than three thousand engravings and the illustrations to 150 books), who conquered the Romantics with the spontaneous charm and vivacity of his drawing.

The book invokes the title of a play by Calderón, *La vida es sueño* ('Life is a dream'). It relates the nightmare of a young man in love; dream alternates with reality, but the dream is a nightmare and reality is idyllic.

On the title-page of *Voyage où il vous plaira* (*pl. 177*) the word Introduction appears comically in the gaping maw of the beast, while above the latter's head, the hero's betrothed – who will banish the monsters of the imagination – lies in a languorous pose.

The hero's steed tips him into the water (*pl. 178*), where he wakes the sleeping marsh demons (in fact the weeds in which he has become entangled). 'When I was at the bottom of the water, I remembered these lines from Ariosto: one must be very obstinate not to cry mercy when one has water up to the waist.' The figure of Jean, the narrator's friend, is seen silhouetted in the distance.

'In a narrow valley we met three individuals of somewhat evil appearance' (*pl. 179*). They are in fact pilgrims, an honest trio bringing back indulgences from their journey. These three illustrations show all the characteristics of Johannot's style: verve, humour, a taste for the grotesque, and a rather careless technique.

180–3 JEAN-IGNACE-ISIDORE GÉRARD, called GRANDVILLE (1803–47). Plates from *Un autre monde* by Taxile Delord, Paris 1844.
Grandville was the son of an obscure miniaturist from Nancy. His health was poor and he died at the age of forty-four. Possessed of an open mind and a critical intelligence, he approached all ideas, whether new or old, in the same questioning fashion. A ferocious political satirist, he treated the July Monarchy mercilessly until *Le Charivari* and *La Caricature*, to which he contributed, were banned.

His first wife, Marguerite, urged him to exploit his talent commercially, and used any of his productions which did not satisfy her business sense as curling papers. When she died, he remarried, but this was not enough to cure his sadness at having lost his first two children, and the sudden death of his last son was the final blow. After various morbid presentiments (the figure seven appeared frequently in his work at the time) he died on 17 March 1847.

The name Taxile Delord may have been a pseudonym for Grandville. This is Grandville's most famous work, and one of those chiefly responsible for the modern tradition of 'nonsense'. The opening quotation 'To travel is to live' could equally have served for Musset's *Voyage où il vous plaira* (*pl. 177*). We find here the same mixture of dream and reality. Grandville's extraordinary ability to re-invent objects and their functions and his observations of nature combine in the creation of a series of characters whose actions parody either the events of his time, or the incidents and misfortunes of his own life. The resulting works are pictorial poems, resembling the 'collages' of automatic writing, but in which the element of chance is perfectly controlled. Baudelaire once wrote: 'When I enter Grandville's world I have a feeling of unease, as though I were in an apartment in which the disorder was systematically organized, where absurd-looking cornices were resting on the floor; it is by virtue of the insane side of his talent that Grandville is important.'

Un autre monde is a series of wanderings by three characters, Doctor Puff, Krackq and Hahble, through various strange worlds. As in *Gulliver's Travels*, each chapter contains a moral tale in which the text and illustrations are closely linked.

In *The Mysteries of the Infinite* (*pl. 180*) a conjurer juggles with the planets and aeroliths (or meteorites), one of which happens to be a *Croix d'honneur*.

'Thus it was that Hahble was initiated into the great law of the equilibrium of worlds, though not without running a very great risk. In mounting the part of the planet which the Ancients called Culmen, an aerolith, known to the scholars under the name of *Croix d'honneur*, passed a short way away from his head. If his forehead had been tilted a little further to the left, it would have been all up with him. Woe betide the mortal upon whom the aerolith has executed its descent!'

The Steam Orchestra: Melody for 200 Trombones (*pl. 181*) transforms the steam-engines of the last century, with their vast machinery, their copper tubes and their rich variety of rhythms, sounds and reverberations, into an orchestra of mechanical trombonists.

The Kingdom of the Marionettes: the Apocalypse of Ballet (*pl. 182*) is inspired by Grandville's memory of the occasion when one of his cousins, who was a stage-manager at the

Opéra, took him into the wings. Dazed and fascinated by the movement of the ballet, its ability to fill and transform the space of the stage, Grandville translated it into this whirlwind of different creatures and objects, following one another round and round in a series of endless spirals. The hands of the audience turn into lobsters' claws. Grandville often uses this kind of 'shorthand' to give a more intense expression to his ideas; the seats occupied by hands give a forceful impression of the audience's applause, just as in another picture the men in the stalls, dazzled by a beauty sitting in a box, are reduced to rows of figures in evening dress whose heads are a single eye, absorbed in contemplation of the woman.

In *The Kingdom of the Marionettes: the Landscape Painters* (*pl. 183*) Grandville satirizes the landscape painters who formed one of the turning points of representative art in the nineteenth century. He mocks their methods, their equipment, their subject matter and their obsession with the 'finish' of the composition: 'He learned with admiration that one of these conscientious artists, having undertaken the task of reproducing a palm, had seen his model flower and fade three times before this work of patience was finally completed.'

Here the artists are 'striving to paint a vast expanse of birches'.

184–8 EUGÈNE DELACROIX (1798–1863)
Prompted by the illustrations for Goethe's *Faust* produced by Moritz Retzch in 1821, Delacroix decided in 1828 to do a series of lithographs for the work in its translation by Albert Stapfer (*pls. 184–5, 187–8*). Delacroix was in a fallow period, deprived of work as a result of the intrigue mounted against him after *The Death of Sardanapalus*.

He prepared for this work with a series of paintings so as to show the publisher and lithographer, Motte, exactly what he wanted to do. Although a great deal of care was lavished on the book, it was not a success, which distressed Delacroix and also resulted in his being labelled the 'master of ugliness' (see Pierre Courthion, *Romanticism*, Lansanne 1961).

Certainly the work does not fit in with the standards of the time, and 'expert' opinion tends to be critical of the drawings' lack of finish, and a degree of carelessness in the anatomical rendering of horses and human beings, which was a sacred subject with academicians of the time.

The series consists of seventeen plates which are now considered as the masterpiece of Romantic lithography. Delacroix has imbued his compositions with a visionary force which amply conveys the Germanic passions of the original.

Goethe himself was astounded, and proved to be the most lucid critic of the time: 'The powerful imagination of this artist forces us to rethink the situations as perfectly as he has conceived them himself. And if I have to confess that in these scenes Monsieur Delacroix has surpassed my own vision, how much more vivid will they appear to the readers, and superior to what they had imagined.'

Margarete's Ghost appearing to Faust (*pl. 184*) shows the hellish realm of monsters which symbolizes Faust's inner world, with Margarete appearing white and pure as the incarnation of remorse.

Faust and Mephistopheles galloping in the Night of the Sabbath (*pl. 185*) are shown passing the gibbets – an allusion to the one on which Margarete is executed after her infanticide.

In *pl. 186*, *Faust and Mephistopheles flee* after the murder of Valentin, Margarete's brother, who wanted to avenge his sister's honour but dies cursing her.

Macbeth consulting the Witches of 1825 (*pl. 187*) is a Shakespeare subject produced before *Faust*, and marks an important stage in the development of Delacroix's graphic work. Here he shows his perfect mastery of the lithographic technique, which he only took up in about 1821 after seeing the works of Charlet, Goya and the young Géricault. It should be remembered that at that time lithography was considered a minor art in France, whereas in London it was fully recognized. After some initial trials with aquatint, Delacroix showed the maturity of his technique with *The Negro on Horseback*.

His stay in England gave him a view of those misty landscapes which were so favourable to Romantic inspiration. *Macbeth* was one of the first works he had printed by Motte, in the year of his return from London.

Faust and Mephistopheles in the Tavern at Auerbach (*pl. 188*) is one of the first episodes in the work. 'Delacroix has chosen the moment where the spilled wine bursts into flames and the drinkers reveal their bestiality. The scene is filled with movement and excitement; only Mephistopheles retains his customary serenity and calm. The blasphemies, cries and imprecations, the unsheathed knife, all leave him indifferent as he sits at the end of the table. His raised finger is all that is needed to extinguish the flames and calm the general excitement.' (Pierre Courthion, *Romanticism*, Lausanne 1961.)

189 GUSTAVE DORÉ (1832–83). Plate from *Contes drolatiques* by Honoré de Balzac, Paris 1855.
A painter, sculptor and engraver who showed great talents at a very early age, Doré produced his first lithographs at the age of twelve. His early influences were Grandville, Toepfer and Gavarni. In 1847 he began contributing to the *Journal pour rire* and from then on established a continuous and prolific rate of production. Because of his massive output, his work is not always of the same quality, and some of his engravings are no more than routine studio works. But the variety of his subject matter and his power to evoke a sense of mystery make him one of the most forceful and poetic of illustrators. He has left his mark on the imaginations of all those who were exposed to his work in their childhood, and Colette is not the only one for whom the magic world of Perrault's tales is forever linked with Doré. Théophile Gautier exclaimed: 'What richness, what strength, what intuitive depth, what penetration of the most varied subjects. What a sense of reality, and at the same time, what a visionary and fanciful mind!' and Henri Focillon described him as 'the last magic wand of Romanticism'.

Doré did not do his own engraving, and his drawings were done in wash as well as line, so that the engraver was left a certain amount of freedom. At least 137 engravers of his work are known.

The *Contes drolatiques* are considered by many as a masterpiece of comic style, or imagination and Rabelaisian good humour, showing all the grotesque and truculent animation which he was to show in his engravings of London. Bibliophiles now tend to prefer his small-format works, in which the drawing is more spontaneous and full of vivacity, and which are more manageable than the large-folio volumes with their carefully prepared and rather theatrical plates.

In his work, Doré gave free rein to his medieval inspiration, his taste for the 'gothic' which was so dear to the Romantics, and which he became imbued with during his childhood, which he spent in the shadow of Strasbourg cathedral.

190 JEAN PIERRE MARIE JAZET (1788–1871). *Leonora; or, The Dead Travel Quickly*. After Horace Vernet (1789–1863).

Jazet was an engraver who specialized in aquatint and mezzotint; he exhibited at the Salon between 1817 and 1865, chiefly with reproductions of the works of Horace Vernet.

The theme of Leonora, inspired by the ballad by Bürger (1775) was bound to appeal to the Romantics. It is the story of a girl who curses God for having taken away her fiancé, who has died in battle. One night the fiancé returns and carries her off on his horse; after a fantastic ride the earth swallows her up in the arms of her lover, who has turned back into a skeleton.

Tony Johannot did a lithograph on the subject; in 1830 Ary Scheffer produced a forceful sketch in oils which is fairly near to Delacroix. Horace Vernet's version was painted in 1839; it is an unusual work for a painter who otherwise specialized in rather academic pictures of battles.

The composition of the engraving is striking: on the back of the horse with its smoking nostrils (we have already seen the nightmare associations of the horse in Hans Baldung Grien's *The Bewitched Groom*, Fuseli's *The Nightmare* and Delacroix's *Faust and Mephistopheles galloping*), the white flesh and blonde hair of Leonora contrast with the dark, gleaming armour of the rider. An intense light shines from the eye sockets of the macabre face, bathing the whole scene in a sinister glow. The whole picture gives an impression of the terror of Hell.

191–5 GUSTAVE DORÉ (1832–83)

The illustrations to Dante's *Inferno* (Paris 1861) made Doré known to the general public and brought him international fame, since some of them were published simultaneously in ten different countries. He subsequently illustrated the whole of the *Divine Comedy*, and not the least of his *tours de force* was his successful treatment both of the oppressive world of the Inferno and the luminous, airy world of Paradise, with its whirling clouds, its plays of light and suggestions of the aurora borealis. The series of engravings from the *Inferno* shows Dante, guided by Virgil, descending into the Circles of Hell in the very depths of the earth.

Pl. 191 illustrates the punishment of the hypocrites, each forced to wear a gilded cope made of lead (Canto XXIII, v. 91–3).

In the Fifth Circle (*pl. 192*) the quick-tempered crawl in the muddy sloughs of the Styx, tearing at each other with their teeth, while the lazy, at the bottom of the mud, sigh for the gentle sun (Canto XII, v. 115–16).

In the Seventh Circle (*pl. 193*), beyond the Phlegethon lies a jagged wilderness of scrub where the harpies live. The souls of suicides try in vain to tear themselves free from their bodies, which have been transformed into twisted plants and roots, and in which they remain imprisoned as a punishment for having tried to escape from them in the first place (Canto XIII, v. 10).

Doré's illustrations to *Le Juif errant* by Michel Lévy (*pl. 194*), were published in 1856, engraved by G. Gauchard.

The theme of the wandering Jew is a very popular legend which can be traced back to thirteenth-century England and later appeared in Germany. It underwent a revival during the Romantic period. Goethe used the story in an epic poem, which he did not finish. Eugène Sue produced a version of it illustrated by Gavarni, Friedrich Schubert and Arnim likewise. Here the Jew tells how he refused to have pity on Jesus when he wanted to stop at his house on the way to Calvary: *Jésus, la bonté même,/Me dit en soupirant:/Tu marcheras toi-même/Pendant plus de mille ans./Le dernier jugement/Finira ton tourment.* ('Jesus, who was goodness itself,/Said to me with a sigh:/You will walk yourself/For more than a thousand years./The last judgment/Will end your torment.')

Doré illustrates the last two lines: 'the last judgment will end your torment'.

His *The Departure from Aigues-Mortes* (*pl. 195*), an illustration to *L'Histoire des Croisades* by Milhaud, Paris 1877, portrays the embarkation of Louis IX and his followers in 128 ships. The mariners sing the *Veni Creator* in chorus and all the knights commend their souls to God, the majority of them being filled with terror as it was the first time that they had travelled by sea: 'A man must be mad to put himself in such danger just because he has a few sins on his conscience; one goes to sleep at night without knowing if the next morning, one may not be at the bottom of the sea.'

Doré preferred working on a grand scale and it was his ambition to illustrate a history of the world, for which his Bible and the history of the Crusades may be seen as a trial run.

196–8 CHARLES MERYON (1821–68)

Born in Batignolles, Meryon had an English father; he first went into the Navy, from which he resigned in 1847 to devote himself to painting. After a fruitless period of apprenticeship in which his colour-blindness proved a major disadvantage, in 1849 he discovered the etchings of Eugène Bléry (a lithographer chiefly known for his views of the forest of Fontainebleau) and asked him to teach him the technique. In 1850 he produced the first of a series of views of Paris which he was to continue until he entered the Charenton lunatic asylum in 1866; he died there two years later.

When in the Navy, Meryon had spent some time in the South Pacific, and had brought back numerous drawings which for some time he thought of engraving; but it was above all Paris which he explored and depicted and to which he devoted his best efforts. A solitary person, he remained cut off from the world both in art and inspiration. Possessed of a solid technique, he deliberately ignored the artifices and effects which were practised at the time. His lines are as clean as those of an architectural drawing, but saved from sterility by a profound sensitivity to light. Line work is used to render shadows, greys and whites, the texture of rough-cast walls and the velvety surface of zinc roofs. The only additions are those of his own personal fantasies, introducing a note of irrationality which was to become stronger and stronger as he yielded to insanity.

In *The Ministère de la Marine* of *c.* 1860 (*pl. 196*) Meryon gives us a cleverly angled view of Gabriel's building as seen from the rue Royale. The clarity of the scene, the crispness of the lines and the cold contrast of the shadows suggest an almost 'clinical' study of the building. At the same time the delicate vibration of the hatching gives warmth to the reflected light and conveys the artist's emotion in the face of the building's historical associations; for it had witnessed many human dramas, as is suggested by the scene outside the building. The contrast is therefore all the more striking with the devilish invasion from the sky, where primitive figures riding dolphins like war-canoes float down as if coming to attack and defy the Cartesian classicism of Gabriel's architecture.

The Old Gate of the Palais de Justice of 1854 (*pl. 197*) is detached from the rest of the building and placed by the artist in a circular frame, transforming it into a symbol of the city, an effect which is reinforced by the banner spread aloft by a devil. In an earlier version, Meryon had also engraved the tomb of Molière above it. Here again, Meryon

171

is sensitive to the monument's historical weight, to the sinister events it had witnessed, which he combines with his own anguished visions.

The *Pont au Change* of 1852 (*pl. 198*) was among the first 'Etchings of Paris' Meryon produced in the years 1850–2. Although it is an early work, his technique is already perfect. His penetrating mind has so to speak cleared the Parisian atmosphere of that hint of mist which only disappears in times of intense cold. The northern façades of the Conciergerie and the Palais de Justice are bathed in an unaccustomed light which transforms this familiar scene.

The atmosphere is made even stranger by the presence of a balloon and a flight of birds in the sky. When Baudelaire asked him why he put so many eagles in the Parisian sky, Meryon replied that 'this was not without foundation since those people (the Emperor's government) had often set free eagles to study the omens according to ritual'.

199 FÉLICIEN ROPS (1833–98). *The Organ of the Devil.*
A Belgian engraver, Rops began by producing lithographs in his newspaper *Uylenspiegel*, then came to France and discovered etching. He specialized in illustrating books with an erotic flavour, and his somewhat superficial and contrived blend of satanism and eroticism is not devoid of humour. But if one compares his figures to those of Ensor, another Belgian engraver and painter (*pl. 214*), the commercialism and lack of sincerity immediately become apparent.

The plate shown here reflects the popular nineteenth-century Catholic view of lust as the worst of all sins, and woman as the devil's instrument *par excellence*. The theatrical composition lays great emphasis on the whiteness of the female figure, wearing only a pair of stockings, which stands out against the dark drapery, while behind it is the outline of the devil who manipulates her.

200 EDMOND MORIN (1824–82). *The Sources of the Budget,* illustration from *Le Monde illustré*, 2 May 1863.
Morin was a caricaturist who contributed to French and English journals, including *Pen and Pencil* which he founded, and *Le Magasin pittoresque, Musée des familles* and *L'Illustration*, for which he produced very lively drawings of minor current events. The most famous work which he illustrated was *Monsieur, Madame et Bébé* by Gustave Droz, in 1878. The plate shown here is a satirical one. In a seedy office which suggests a cross between an alchemist's den and a clandestine distillery, all the sources of taxes and levies of the time (dogs, tobacco, alcohol, coaches, postage stamps, doors and windows) are boiled up in a vast retort to produce the gold to fill the nation's coffers; the fire beneath is fuelled by legal notices and summonses.

201–6 RODOLPHE BRESDIN (1822–85)
Bresdin led a miserable life although he was admired by a brilliant intellectual elite including Robert de Montesquiou, Théophile Gautier, J.-K. Huysmans, Baudelaire, Théodore de Banville, Mallarmé, Courbet and Odilon Redon, who was both his pupil and his most accurate biographer. He was nicknamed Chien-Caillou, a corruption of Chingackgook (the hero of *The Last of the Mohicans*), meaning the master with the rabbit, because he lived with a variety of animals. He usually lived in attics – in Bordeaux he even lived in a roadmender's hut – feeding off grasses, vegetables and water and dreaming of 'the Americas'. When he finally realized his dream by going to Canada, it was a disappointment. He got married in 1865, but found himself alone again after quarreling with his wife. He was appointed deputy roadman

at the Arc de Triomphe, and died of pneumonia in Sèvres, in a vast attic forty metres long.

Bresdin's works were very small and are often reproduced larger than the original. The detailed and elaborate composition, the predominance of vegetable forms – which won him the additional nickname of the 'inextricable' engraver – the mysterious distant prospects and the play of light and shadow in his forest landscapes all combine in a meticulously engraved dream world which links Bresdin with the Northern medieval tradition. At the same time, his technical virtuosity is never an end in itself, but always the servant of his inspiration.

The Comedy of Death (*pl. 201*) is described by J.-K. Huysmans in *A Rebours*, 1883. It dates from 1854 during Bresdin's period in Toulouse. Everything is dead, except for a rampant undergrowth covering the earth; the trees spread their leafless branches, water no longer flows (cf. an entirely different treatment of the same theme in Hogarth's *Finis; or, The Bathos, pl. 138*). Time is fettered, Death triumphs. Fantastic nocturnal creatures complete this vision of another world, the world of Death. Only the light, treated in the manner of Rembrandt, leaves some room for hope, which is perhaps confirmed by the gesture of Christ.

The Port (*pl. 202*) dates from 1882, during Bresdin's last period in Paris, when he was deputy roadman at the Arc de Triomphe. At the time he was living in the hope of an exhibition in his honour which was to be organized by *La Vie moderne*. As in his other engravings of ports, which were a favourite subject of his, the water is reduced to a small area at the bottom of the composition, and the boats here in particular seem destined to remain with sails furled and never put to sea. Their occupants appear to have settled down to providing their own subsistence like castaways, while the few ships which do have their sails spread seem out of place against the confining wall of the town beyond.

One is struck by the symbolic likeness to Bresdin's own situation, confined to port without any hope of escape.

Entrance to a Village of 1861 (*pl. 203*) depicts a peaceful little village by some water, with all the familiar signs of life – the man on a mule, the boat and its fishermen, the birds and children; and yet the water is somehow suggestive of evil; it is stagnant water with reeds, such as Bresdin was fond of depicting (*The Butterfly and the Pond; The Woodland Stream; The Watercourse, the Marsh, the Fen; The Town beyond the Fen; The Lake in the Mountains*). Bresdin's fascination with water calls to mind the study by Gaston Bachelard in *L'Eau et les Rêves* (Paris 1942), according to which there is always some spell connected with it: 'The water fairy who is the guardian of the mirage holds all the birds of the air in her hand. A puddle contains a whole world, a moment's dreaming contains an entire soul.'

Fishermen's Hamlet (*pl. 204*) dates from 1848, during Bresdin's first period in Paris. He was twenty-six years old and living in a sordid room in which a narrow ladder served as a shelf for his rudimentary engraving equipment. The description is given by Champfleury in *Chien-Caillou*, a novel based on Bresdin's life which helped to perpetuate the legend of the neglected artist leading a bohemian life. But Bresdin's correspondence shows us that his suffering was real enough. One of his engravings carries the title 'I have been carrying this stone for fifty years', and Montesquiou called him 'the Ixion of the lithographic stone'.

This fisherman's hamlet has an almost exotic appearance. The vegetation is no longer just a setting, but a force which exercises an influence on the lives of men.

The City beyond the Defile or *The Distant City* (*pl. 205*) was

produced in 1866 during the period in Bordeaux (1862–8), which marks an important stage in Bresdin's life. At this point his output increased, he had a pupil, Odilon Redon, and also friends and admirers.

The City beyond the Defile suggests some Eastern mirage – a magnificent city suddenly appearing resplendent with whiteness and gold. And into such a scene as this Bresdin projects his own hopes. His own life is like that of the traveller lost in a wilderness where nature reveals her splendours but leaves him unprovided. Then it is the narrow gorge, the final passage, with beyond it the city of the just where he will finally be able to settle – the 'America' which was his own personal mirage. But just as mirages vanish when one approaches them, so the city must remain far off; like Buzzati's Anagoor, one cannot enter it. 'The true paradises are lost paradises' said Proust, and likewise a true ideal can never be attained.

The Bather and Death (*pl. 206*) of 1837 was made in Toulouse, after Bresdin's stay in Tulle, which marked his first interest in engraving, and his taste for fantastic expression.

Here again the theme is a Northern one – a young girl's meeting with Death, in which Bresdin manipulates the customary contrast between the delicate young flesh and the skeleton. But here the presence of Death is neither threatening nor even alarming; instead it becomes a manifestation of nature. The tranquil scene is scarcely affected by the distant mountains, bathed in light, and the scene is made even more bucolic by a flight of birds. Death is included quite peacefully as part of the inevitable cycle of nature.

207–10 ODILON REDON (1840–1916)

Redon was born in Bordeaux and led an outwardly calm and unassuming existence, somewhat apart from the concerns of his generation. A contemporary of the Impressionists, he rejected their preoccupation with the thing seen, commenting that he thought the painting of his time 'a little dull-witted'. He was a pupil of the academic painter Jean-Léon Gérôme, but was attracted above all by Gustave Moreau, in common with a whole sector of contemporary youth.

Two encounters were to be decisive for him; the first was with Armand Clavaud, whose theories on the links between the animal and vegetable worlds appealed to his imagination; the second, and by far the most important, was with Rodolphe Bresdin (*pls. 201–6*) in Bordeaux in 1863, who introduced him to engraving and lithography and at the same time into his own fantastic world. Redon's work is divided into two distinct periods, with the watershed around 1900. The first is the period of his charcoal drawings or 'black' works as he called them, commenting that 'black is the most essential colour, it is the agent of the mind', while in the second he produced pastels which were to dazzle Matisse by their colours. Redon, too, was a solitary person. Discovered by the Symbolists, Mallarmé and Huysmans, with whom he struck up a friendship and found much in common, admired by the new generation of Nabis who came to ask him for advice, he continued his work without allowing himself to become diverted or absorbed by other matters. Long walks in the deserted grounds of his father's house during the holidays had fed his imagination as a young man. A taste for the natural sciences led him to study the vegetable world, and this study was to last throughout his life, each element of it forming part of his pictorial language. The thing 'seen' should be described and examined in all its details, but it cannot be the final object of artistic creation. The work of art must use these elements as a starting point; this is why a picture may give an impression of obviousness but quickly

reveals infinite perspectives, which are the fruit of the painter's poetic vision.

Limbo (*pl. 207*) is the fourth engraving in the first album by Redon to be published – *Dans le rêve* (1879). He wrote of himself that up to that age he had 'a plaintive, mystical soul, sympathizing with the outcasts of life'. This series of lithographs began his lifelong misunderstanding with the critics, who failed to see 'that one must define nothing, understand nothing, limit nothing, specify nothing because everything which is sincerely and quietly new ... carries its meaning within itself.' And he adds that his drawings 'therefore have no other more precise definition. They are the result of a human act of expression, placed by means of legitimate fantasy in a play of arabesques, in which I believe the activity resulting in the mind of the spectator will move him to imaginative inventions which will be of greater or smaller significance according to his sensitivity and his tendency to magnify or diminish everything.'

The Reader (*pl. 208*) of 1892 is first of all a homage to Bresdin, since it is a portrait from memory of Redon's true teacher. It was Bresdin who enabled him to depict the world as he saw it, pulsating with life, whereas Gérôme 'at the School of so-called Fine Arts', made him depict shapes 'in outline', so making a straitjacket for Redon's imagination.

It is also a tribute to Rembrandt, not only in the composition but also in the play of light which is softened by a succession of chiaroscuros. Redon said of Rembrandt: 'He created chiaroscuro as Phidias created line. . . . He retained the sensibility which leads into the pathways of the heart; there is no other master whose paintings convey the same sense of drama as Rembrandt's. Everywhere, in his most trifling sketches, the human heart is present.'

Sans cesse à mes côtés s'agite le démon (*The Demon stirs unceasingly at my side*) of 1890 (*pl. 209*) is no. 7 from the illustrations to Baudelaire's *Fleurs du Mal*, which Redon discovered at the age of seventeen, and which had a profound effect upon him. The illustration refers to the first poem of the section entitled *Fleurs du Mal*, which deals with the theme of ennui. Here again, Redon evades the symbols which Baudelaire provides in abundance. But if at first sight Redon's engraving appears as calm as the dawn of creation, by projecting ennui on to this primeval family he applied it to the whole of humanity, like a vast echo of Baudelaire's *Spleen*.

His *Buddha* of 1895 (*pl. 210*) was published in *L'Estampe originale*. Redon was entirely introspective, a man devoted to meditation, and this 'Buddha figure' links him with the Far-Eastern religions such as Zen. Meditation and reverie were for him a means of sounding the universe, and as he wrote on the fly-leaf of his diary, 'I have made an art in my own image.'

211 GUSTAVE MOREAU (1826–98). *King Lear during the Storm*.

Better known as a painter, Moreau occupies a special place in nineteenth-century art. For a long time he was seen only as the teacher of Matisse, Marquet and Rouault. Only writers such as J.-K. Huysmans, Lorrain or Villiers de l'Isle-Adam extolled his magical canvases which were full of mythology and his own personal obsessions.

He produced only a few engravings, being too attached to the use of colour, and certainly they lack the sombre richness and sparkle of his paintings which so recommended them to Des Esseintes and M. de Phocas.

The engraving of *King Lear during the Storm* is done in a fairly bold, modern style, and there is less evidence of the

taste for sinuous lines and the 'finish' which is found even in Moreau's sketches. The storm symbolizes the collapse of Lear's world, but will give him access to an infinitely superior internal reality. The storm plays its part in the destruction of false values which will enable 'initiation' to take place.

212 HENRY HOLIDAY (1839–1927). Plate from *The Hunting of the Snark* by Lewis Carroll, 1876.
The engraving illustrates the fifth 'fit' which is 'The Beaver's lesson': 'The Beaver brought paper, portfolio, pens,/And ink in unfailing supplies:/While strange creepy creatures came out of their dens,/And watched them with wondering eyes./So engrossed was the Butcher, he heeded them not,/As he wrote with a pen in each hand,/And explained all the while in a popular style/Which the Beaver could well understand.'

213–15 JAMES ENSOR (1860–1949)
Ensor was born and died in Ostend, and practically never left his home town except to go to Brussels at the age of seventeen for his formal art training – which, it may be said, he quickly rejected. In 1884 he joined the Belgian group known as Les XX, who held militant exhibitions in favour of freedom in art. His greatest artistic output was in the 1890s, when he underwent a kind of imaginative explosion which lasted five years. His old age was marked by whimsicality, and his creative sense had been lost.

The themes of the mask and the skeleton recur in his work in an obsessional fashion. The mask theme is linked to his childhood. His parents had a souvenir shop in Ostend, which was a treasure-trove of exotic objects, full of dried plants, stuffed animals and masks brought back from overseas. His imagination was captured by the bizarre, staring masks, suggesting a world of magical spells and sacred rituals designed to exorcize the fears of primitive men.

In *Odd Insects* (*pl. 213*) the characters have insect bodies. It is Ensor's own face which appears on the body of the beetle, a comical figure with its cumbersome abdomen and delicately poised legs.

The dragonfly, with its lacey wings suggesting the feminine fashions of the time, is Mariette Rousseau. She was the sister of Leo Hannon (editor-in-chief of *L'Artiste*) and had married Ernest Rousseau who was seventeen years her senior. All three of them were close friends of Ensor. Mariette Rousseau worked in the natural history museum and it was she who taught Ensor to use a microscope. He had already portrayed her in a pencil drawing entitled *Madame Rousseau at the Microscope*. Ensor was probably in love with her, and Blanche Rousseau (*Ensor intime*, Paris 1898) gives the key to this engraving by telling us that Ensor was fond of reciting a passage from *Les Caprices amoureux*. A beetle was sitting under a hedge, sad and pensive; he had fallen in love with a fly: 'Oh fly, light of my soul, be my chosen wife. Marry me, do not reject my love, I have a belly all of gold.'

The first state of the engraving did not show the dragonfly's tail, which was added later.

Odd little figures of 1888 (*pl. 214*) are more portraits of friends and acquaintances, a skull etc. on to which Ensor has grafted insect bodies.

The Triumph of Death (or *Death pursuing the People*) of 1896 (*pl. 215*), is a characteristic example of the carnival pictures which made Ensor famous. These are the festivals in which whole towns spill out into the streets, all social restraints are loosened and all barriers broken down, unleashing the primitive forces of pagan rituals. But by abandoning the protections and barriers which society tries to erect, the crowds are exposed even more directly to the inexplicable forces that govern life. That is perhaps why we often find the figures of skeletons at carnivals, simultaneously defying and deifying Death.

216 ODILON REDON (1840–1916). *The Spider*, 1887.
The Spider is a reworking of a charcoal drawing done in 1881. A grinning human face is superimposed on the hairy body of a spider, an object of horror. The uncertainty of the meaning increases one's sense of unease. The spider is a theme of fantastic literature, the best known example being Marcel Béalu's *L'Araignée d'eau* (the author also produced a drawing on the theme of a human face in a spider's body, which is even more disturbing than Redon's). But the last word is Redon's: 'My drawings inspire but are undefined; they determine nothing.'

Plates 152–216

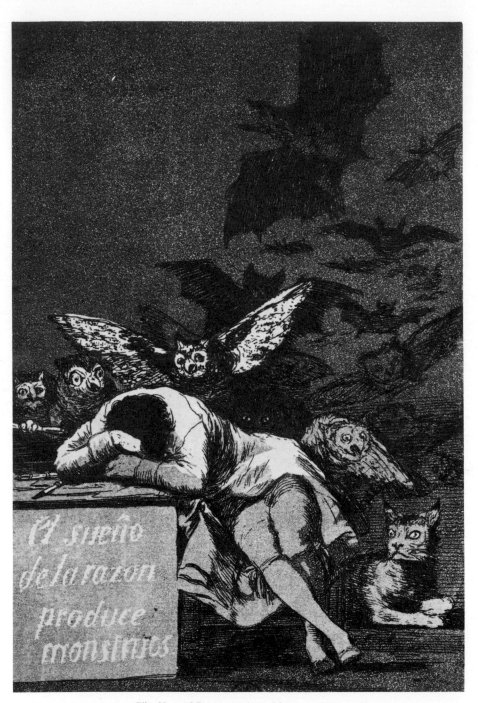

152 FRANCISCO GOYA *The Sleep of Reason produces Monsters* 1799

153 FRANCISCO GOYA *The Colossus* 1810–17

154

155

156

157

158 FRANCISCO GOYA *Strange Folly*

159 FRANCISCO GOYA *Matrimonial Folly*

160 FRANCISCO GOYA *They Escape through the Flames*

161 FRANCISCO GOYA *Charity*

162　FRANCISCO GOYA *Truth is Dead*

163　FRANCISCO GOYA *There is No One to Help Them*

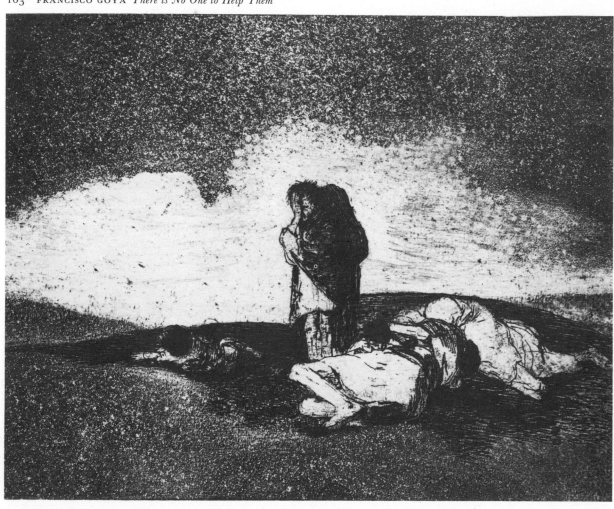

164

165

167

166

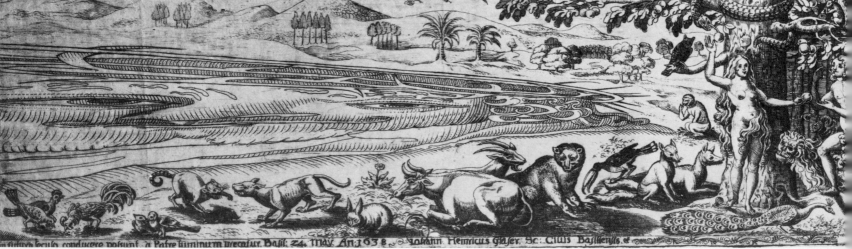

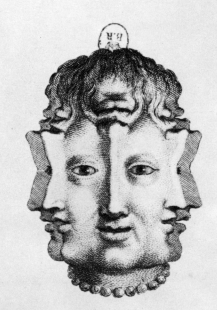

J'aime un bon vieux barbon riche et de
bonne mine
afin d'entretenir mon luxe et ma cuisine

Si vous voiez en moy changement de figure
C'est pour m'acomoder au sexe d'apresent
Chacun sçait que la femme est de cette nature
Qu'elle change a toute heure et tourne
au moindre vent

Ma barbe a vous orner vous est
si necessaire
Que sans elle jamais vous n'auriez de quoy
plaire

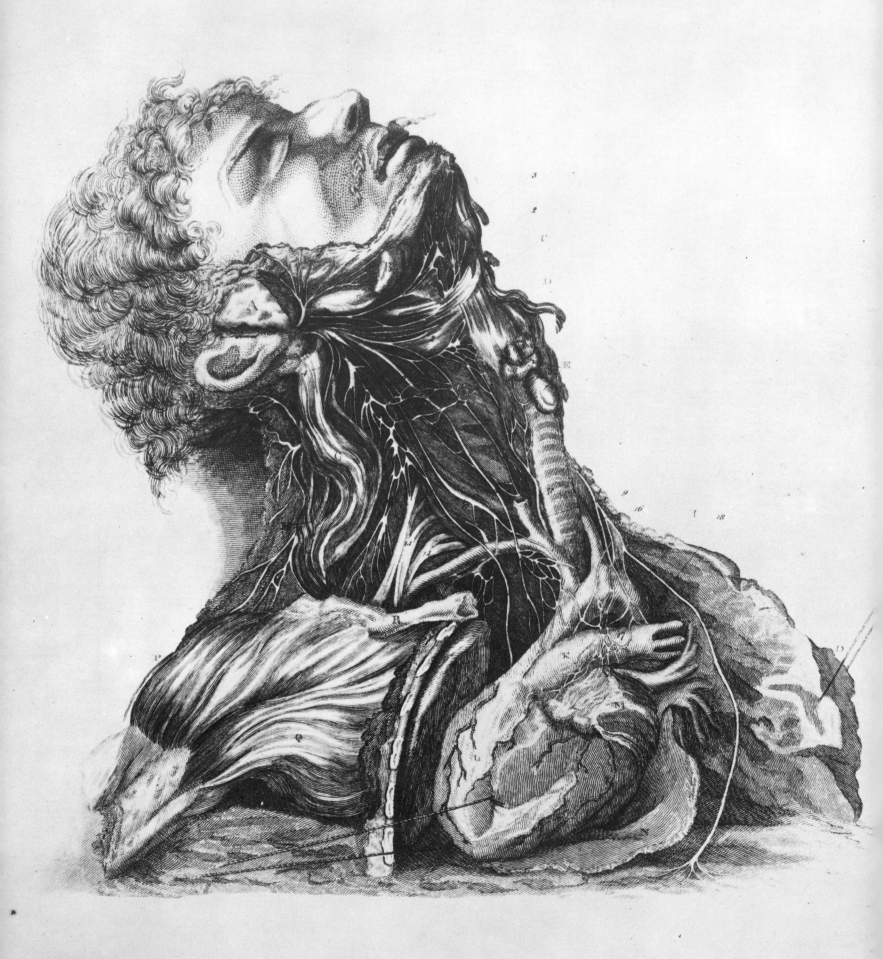

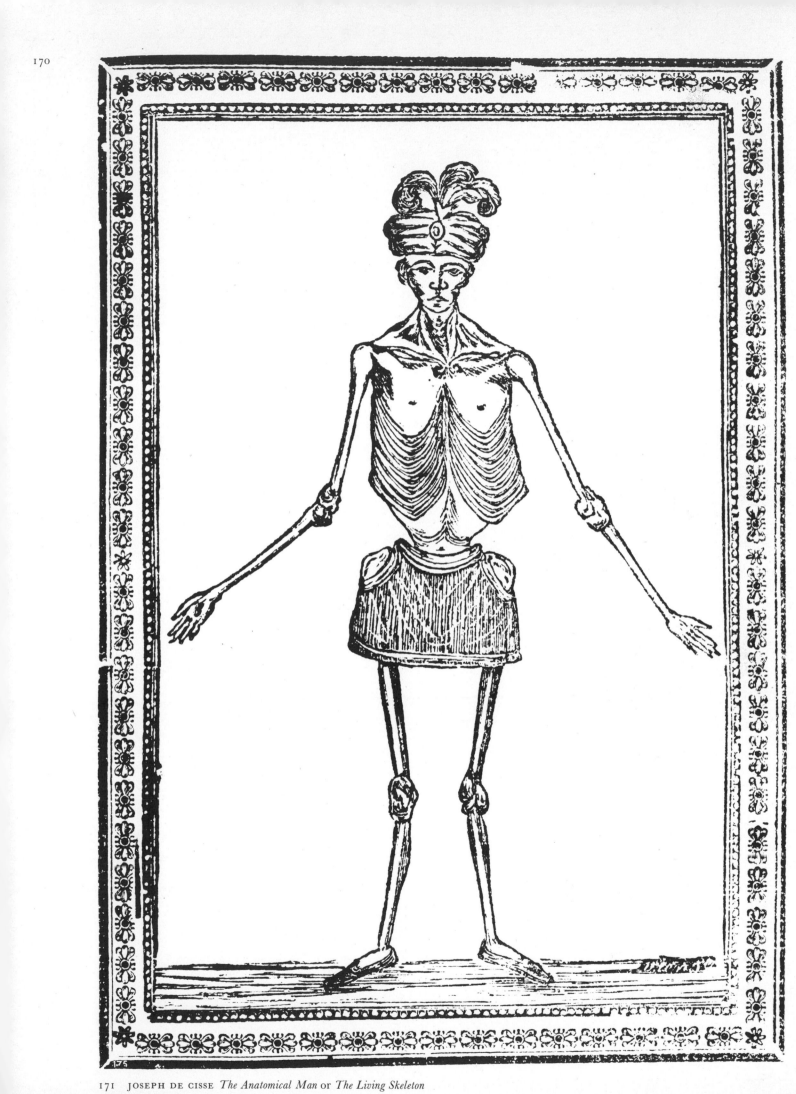

171 JOSEPH DE CISSE *The Anatomical Man* or *The Living Skeleton*

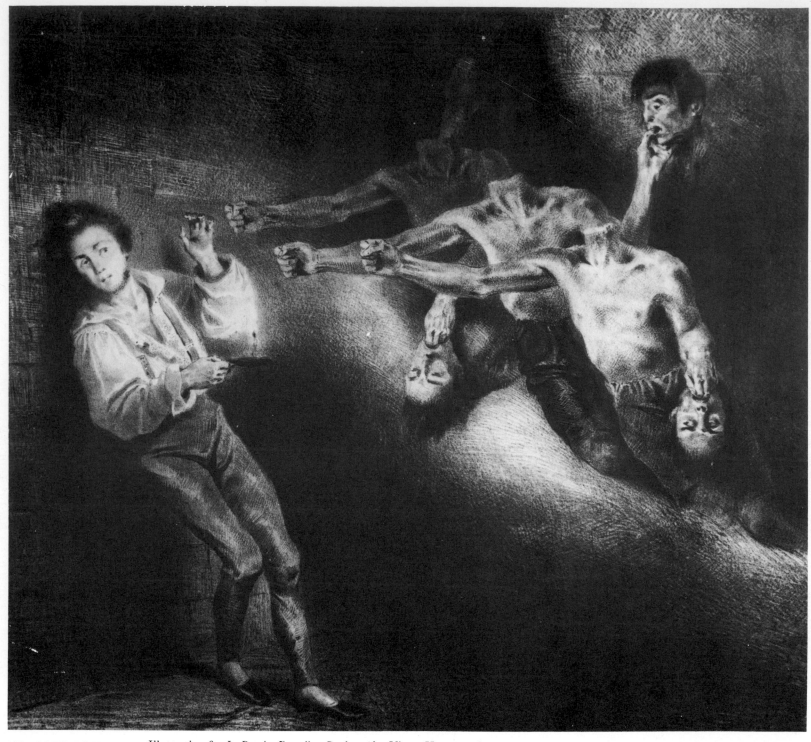

172　LOUIS BOULANGER Illustration for *Le Dernier Jour d'un Condamné* by Victor Hugo, *c.* 1830

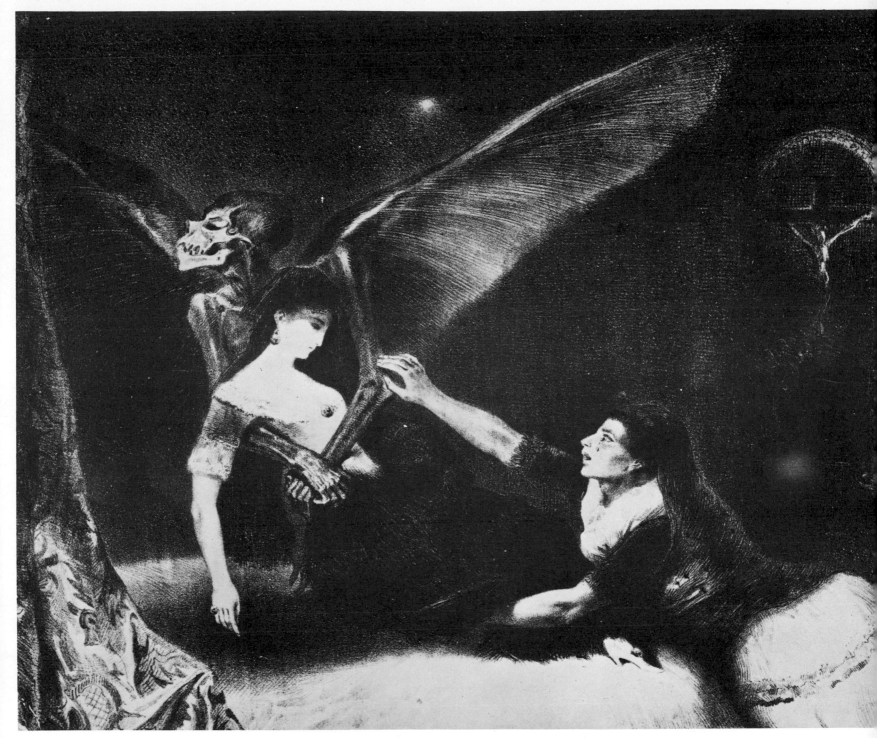

173 LOUIS BOULANGER *The Phantoms* 1829

Overleaf
174 JOHN MARTIN *The Fall of Babylon* 1834

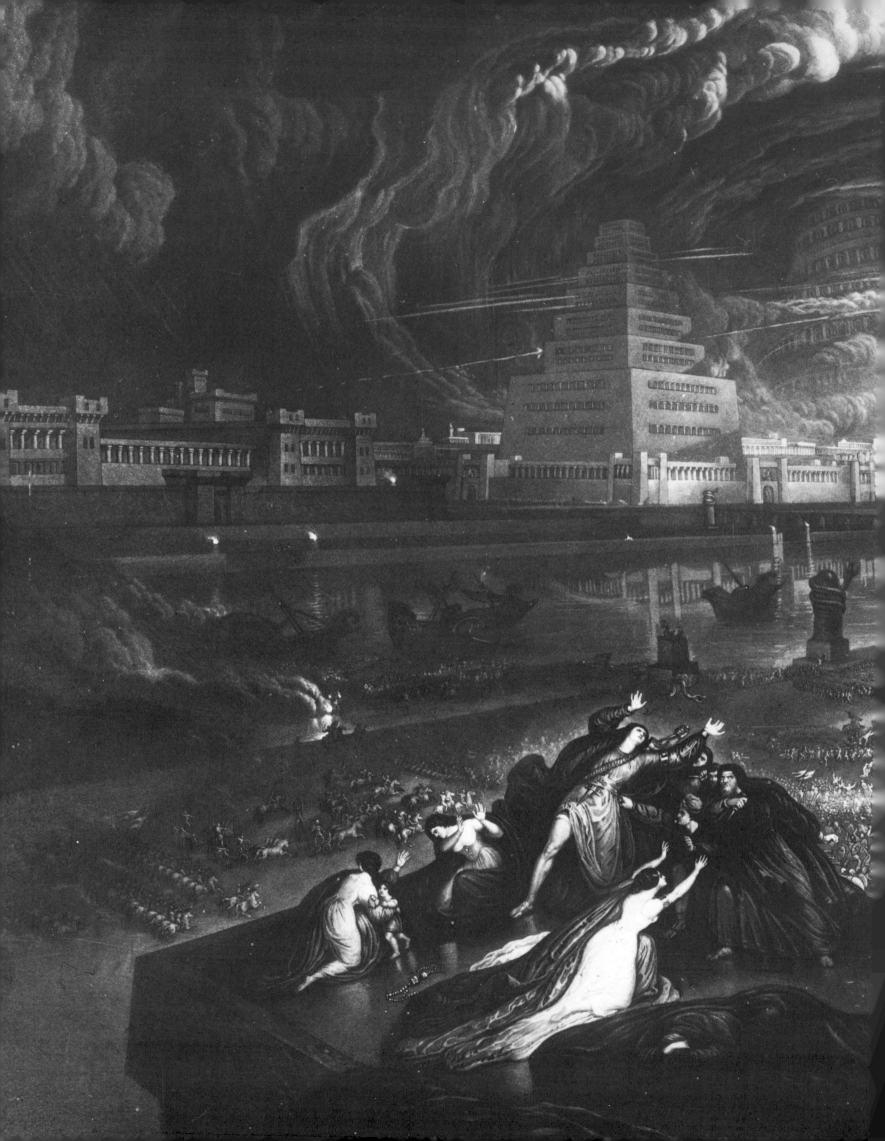

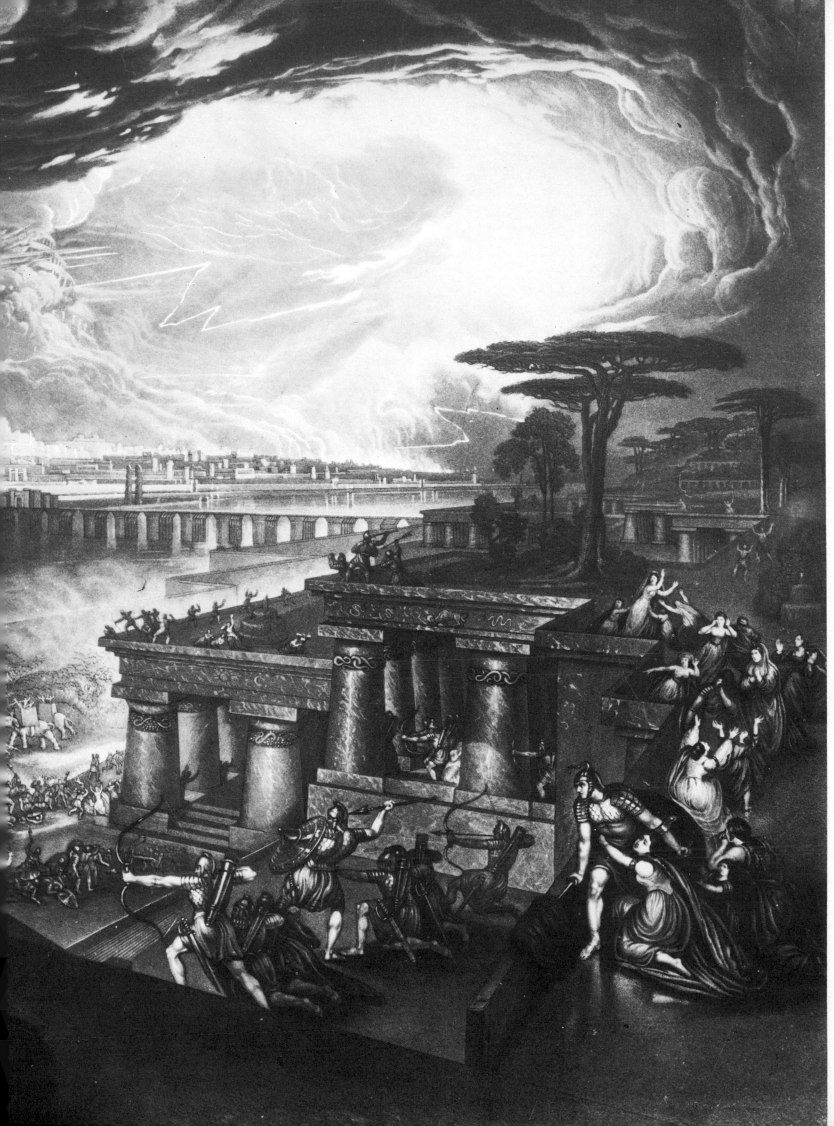

177 TONY JOHANNOT Plate from *Voyage où il vous plaira* by Alfred de Musset, 1843

178 TONY JOHANNOT Plate from *Voyage où il vous plaira* by Alfred de Musset, 1843

179 TONY JOHANNOT Plate from *Voyage où il vous plaira* by Alfred de Musset, 1843

Overleaf
180–3 GRANDVILLE

180 *The Mysteries of the Infinite.* Illustration from *Un autre monde* by Taxile Delord, 1844
181 *The Steam Orchestra: Melody for 200 Trombones*
182 *The Kingdom of the Marionettes: the Apocalypse of Ballet*
183 *The Kingdom of the Marionettes: the Landscape Painters*

184

185

186

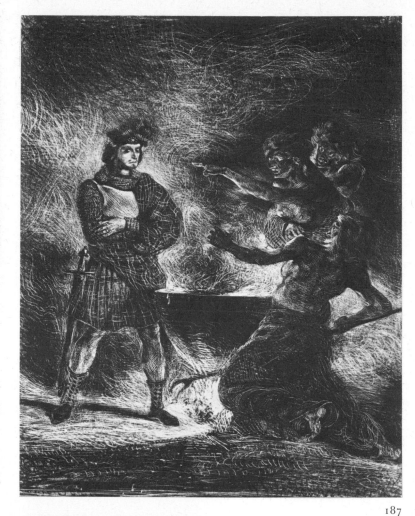

187

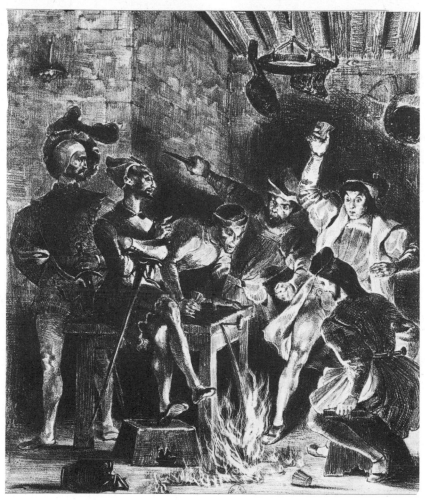

188

189 GUSTAVE DORÉ Plate from *Contes drolatiques* by Honoré de Balzac, 1855

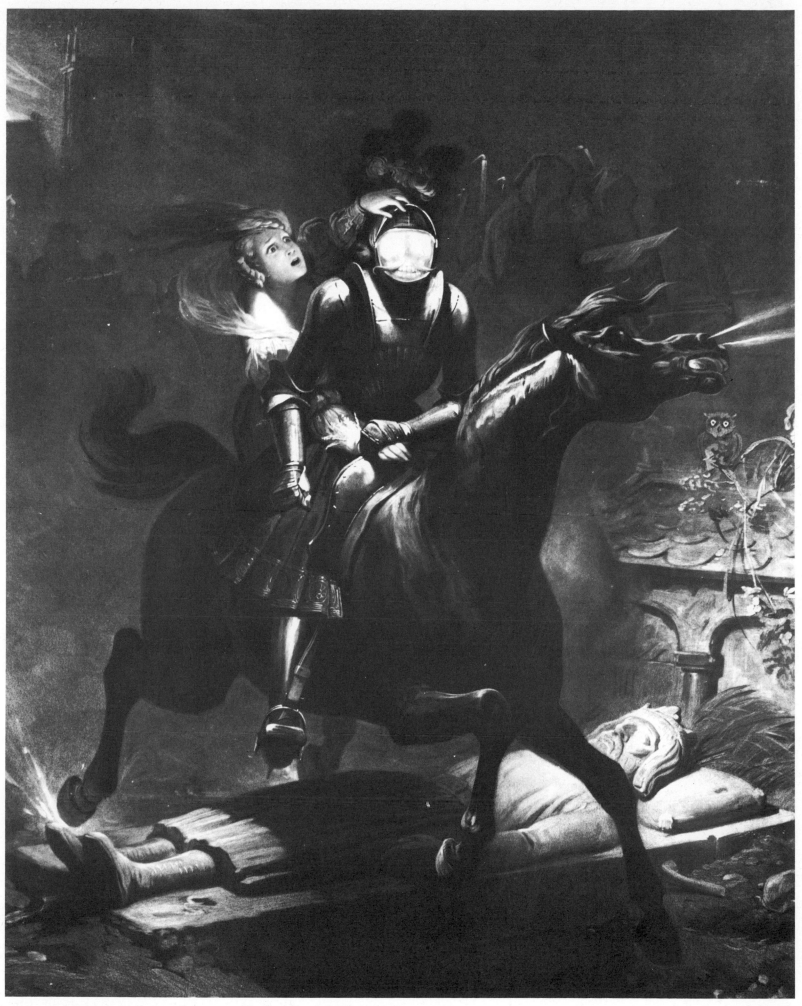

190 JEAN PIERRE MARIE JAZET *Leonora; or, The Dead Travel Quickly.* After Horace Vernet

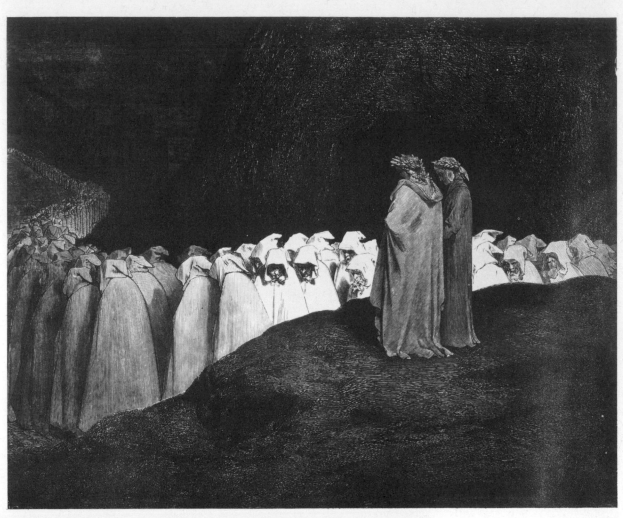

191

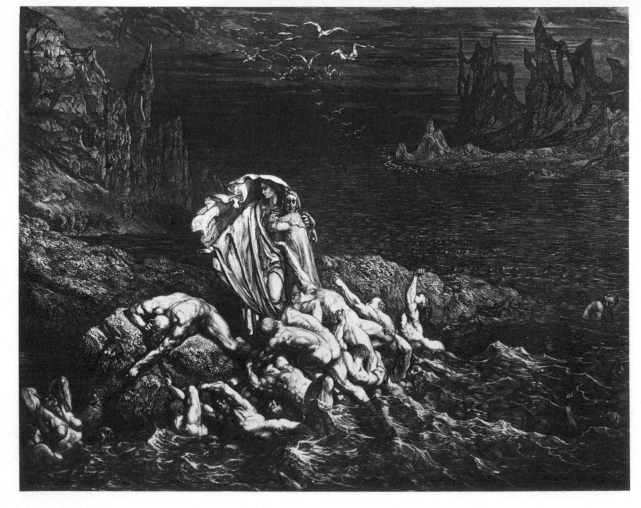

192

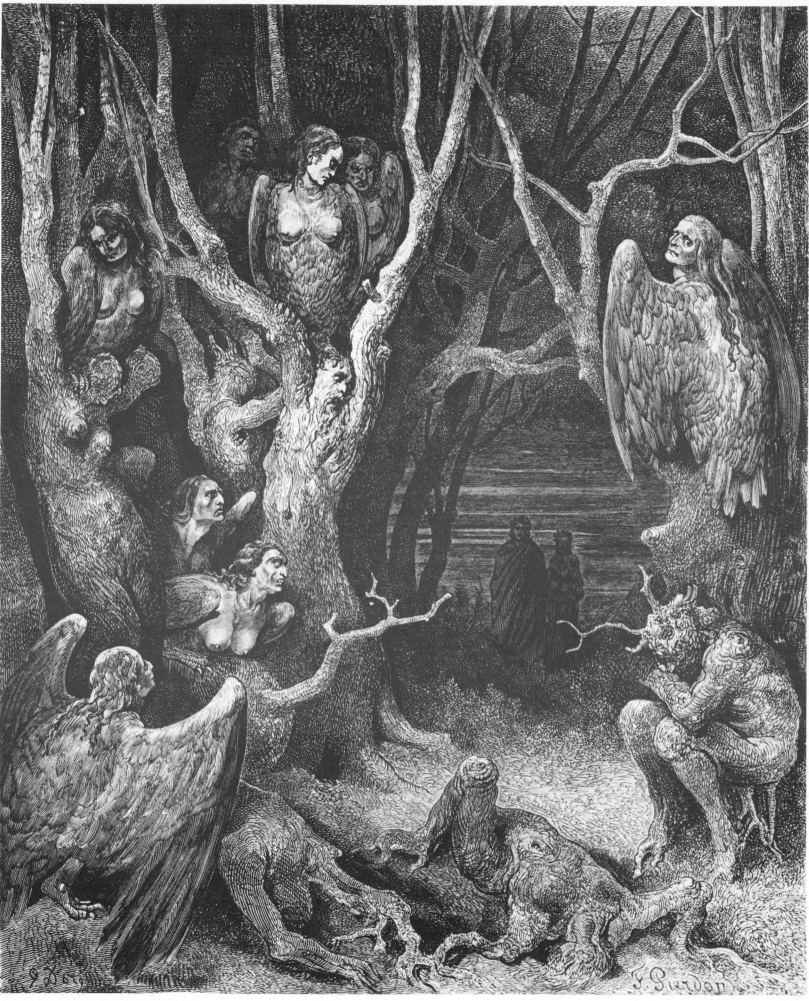

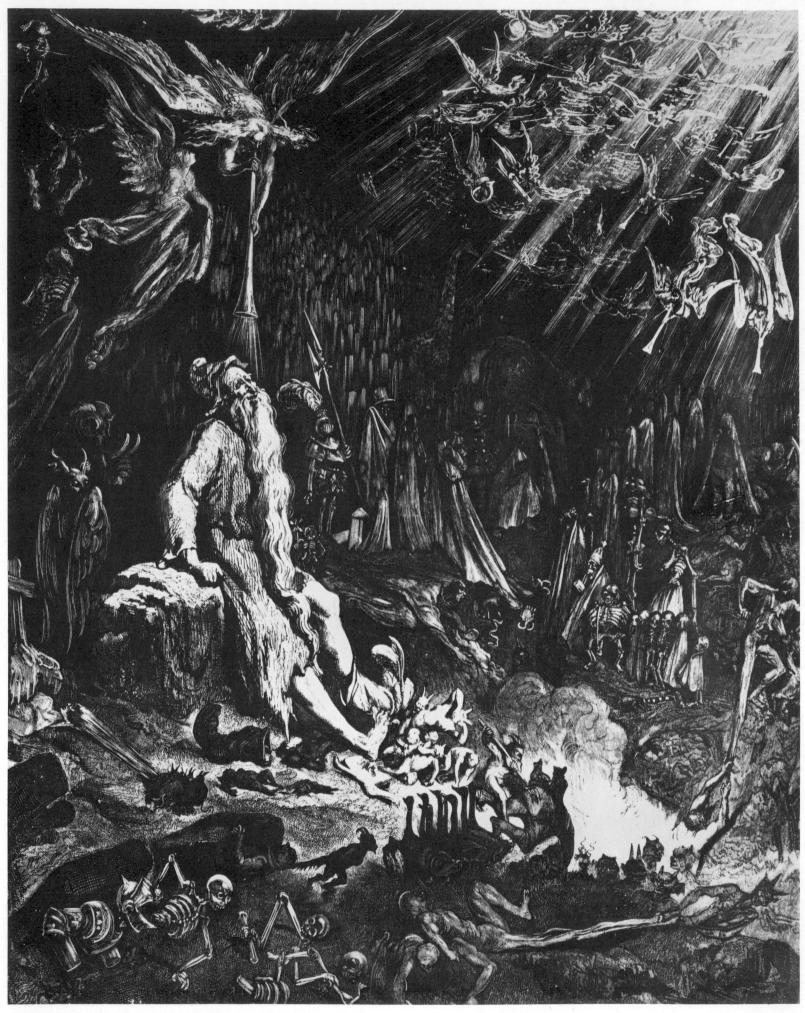

194 GUSTAVE DORÉ Plate from *Le Juif errant* by Michel Lévy, 1856

195 GUSTAVE DORÉ *The Departure from Aigues-Mortes*, from *L'Histoire des Croisades* by Michaud, 1877

196 CHARLES MERYON *The Ministère de la Marine, c.* 1860

197 CHARLES MERYON *The Old Gate of the Palais de Justice* 1854

198 CHARLES MERYON *Pont au Change* 1852

201,202
RODOLPHE
BRESDIN

201 *Comedy of
Death* 1854

202 *The Port*
1882

204

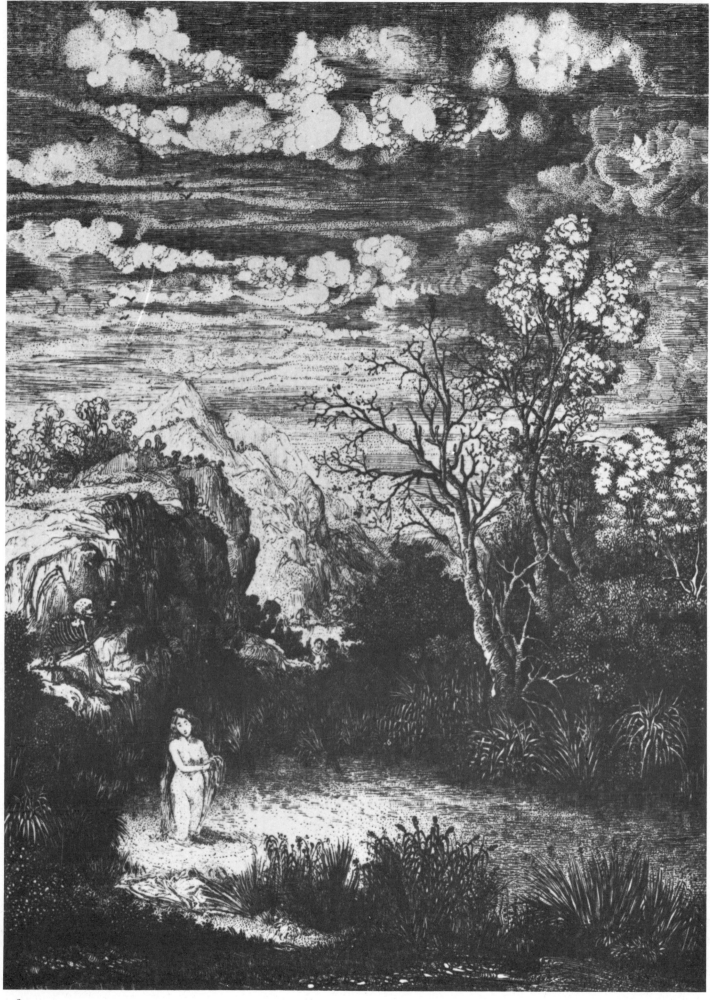

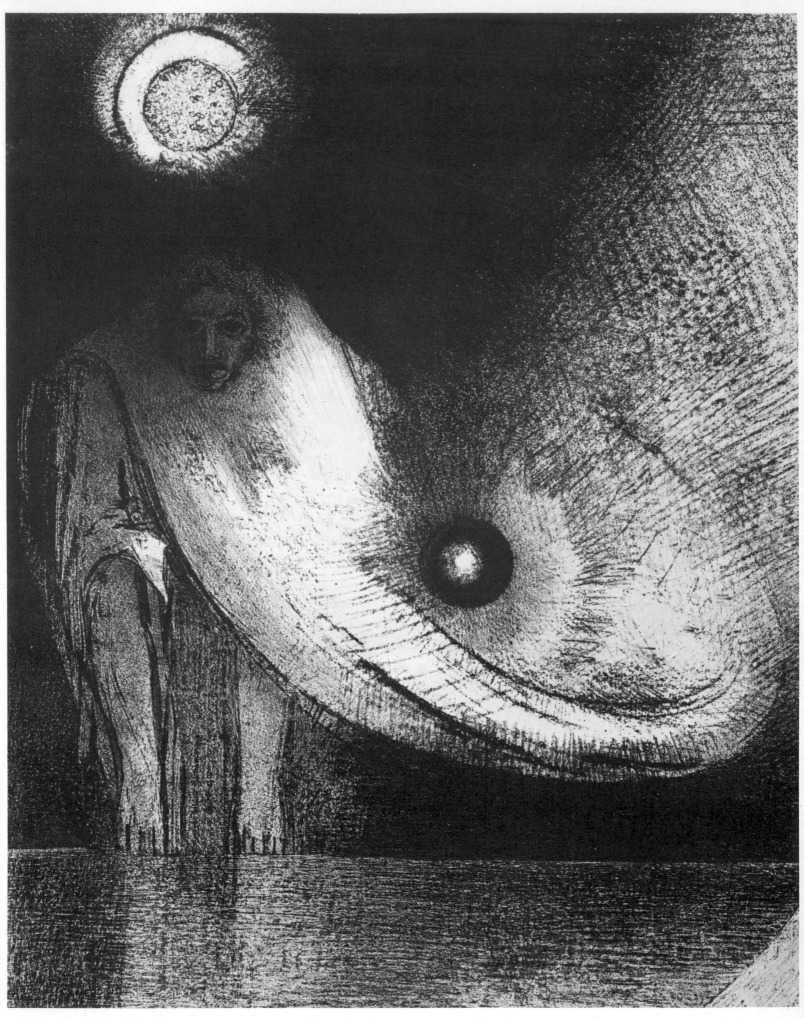

207 ODILON REDON *Limbo* 1879

208　ODILON REDON *The Reader* 1892

209 ODILON REDON *Sans cesse à mes côtés s'agite le démon* ('The Demon stirs
unceasingly at my side') 1890

210 ODILON REDON *Buddha* 1895

211 GUSTAVE MOREAU *King Lear during the Storm*

213 JAMES ENSOR *Odd Insects*

212 HENRY HOLIDAY Plate from *The Hunting of the Snark* by Lewis Carroll

214 JAMES ENSOR *Odd Little Figures* 1888

215 JAMES ENSOR *The Triumph of Death* 1896

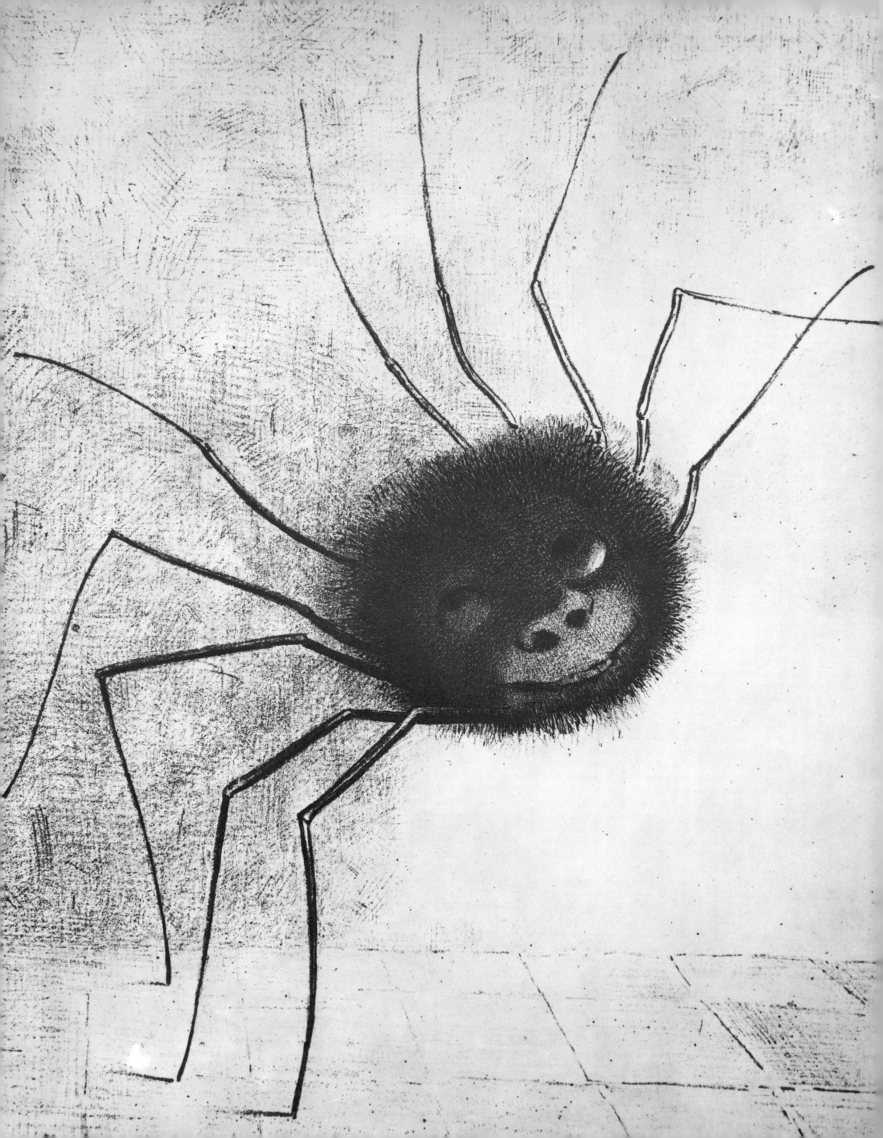

216 ODILON REDON *The Spider* 1887

INDEX OF PLATES